HOW TO MAKE MONEY WITH YOUR CAMERA

Ted Schwarz

Publisher: Carl Shipman; Editors: Bill Fisher, David A. Silverman
Design: Josh Young; Photography: Ted Schwarz; Book Assembly: L.P. O'Dell
Typography: Joanne Nociti, Cindy Coatsworth

ISBN 0-912656-30-1
Library of Congress Catalog Card Number 74-82517
Published by **H. P. Books**, P.O. Box 5367, Tucson, AZ 85703 602/888-2150
Printed in U.S.A.
©1980, 1974

About This Book

This is one of a series of H. P. Books on photography. In choosing subjects, we thought it important to offer a good manual to guide the serious amateur into the ranks of part-time or semi-pro photographers. For many people, it's a way to improve skills, add to your bank balance, and expand your camera equipment by reinvesting the money you earn.

Earning money through photography offers rewards beyond the extra dollars. It adds the zest of fulfilling an assignment and pleasing your client. It adds technical challenge because you solve the problems you find at shooting locations—that's part of your job.

Anybody can take pictures these days and there are few measures of quality to separate the work of one amateur from another. In the no-fooling environment of earning money with your camera, your skill is truly tested and the money you earn is satisfying testimony that your work measures up.

Author Ted Schwarz carefully describes a variety of money-making projects you can do, starting with relatively simple methods for candid photography of children and building to weddings, industrial assignments and shooting for publications.

You will learn what to do—and what not to do—because the author has done these things himself. This is not a wistful wishful-thinker's book. It's a practical manual of how-to.

I think you will be challenged by this book and by the new opportunity it opens to the ambitious and confident amateur.

Carl Shipman
Editor

ABOUT THE AUTHOR

Much of this book is a sort of autobiography, recounting experiences Ted Schwarz met along his route from earnest amateur to seasoned professional. By forthrightly offering his camera and talent, Ted gained assignments from Standard Oil, hospitals, Stouffer Foods, model agencies, businesses, theater and entertainment groups, magazines, and even a belly-dancing school.

Author of the book *The Business Side of Photography,* he is a columnist for *Rangefinder* magazine and a regular contributor to magazines in a variety of fields including coin collecting and medical economics.

Mr. Schwarz lives in Tucson, AZ and now is a full-time professional writer and photographer.

Getting Started

Photography is not the most expensive hobby you can have. You could enter your Rolls Royce in the demolition derby. Or you might collect used Boeing 747 airplanes. Unlike the other diversions, it is possible to make your hobby of photography pay for itself. Many a skilled amateur has used his cameras to earn a nice nest egg that helped buy more cameras and equipment, pay for schooling, or even a long over-due vacation for the family.

When was the last time you picked up a magazine or passed by a photographer's studio, looked at a photograph and said to yourself, "Why, I could do better than that!" At that moment you realized one of the truths of professional photography. There is often little difference between the work of the professional and the amateur. When there is a difference, *sometimes* the amateur's work is better!

Technically a professional photographer is just a person who shoots pictures for money—nothing more and nothing less. However if you talk to the average professional, you may come away feeling that the pro was uniquely appointed by some cosmic force to go forth and take pictures. You feel inferior to his vast skill even though, in the back of your mind, you know his work is sometimes no better than your own.

Anyone can call himself a professional photographer. There is no required training, no special licensing exams, and no minimum skill level necessary. If a person has a camera and, perhaps, the money for business cards and a Yellow Pages listing, he or she can become a "professional."

More than 90% of the photographers who turn full-time professional and open a studio will fail in the first year. Lack of business sense or a lack of working capital sends them into bankruptcy. It makes sense to work into it gradually. Lack of photographic ability is seldom the cause of such failures.

The word "amateur" is from Latin meaning "to love." An amateur is someone who does something because he loves it. By that definition, a professional is quite likely also to be an amateur

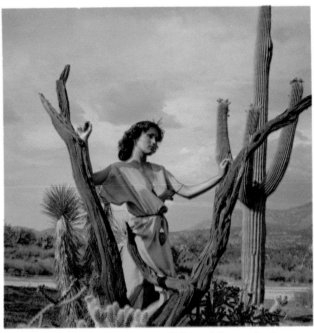

Working on location with beautiful models can be fun as well as profitable.

Subdued light from a window makes place settings on this restaurant table more appealing.

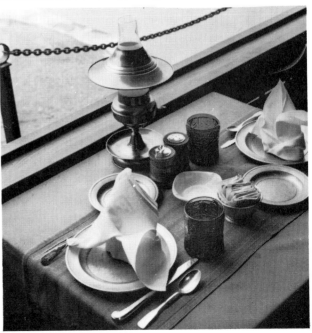

because few people try to earn their living with a camera unless they truly love photography.

Now that's out of the way, there should be no question whether or not you can make money with your camera. Of course you can! This book will show you how. We start with relatively simple projects which will earn you some money. By the time you try everything in this book, you should have enough money in the bank that your friends will be convinced you have joined the ranks of the "professionals."

CHECK THE LEGALITIES

Some communities have zoning and tax laws covering a freelance photography business. Home portrait studios, for example, must comply with laws concerning a business in a residential area. Pictures you take on location are not in this category, but the price you set for them may be subject to sales tax. Check with your local city, county and state offices to be certain your business is handled in a legally proper manner. It is a nuisance, I'll admit, but it can save you many headaches in the future.

Visit or phone your nearest Federal Internal Revenue Service office to get information about the business records you must keep and how you should report your income as a freelancer. The IRS has a toll-free number for each state which should be listed in your local phone book. Ask for IRS publication 552 "Record-Keeping Requirements and a Guide To Tax Publications." This will get you started and you may see other publications listed there that will help you. Publication 552 is free and will be sent to you on request.

You will need some organized way to keep your business records, expenses, appointments, and perhaps a record of time and travel expense for various jobs you do. There are several publishers of pocket-size and desk-size diaries with space for such entries. Write to Day-Timers Inc. P. O. Box 2368, Allentown, PA 18001 and ask for their catalog.

Back lighting a model's hair creates a feeling of softness and sensitivity.

Timeless photographs such as this one of a covered bridge sell to newspapers, magazines and even art galleries. Photo by Charles Jacob Tschupp, Amity, Oregon.

Fashion show photographs can sell to the department store and clothing manufacturer as well as the models.

Right now you may be thinking, "But what about equipment? All I own is a 10-year-old-pawn-shop special. Shouldn't I have a triple-coated, dual-carburetor, Moneyflex SLR?"

If your camera can take a picture that looks good when enlarged to 8x10 or 11x14, you can use it to make money. It does not have to have interchangeable lenses. It can use any film from 35mm to 8x10. It can be 40 years old or just purchased yesterday. All that matters is that it yield negatives from which good enlargements can be made.

Naturally the more lenses you have and the more features your equipment offers, the more you can do. But this book will show you how *any* camera can help you earn money. You can use the profit from your early projects to buy better equipment, or you may stay with what you have all the way through the book. You can even use the better Polaroid cameras for some of the projects, though you will find there is greater profit potential in working with cameras which provide a negative. Polaroid does have a positive/negative film but it is more for studio use than general shooting.

Even a top-of-the-line 126 *Instamatic* can be used to make money—the negative is about the same size as you get from a 35mm camera. I do not recommend the *Pocket Instamatic* series however because the tiny 110 negative requires so much enlarging that quality can suffer.

Projects in this book are arranged so the easier ones requiring the least equipment are at the beginning. If you feel you are ready for work such as wedding photography, you should still consider the early projects. All the ideas offered can make you extra money. Even if you are lucky enough to own a fancy Moneyflex, there is nothing wrong with trying a plan which can also be handled with an Instamatic. The goal is to make money and every chapter gives you definite ways to go about it.

You will also find special lists which tell you what type of equipment you need for each project, how to figure your costs, where to get special items or special processing, and other valuable information. These lists will make this book as indispensable as your gadget bag when you are on a new project. Let's look at some ways you can make money with your camera.

Photographing Children at Play

Working on a puzzle may give as many expressions as there are children.

Of all the ways you can earn with your camera, none is so easy as taking unposed photographs of children. Your subject matter is always right at hand and parents find it hard to resist buying at least one picture for the family album and several more to send to the relatives.

Candid child photography is not the same as portraiture, a subject discussed later. It is the spontaneous recording of a child at play, capturing the pleasures and moods of childhood.

Parents *can* easily take candid photos of their children but they *seldom do*. Either the camera's out of film, the flash is broken or it's too much of a nuisance. Also, the more children a family has, the fewer the photographs. A couple tends to take the most pictures of their first born but as the child gets older and the family gets larger, the camera is used less. Parents still want pictures of their kids but some no longer want to be bothered making the effort themselves. That's where you come in.

You don't need fancy equipment and you don't have to worry about extreme enlargements such as professionals offer. See Equipment List A at the back of the book. Most of your customers will want prints for albums, 3x5 to 8x10, with the smaller sizes comprising the majority of your sales. In addition you will be working primarily with black-and-white film so your costs will be low.

Before you begin, consider what films to use. Most photographers taking candid pictures prefer Tri-X because of its high speed rating, and relatively fine grain. This film can be used indoors and out and is readily available for Instamatics, 35mm cameras and roll film cameras.

If you will be working in bright sunlight you should use a slower film such as Plus-X or Verichrome Pan. These are rated at ASA 125, can take greater enlarging than Tri-X because they are not as "grainy," and they allow more control of depth-of-field.

Both color negative film and black-and-white film allow under-exposure and over-exposure by a relatively wide margin without affecting print quality too much. They are also inexpensive to use by comparison with color slide film. Because slide film also requires almost perfect exposure to get an acceptable photograph, it is best avoided for this type of work.

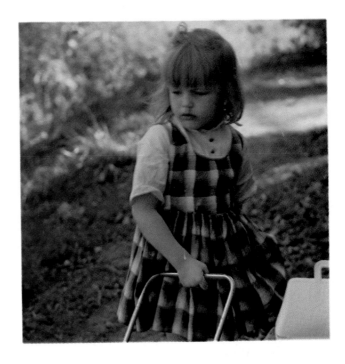

The concentration of a child at play lets you take photographs unobserved.

 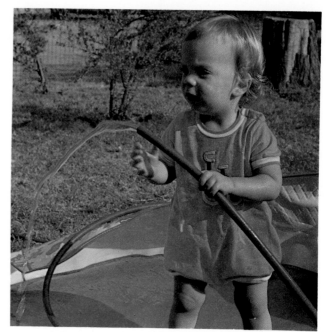

Give a small child a garden hose and the end result can be delightful. Just keep your camera out of firing range and be alert to when the child is going to swing the hose toward you.

Color-slide film does not allow you to make mistakes. A slight over-exposure usually means the slide will be washed out, the brilliancy of the colors completely lost. With under-exposure everything goes toward black. Detail is lost and the picture may be only barely identifiable when projected.

Some parents want color photographs of their children, so you should be prepared to take them. However, use color-negative film only. You can use Kodak films or try those made by Agfa, Fuji and others. Color negative film has three advantages: It has more exposure latitude than slides, single or multiple prints can be easily made and, in the case of slow speed Kodak color negative film, the grain is microscopically fine.

Before you can begin to sell your service, you must have a few samples to show. The best approach is to take black-and-white photographs first until you are pretty good at it, then take some samples with color-negative film and have prints made to show your prospects.

Once you get started you will probably find that color prints have much more sales appeal so you may gradually emphasize color prints. The cost difference is actually small in the mind of the average customer. Check some of the high-volume color labs listed in the back of this book—and some that advertise in the photo magazines. The

prices may surprise you. Some labs don't even want b&w anymore and their prices for color work prove it!

TECHNIQUE

There are several appoaches you can use when shooting your samples. Some photographers hide in the bushes until a child appears, then suddenly leap out—shout "Smile!" take the photograph and jump back into the bushes while the child's mother calls the police.

Another bad approach is to walk up to the child and ask him to pose, directing every movement while the child grows increasingly bored. You are less likely to create a riot situation but the resulting photographs are not going to be a lot better.

You will have success by working casually and openly. Your camera should be in view and you should answer questions such as "What's that?" or "Are you taking my picture?" Explain about the camera and tell the child you will take his photograph while playing. You might even let the child look through the viewfinder to satisfy his curiousity.

A little caution is in order. I once made the mistake of letting a little girl near my camera at the same time she was holding a wad of chewing

This highly salable photograph was taken with a $15 pawn-shop camera. My camera dealer said I was over-charged $5.

gum. The gum ended up as a sticky coating on the viewfinder and took about fifteen minutes to remove.

The secret to successful child photography is the same as good portrait photography—composition. Try to fill the frame only with images which help the final print. Usually this means moving in close. Sometimes you may want to include some toys but never stand back far enough so you get the child, his house, six of the neighbors and the jet flying overhead. When you crop to whatever seems appealing, the section of the photograph with the child will have to be enlarged so much it will be meaningless blobs of grain.

Every standard camera can focus as close as five feet and most will be sharp as close as three feet or less. Take advantage of this and move in on your subject. If you are in doubt as to what the best compostions will be, take several photographs from different distances and see which you like best. Eventually choosing the right spot to stand, kneel, or lie will become second nature, but at first you will learn mainly through trial and error.

A marvelous aspect of childhood, though it frustrates parents and teachers, is the shortness of a child's attention span. He gets bored very quickly and wants to do something else. He is pestering you with questions one minute, playing with his friends the next. You can stand in the middle of extremely active play and the children will forget you are there. Your pictures take on an uninhibited feeling that candid photos of adults can seldom match.

During the first few minutes a child is likely to want to pose for you. Children will stick out their tongues, make funny faces, leap about and do anything that seems humorous or a little naughty to them. Sometimes this results in cute photographs but it seldom results in salable ones. Parents don't want pictures of their children acting silly. They see enough of that at home and it is not a part of childhood they want to pay to remember.

The best way to get a child to stop making faces is to humor him. Take a few pictures while he poses, even if you do it without film in the camera. The child will like you for going along but quickly lose interest. When that happens you can get down to serious photography.

Most photographs of children are taken from the adult's viewpoint. The photographer is standing, looking down at the child at play. Try kneeling down to get a child's viewpoint of the world or even lie down looking up at the child in much the same way as a child sees an adult. Varying the angle of view will improve the interest of your pictures.

Never try to guide the child. You might have an idea for an "adorable" pose or want to move to an area with different lighting conditions. However, the purpose of candid child photography is to capture the child's world. Adjust yourself to each situation rather than trying to force it to fit your preconceived ideas. If you start to offer direction, your work is liable to look stiff and unnatural.

If you want to get a reaction from the child, you can try making an odd noise or a funny face. You will usually get laughter or surprise the first time you do it.

Getting some nice photographs of clean, fresh kids when they come out to play will usually result in sales. But parents will also cherish the photographs which result from staying around a while until the children are covered with mud and look as though nobody ever cared for them. The broader the range of photographs you take, the greater your sales will be.

SAMPLES

Your sample photographs can be shot anywhere and of any children. However it's best to start with children in your neighborhood. You should know their families or at least where they live. The parents of the children in your sample pictures may be your first customers.

Once you have taken some good photos, make up a sample album with different-sized prints. One of the "magnetic" photo albums with clear overlay sheets will work perfectly. Each page should have from one to four prints showing the different sizes you will be offering. For example, one page will have an 8x10, another will have four 4x5's. A third page shows two 5x7's and a fourth page has four 3x5's. Display b&w and color prints.

PRICING

There are two methods for pricing your services as the neighborhood "candid kid" photographer. By the hour, charge from $10 to $25 or more for every hour you are taking pictures. The parents also pay for prints. Add a slight mark-up for each print if you feel you can get away with the additional charge. This is best when offering your services at a child's birthday party.

The second method is just to charge by the print. A photograph can be sold for from 2-1/2 to 5-1/2 times your cost, for example. This is usually best when photographing children at play, either at home or on a playground. See the pricing checklist at the back of this book.

GETTING ASSIGNMENTS

Some photographers find they can make money by going places where families gather such as parks and recreation areas. They take candid shots of the children, get the parents' names and addresses and make arrangements to show the finished prints. The photographer pays all costs himself, making his profit from selling the finished prints with enough mark-up so he will meet his expenses and have money left over. This requires selling a large number of photographs and is rather risky. If your work is good and you have had success with parents in the past, it might be worth a try. However, it should not be the way you begin.

First, take sample photographs, make up your sample-album, and use the checklist at the back of this chapter to figure costs. Then you will know what you need to charge.

Next, go to the parents of the children you photographed for your samples and show them your work. Explain what you are doing and ask permission to use the photos of their children for samples. They will usually be happy to give permission, all the while complimenting you on your excellent choice of models.

At this point you can offer copies of your samples to the parents for either your cost or a slight mark-up, whichever you prefer. Do not give any prints, however, as you have already spent money for film and processing. The whole purpose, after all, is to make money with your camera.

In case you are wondering where you stand legally, here is some information as a guide. For more detail check the book *Photography And The Law* by George Chernoff and Hershel Sarbin. Specific legal advice must come from an attorney in your community who knows which laws apply to your particular situation.

In general, you can photograph anyone in any public place providing you do not subject the person to ridicule or embarrassment. This means that children in a playground are probably perfectly all right for you to record, even if the parents do not like the idea.

You can generally use photographs of anyone—meeting the previous conditions—to show *your* ability as a photographer when seeking other assignments. You cannot sell the pictures without permission of the subjects, or their parents if they are under legal age. Also you cannot represent the subjects as customers if they were not.

Many photographers use standard printed forms for permission to sell photos of an individual. These are called *Model Releases,* often available in camera stores.

Despite your legal rights, I feel that if parents object to your photos of a child, you should accept the decision. At the worst they can drag you into court. Or else they may "bad mouth" you to neighbors who are your potential customers. It isn't worth the trouble.

> Child-adoption agencies may be interested in your taking posed or candid photos of the children. These are used to show adults interested in adopting a preliminary idea of what a child looks like.

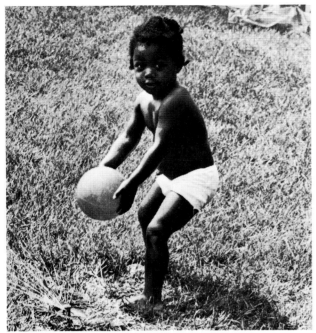

"I'll bet you can't hit me with that ball." I got a cute photo. I also got hit with that ball!

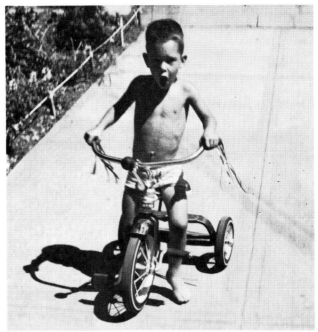

Pawn-shop special again. Print quality isn't great but the family bought prints and Christmas cards.

If you plan on spending a lot of your time photographing kids, it will pay you to get business cards and even to advertise a little. The cards should include your name, telephone number and, if desired, your address. They should also have a line briefly describing what you do. For example: "Peter Smith—Kandid Kid Photographer." If you are a student or work during the day, the hours when you can be called should also be included.

Advertising can be handled in a variety of ways. A New York candid kid photographer who teaches school during the week advertises in the classified section of his local newspaper. The advertisement only appears on Saturday and Sunday when the *Personal* section, where the ads appear, is most widely read. The cost is small and the ad has increased his profits.

A California waitress advertises in a weekly newspaper and an enterprising Iowa high-school student arranged to have his photography mentioned in a PTA newsletter. The response was so great he was scheduling birthday parties three months in advance.

If you work for a company which has a news-letter or magazine, this is an ideal way to acquaint co-workers with your services. In apartment buildings put information about your service on the bulletin boards found in most apartment laundry rooms. One elderly Ohio photographer, a retired sales clerk who wanted to supplement her Social Security check, advertised in her apartment building which rented exclusively to senior citizens. She made a nice income photographing grandchildren visiting residents.

Another type of self-promotion has been successfully used by a Florida woman. She took her best photographs, had them dry-mounted, and asked local pediatricians if they would allow her to hang them in the doctors' waiting rooms. Most were delighted to let her use wall-space for the displays. Naturally, her business card was prominently visible underneath the prints.

You can find the names and addresses of local pediatricians in the Yellow Pages of your telephone directory. Write a letter saying you are a local photographer of children and would like to display some of your work in his waiting room. Then go to each office, talk briefly to the receptionist and leave some photos and the letter for the doctor to examine at his leisure. Check back in a week.

EQUIPMENT TIPS

Dry-mounting prints is not difficult. It means mounting a print on special mounting board with a "dry" adhesive. This is a thin tissue-like material which fits between the board and the print. You can use a special dry-mounting hot press or, with great care and paper or cloth over the print for protection, use a dry hot iron to melt the adhesive. Your dealer can furnish information and supplies for dry-mounting.

You can use other approaches for mounting prints. Kodak and other companies sell photo-mounting cement. There are also mounting boards pre-coated with adhesive.

Be careful to use only products specifically intended for mounting photographs. Don't use ordinary household glue. Adhesives not meant for photographs may turn them yellow over a period of time—often as short as a year.

Earlier I mentioned party photography and this means taking your camera indoors. Going inside means using extra lighting, though my earlier statement about equipment still holds true. No matter what you own, you can produce salable photos.

Occasionally you will find a home with adequate lighting for photography without flash, but it is the exception. Most homes have lamps spotted around so you find areas with harsh light and areas in dark shadow. It may be possible to take available light photographs of children sitting quietly but when they start running amok, as they will, only flash will stop the action.

Every type of lighting has its drawbacks. Some people use the architecture photographer's trick of putting small flood bulbs in room lamps instead of the normal, low-wattage variety. This is very dangerous! The bulbs become extremely hot when left burning for as long as necessary for a party. There is a chance they may set the lamp shade on fire, or burn the hand of a child curious enough to touch them. Your safest approach is to use a flash attachment with your camera.

If you have an Instamatic or similar camera, you are probably using tiny AG-1 flashbulbs in cubes. Although professionals may scorn these bulbs, these midget bulbs provide almost as much illumination as the big ones did not long ago. The light falls off quickly so best illumination is between four and seven feet from the camera. You will not be able to take a flash cube picture of anything more than ten feet from the camera.

This does not mean you should avoid using AG-1 bulbs. Understand their limitations and plan accordingly. Keep the center of interest in the four to seven foot range.

A problem with on-the-camera flash units and color film is called "red eye." No, this isn't a drink at the Long Branch Saloon. It's the color of your subjects' eyes when the flash lamp is too close to the camera body. It's caused by light going into the eye and then reflecting straight back to the camera.

There are two cures for "red eye." One is to hold the flash in your hand so it is several inches from the camera. This can be done with any flash linked to the camera by a cord.

The second method, for flash cubes, is a flash extender. This fits into the socket where you would normally place a flash cube and elevates the cube several inches above the lens. It's free with many Instamatic kits and can be purchased separately for very little money.

When using cameras more complicated than the Instamatic, you will probably have the type of flash which plugs into the camera with a cord known as a PC cord. You can remove the flash from the camera to cure "red eye," and also vary the angle of the flash.

Learn to use bounce flash. This is possible with adjustable cameras using flash with PC cords. Aim the light at a white or light-colored ceiling instead of the subject. The light is bounced from the ceiling onto the subject, providing an even soft illumination similar to an overhead light.

To determine lens opening when using an adjustable camera, divide the Guide number provided by the manufacturer of the flash bulbs or electronic flash, whichever you use, by the flash to subject distance. With bounce flash, the flash to subject distance is not a straight line.

Estimate the distance from flash to ceiling, then add the distance from the ceiling to the subject. Divide this total figure into the guide number to get the *f*-stop. However, because the ceiling absorbs some light, open the lens an additional *f*-stop. If the ceiling is dark or dirty, use two *f*-stops more exposure.

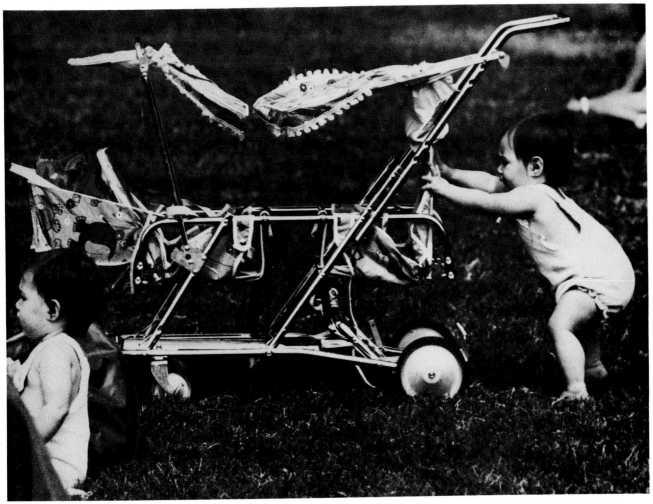

What does an infant do when she is bored? Just pushes her own carriage. An enterprising individual with camera ready can capture the moment and make a sure sale!

You should not use bounce flash until you have practiced with it. You must learn to guess distances with some accuracy. Even when skilled, you should make several exposures when possible, bracketing static scenes such as people talking in a corner. For sudden, non-repeatable action such as when a guest pours ice cream over the head of the birthday boy, direct flash is safer.

Automatic-flash units are generally fairly accurate for bounce flash, but you still need to test and practice. The automatic units offer a consistency of exposure unmatched by standard flash. Practice bounce flash with your automatic unit at home to see what lens opening gives best exposure. This should be consistent wherever you take your unit as it will compensate for distance by itself.

Caution! Many auto flash units are accurate on "automatic" for only a specified distance at a particular f-stop. If the distance between flash and ceiling added to the distance between ceiling and subject exceeds your unit's limitations, the photograph will "automatically" be too dark!

Learn to estimate distances. Measure some distances at home and compare against your estimates. A trick I have used is to imagine I am lying down. I know how tall I am so I can guess a distance by mentally deciding how many body lengths there are between flash and subject.

Another problem with direct flash is shadows. If the flash is aimed directly at the subject, shadows will be visible on the wall behind. This is acceptable for some candid work, but a more professional approach is to have the flash slightly above your subject and aimed downwards. The shadow will be out of the picture area.

Watch for things which reflect light. Mirrors, glassware on the table and other shiny objects will

Kids and dogs at a pet show are natural subjects.

Make extra money putting kid photos on buttons. Coat them in the darkroom with Print-E-Mulsion or other liquid emulsion available from your dealer.
Two sources of supplies and equipment to mount photo prints in buttons: N.G. Slater Corp., 220 West 19th St., New York, New York 10011, and Edmund Scientific Company, 300 Edscorp Building, Barrington, New Jersey 08007.

produce glare if close to the flash. Try to angle your flash head so you avoid illuminating such objects, or keep them behind your subject to reduce the distraction to a minimum.

Once you have established yourself as a photographer, buy film in larger quantities, storing what you do not immediately need in your refrigerator. The number of rolls you have to buy to get a discount will vary, but generally it's 10 to 20. Most dealers in my area sell a 36 exposure roll of Tri-X for $2.50 or more. When I buy 20 rolls at a time, I get a discount of from 10% to 20% depending upon the dealer. Different camera stores offer different discounts, so compare bulk purchase prices.

Don't buy outdated film. In theory, black-and-white film is good beyond the dated period, but that depends on how it was stored. Few retail stores keep their stock refrigerated until time of sale, so the film has been deteriorating on the shelf for many months. Refrigerating or freezing film prolongs its life for as long as several years.

Some photographers buy bulk 35mm film, 100 feet at a time. They use a film loader and specially-purchased cartridges to make their own loads. This represents a greater saving but may be risky when you are earning money with your camera.

Bulk-loaded film can be damaged in several ways. Older loaders have felt-sealed light traps so designed that dirt can accumulate and scratch the film being wound into the cartridge.

The cartridge light trap may also be dirty, especially after it has been used once, and scratch the film. To keep everything clean you need a loader without a felt light trap. Keep your cartridges spotless with pressurized cans of air sold for lens cleaning. This becomes a nuisance and does not completely eliminate the risk that your valuable negatives may be scratched. I think it is better to pay for factory-packaged film than to bulk load your own and risk losing your photographs.

Is there a square dance club in your area? Photos can be sold to the members and also to local newspapers interested in a feature on the "revival" of this form of dancing.

School Photography

School days can be profit days for the student or teacher with a camera. Almost everything that happens, from classroom projects to special events, can result in money-making photographs for you. See equipment list A, B or C for suitable camera gear.

You may be faced with camera snobbism, a disease that begins about the time a person gets serious about photography.

It exists in the boy who glances at your Instamatic and says, "Oh, you're using one of those! I thought you were going to take *real* pictures." It exists in the girl who comments, "That's your *only* lens? I have 127 different lenses including a wide angle that lets me take a self-portrait when I am pointing the camera at somebody else." And it exists in the man who comments, "Oh, *that's* your camera? Someday I'll show you mine."

Basically camera snobbism is a "costlier-than-thou" attitude. Many people recognize dollar value only, not the ability of the photographer.

Because of camera snobbism, it will be difficult for you to make money with the 126 Instamatic, though there are a few areas where this can be done. In general, school photography must be done with 35mm or roll-film equipment. If you don't have interchangeable lenses you will be limited. Even so, you can earn enough without extra lenses to buy lenses and things you need to make still more money with your camera.

After-school clubs are probably your best source for additional money. Every school has a variety of activities such as a Chess Club, Drama Club, Debating Team, and 4-H Club. Because membership is voluntary, those who belong are enthusiastic and proud of what they are doing. They like

School ballet groups allow sales to the dancers, parents and school. Cheerleading and related activities also offer the photographer potential for multiple sales. Most shots can be duplicated with *any* camera.

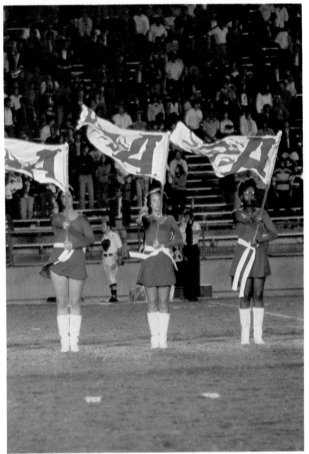

to be photographed during club activities and will pay for photographs of themselves and other members.

GROUP PHOTOS

Talk with the club president or teacher advisor. Explain that you want to take pictures of the club which you will sell at a nominal charge. 99 times out of 100, the members will be enthusiastic.

If the room where they meet is well lighted, you can load your camera with Tri-X or any equally fast black-and-white film, arrange the group and take a group picture. Take extra shots at different exposures for insurance. You will need a light meter, and you may have to use a wide-angle lens if you cannot stand back far enough to get everyone in.

When photographing a group, you must keep depth of field in mind. Once a lens is focused, a certain number of inches or feet in front and in back of the subject will also be sharp. Everything else will be blurred. If you can view through the lens, stop down to the aperture you plan to use and check depth visually. If not, check the depth-of-field indicator on the lens or refer to a table.

If the light is not adequate, supplement it. One method is to use bounce flash discussed in the previous chapter. You will need a fairly high-powered electronic flash unit rated at 1,000 Beam Candlepower Seconds—BCPS—or higher. Or a flash bulb holder which takes at least a #5 flashbulb or equivalent. Use Tri-X even with flash because the light will have to travel many feet and you want to use a small lens opening.

You can use flood lights. For under five dollars you can buy a clamp-type light bulb holder from most hardware stores. These will generally handle flood bulbs up to 500 watts. Two such lights will do. Buy a 20-foot heavy-duty extension cord for each light so you don't have to worry about finding a place to plug in. The cost is low and you will find additional use for the cords and lights when handling future projects discussed in this book.

A word of caution! There is the saying that if something can go wrong, it will, and that is always the case with supplemental lighting. Both flashbulbs and flood bulbs have a nasty habit of exploding, something that is very embarrassing and often dangerous. Once I was photographing

blind factory workers for the Society of the Blind. I had set up my floodlights and just turned them on when one of the bulbs exploded into pieces. The workmen were quite startled and asked what happened. "Nothing," I lied. "That's the way this equipment always sounds when I turn it on."

When using flood bulbs, make certain they are not cold when first turned on. Mine had been in a car during a snow storm just before I used them. Aim them away from the subject for the first minute as this is when they will explode if they are going to. When you are sure they are safe turn them back towards your subject and proceed normally.

Plastic covers for flash-bulb holders are a good precaution. Remember you may be held legally liable for injuries caused by your equipment. A few precautions will keep your projects money *makers* instead of money *takers*.

As with direct flash, flood lighting leaves shadows. Put the lights high enough so the light is aimed with a slight downward angle. You can reinforce the clamp with masking tape, available anywhere, or an item called Gaffers' Tape, labeled Duct Tape at hardware stores.

Gaffers' Tape is a miraculous invention designed to hold heavy objects on walls, ceilings or anything else. It is a super-adhesive tape which does not leave marks but holds heavy lighting equipment used by professional motion-picture photographers. Most photo dealers and hardware stores either stock it or can order it.

The group photograph will result in picture sales and individual photographs will help you earn even more money. If you are dealing with a debate club, catch each member engaging in a debate. At a chess club photograph players during the game. An interesting approach might be to put the camera on the level of the chess board, taking the picture through the chess pieces. Watch depth of field!

If you have your own darkroom, make small individual prints of each club member. Enlarge one picture to 4x5, 5x7, and 8x10 samples. Group photographs should be no smaller than 5x7 and preferably 8x10.

If you are using a custom lab, it's cheaper to order an *enlarged contact sheet* rather than individual pictures of the group. Instead of 8x10 size, the contacts are printed on 16x20 paper. With

Right way to use a wide-angle for school photography. Adequate coverage and depth of field records both student and model without distortion.

35mm film, each photo will be 2x3 inches, an easy-to-view size.

For large group shots such as choirs and bands, you need space for maneuvering. A school auditorium will work well and generally has adequate lighting for black-and-white. A football field, gym, or bleachers can also be used. Steps in front of a building can also be used. You may want to take both group photos and individual photos, complete with uniforms if the group wears them. Get orders for the individual photographs in advance, so you don't waste a lot of film.

When you show the enlarged contact sheets to the group, have a sign-up list on which each student puts his name and picture order by quantity and size. Get pre-payment to discourage ordering prints with no intention of paying for them.

If you are using a custom lab, find out when the prints will be ready so you can tell the students when to expect their pictures. They will be anxious to get them.

DANCES AND PARTIES

An instant camera, such as one from Polaroid or Eastman Kodak, can be a money maker during school parties, dances, awards programs and similar events. Set the camera on a tripod facing a corner of an even-colored wall. You can use flash or flood lights. Use chalk or masking tape to mark the floor where you want your customers to stand, then use a friend to take a test exposure at that distance to be sure the lighting is correct.

At a dance or party, you can offer the couples an instant souvenir. You can buy inexpensive cardboard mounts for the prints, making them a little fancier and less likely to be damaged during the evening. Some mail-order sources for these holders are at the end of the book but your photo dealer may have them in stock. The prints will sell for about two dollars each in black-and-white, with the folder-mounted print selling for at least 50 cents or a dollar more. Color, of course, will be higher.

Instant pictures also allow you to avoid follow-

School photographs need not be restricted to school classrooms. This picture of entertainment major Carol Laing was taken 15 minutes from the school grounds. Images such as this one can provide more sales potential than shots taken on campus.

up selling. If the couple doesn't have the cash, don't take the photograph.

When there are special awards assemblies, your instant camera can again be of value. Parents will want pictures of their children being honored. If the school will give you permission to set up your camera and announce that you are there to take pictures, you can usually make several dollars for less than an hour's work.

For pictures sold to parents, consider using Polaroid's Type 105 P/N film if your camera takes this size. You get both a positive and a negative at the same time. You can then offer enlargements made from the negatives.

You may run into problems taking pictures

when a prom is held. Many professional school photographers have permission to set-up at the prom, offering packages of small and large prints in color. This is often tied in with a contract to produce prints for the school's yearbook. This still leaves you many other types of parties and opportunities.

Many camera stores in large cities have a stock of used Polaroid or 4x5 cameras with Polaroid backs which they rent for a small fee. Be prepared to put down a substantial security deposit and get a statement in writing that all but the agreed-upon rental will be returned to you if the camera is brought back to the store in the same condition as it went out. You should also buy your film from

Nor should school photos be restricted only to public school programs. There are also excellent opportunities to photograph individuals who take night school, vocational or creative dance courses.

the dealer making the rental agreement, even if you know a store which gives you a better buy. If the dealer gives you a break, you owe him equal courtesy.

There is also a Kodak instant film back for that company's PR-10 color film, which fits certain 4x5 cameras. Check your dealer for details.

The dealer should agree to allow you to return any unopened film that you did not use for a full refund within a day or two of purchase. Beware the man who wants to give you credit on your account unless your bills at the store are regularly high enough that this will be of value.

DRAMA

Drama groups offer another opportunity for making money with your camera. You can make posed pictures of the actors and actresses, as discussed in the chapter on modeling and theatrical portfolios. At this point we will just consider pictures of the cast as they appear on the stage.

When you photograph a school play, you have three potential areas for sales: The participating students and their parents, the group's advisor and at the college level the school itself may use one or more photographs for the school's annual catalog. If there are ten students in the play, your final sale could be several times this number, counting extra prints purchased for relatives.

This section has only general information about theater photography because there is an entire chapter later.

Lighting is the key to success. With adequate lighting, all things are possible. Unfortunately many productions keep lighting subdued. In a darkened theater a small amount of light on stage seems bright to the audience, so they use far less than is desirable for available-light work with most inexpensive cameras. Even worse, during a dramatic presentation any extraneous light is a distraction which must be avoided. Flash is eliminated from consideration, yet flash may be the only way to get the picture.

Because of these problems, the photographer with limited equipment should arrange with the drama department to take photographs during a specially lighted dress rehearsal. The stage lighting can be boosted so Tri-X can be used with available light.

Assuming your camera has a non-interchangeable lens, shoot from the front of the theater so that you can frame about half to two-thirds of the stage, keeping the actors large enough so everyone is recognizable in the photograph.

I still remember the first time I attempted theatrical photography. My camera had been bought at a pawn shop and the lens kept coming off. Because the camera was not supposed to have an interchangeable lens, the fact that it kept coming apart worried me.

At the school auditorium I had arranged to have the lighting boosted. After tightening the screws that held the lens, I walked to the back row of seats where I had a magnificent panoramic view of the stage and just about everything else. While the play was acted out, I took pictures, holding the wobbly lens with one hand while shooting with the other. When I had them enlarged to 8x10, the actors were so small that nobody was recognizable. I went to 11x14, then 16x20, and finally, 20x24 at which time the grain was recognizable but the actors still weren't.

The moral of the story is to move in fairly close to the action on the stage. Except in an occasional extravaganza the action of a play takes place on only a limited section of the stage. By moving in close enough to catch just the action of the moment, you will get dramatic effects. Also, don't buy a camera at a pawn shop unless you

Chance candid with telephoto lens caught this student and faculty member strolling across a college campus. It became a college bulletin cover.

can first get it checked by a reputable camera repairman.

This is one of the times when you can use the top-of-the-line 126 Instamatic as well as more sophisticated equipment. Student actors may be photographic snobs, but there is enough "ham" in them that they will buy good photos of themselves no matter what camera is used.

Even the best light may force you to work with a rather slow shutter speed so action could be blurred. To compensate, wait for moments of peak action. If someone is striding forcefully across the stage, there will come a moment when he stops to make a point, listen to another actor, or strike a pose. At this instant he will be completely still and you can take the picture. If there is much action in the play you are photographing, it helps to attend an earlier rehearsal to familiarize

yourself with the performances. It will then be easy for you to anticipate pauses when you can take pictures.

Use a high-speed black-and-white film such as Tri-X. Other films will be discussed in the section on theatrical photography. But this chapter assumes you are using limited equipment. Make one or two 8x10's for samples—the rest of the photographs should be shown as enlarged contact sheets or small individual prints. The enlarged contact sheets from a custom lab, the small prints if you use your home darkroom.

Sample prints should be ready in time for one of the performances, if possible. You can show them to the cast and, most important, their parents. The actors will buy pictures for themselves and perhaps their parents. The parents will want prints for grandparents, aunts, uncles, cousins and

friends. You must get advance payment of at least your costs when taking orders.

For stage photography you need a light meter. Because the stage is so vast and the lighting so varied, it will be difficult or impossible to get an accurate light reading from the camera position.

Get a good reading before they start the play. Have the lights turned on to the level that will be used. Then take your light reading directly from the actor's face and costume.

So long as the stage lights are turned up all the way, any meter should be sensitive enough. Remember that if your meter is built into the camera, it should be treated like a hand-held meter and brought to the subject for light measurement.

If you are thinking of buying a hand-held meter at this time, there are two kinds: selenium cell and cadmium-sulfide cell. The selenium-cell type requires no battery. It works with just light to give you a reading, but is not very sensitive. The cadmium-sulfide type, found in most cameras with built-in meters, uses a battery and can be extremely sensitive. Many can read light from the proverbial "black cat in the coal bin at midnight." Their sensitivity is reflected in their prices however and the best of them can cost over $200. However, if you ever do extensive theatrical or other low-light work, the cadmium-sulfide-type meter will prove a "must."

EXHIBITS

There are other ways your camera can earn money for you at school. Many high-schools have science fairs, and both high-schools and colleges have art exhibits. After spending many hours or weeks on a project, many students will be happy to pay a few dollars for a photographic record of it on display.

In general you will be able to work effectively at the closest distance your camera can be focused normally. This chapter will discuss such photo-graphy only. If the objects require you to move nearer, the chapter on photographing stamps, coins and other hobby collections will show you how to do extremely close focusing.

Although room lighting is often adequate for photographing science and art displays, it will be easier to use the two clamp-lights discussed for group photographs. They should be placed so they best illuminate the subject. For paintings, this usually means one on each side with the lights aimed at a 45-degree angle. With a piece of sculpture or a science-fair display move lights until you have a good effect.

You will need a light meter. I prefer the kind that measures incident light for this application. If you must use your camera's built-in meter or a hand-held reflected-light meter, use a neutral-gray card at the subject location for metering. A neutral-gray card only costs around a dollar and is a good accessory.

If you photograph in a room cluttered with projects, take a clean unwrinkled sheet or a few yards of inexpensive white material and tack it against a wall. Use this as a backdrop, placing each object you will be photographing in front of it. Or you can have an assistant hold white poster board behind the exhibits. You could use colored material, but the colors may detract from the exhibits.

When photographing art objects, you may be asked to take color pictures. Slide film comes in a variety of types, each designed to work with a specific form of light. You can choose a film to match your equipment. Negative films offer greater margin for exposure error but require filters to compensate for different types of lighting. For this reason I prefer the use of slide film selected to match the type of lighting I will be using.

You can offer the slides to your customers or you can have a color lab make prints from the slides. If you can find a good processing lab, Type

Photograph the programs put on by specialized schools. These might include Karate demonstrations, piano recitals and dance programs. Photos sell to participants, parents and the school owners. May make a newspaper or magazine feature.

Local art galleries may be interested in having you take photos of paintings and sculpture each time they display new works. The negatives are filed and held to prove loss to insurance companies in the event of fire or theft.

A silhouette says "dancer." Such an unidentifiable, dramatic photo can be used by the school for its promotion long after the subject has moved on.

5247 film, discussed later, is a good choice. You can also find labs which will make both slides and prints from Kodacolor film. You can show the slides to get print orders and order the prints from the negatives.

The easiest way to handle lighting is with two floods, turning off any fluorescent light fixtures in the room. Fluorescent lights labeled daylight often have either a blue or green cast, depending upon the bulb. Others have a red tinge. Rather than worrying about color temperature, correction filters and other technical details, avoid the problem by turning them off.

There are two types of photoflood bulbs you can buy for your clamp lights. One is called *photoflood* and will be so marked on the bulb. The wattage—500 watts is the one you want—will also be marked. This bulb has a color temperature of 3400 degrees Kelvin.

I am not going to immerse you in a technical discussion of color temperature. You will get accurate color reproduction with such a light bulb *only* if you use a color film marked Type A. The most common is Kodachrome Professional, also known as Kodachrome Type A. This is only available in 35mm and is rather slow.

You will be better off buying a photoflood marked "3200 degrees K." This will give accurate color reproduction with Type B color film, labeled "tungsten." The most common is High Speed Ektachrome Type B. Remember that if a bulb is marked *photoflood* and has no color temperature on it, it is for Type A film. If it is marked 3200°K, it is for Type B.

Although you will be able to hand-hold your camera for most photography of art objects and science projects, you may want a tripod. These cost from a few dollars to a few hundred dollars, depending on size, weight, flexibility and features.

The heavier the tripod and the larger the camera it can support, the better, except for carrying it around. When you can afford it and have money-making assignments which require it, buy one in the $50 to $75 range. For now, a light-weight tripod will be OK. You can even use one of the inexpensive collapsible units.

If you need to lean the art object or display against a wall or prop it up for a good camera angle, it's best to ask the owner to do it. The camera should be kept parallel to the object you are photographing. When this is done, there should be little or no distortion in your photograph.

Custom labs offer color prints from color slide film in two ways: One is to have them made directly from the slides.

The other is through an internegative. The lab takes a picture of your slide using special negative film, then makes the print from this negative. The internegative costs $5 or $6, but once you have the internegative, prints cost less than prints made directly from a slide. An inexpensive print made from an internegative is of far better quality than an inexpensive print made directly from the slide. Labs providing such services are listed at the end of the book.

PROBLEMS

There is a negative side to school photography which you should know about. Once you start taking and selling photographs, you will become well known. When you show up at a party, you will be expected to record all the fun and excitement. Everyone will want to be in candid photographs and you may think you have discovered a great way to make money. After all, candid kids paid off for you. Why shouldn't candid students be equally rewarding?

Almost every school has a publication which depicts student life throughout the year. Generally this is the school Year Book, though occasionally the project will be tackled by the school newspaper. Some schools have the purchase of the Year Book included in the price of a required *activities fee.* Other schools offer the Year Book on an advance-payment plan. However it is done, students know that they will get all the candid photographs they want right in the Year Book. They are not likely to pay additional money for such photographs. A formal Polaroid of a guy and his date is one thing. A candid party photograph is another.

If you want to take candid photographs of your classmates, join the Year Book staff so you will at least have someone else furnishing the film. But do not be misled into thinking this is another way to make money.

In every school there is a teacher who comes up to you and says, "You do such beautiful work, I'd love to have one (or a hundred) of your photographs." What is left unsaid is, "for free."

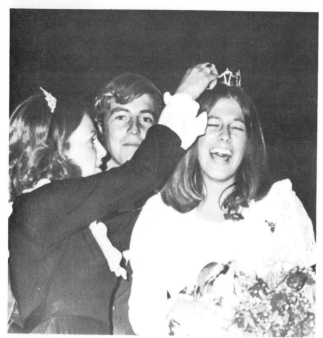

Awards ceremonies, Homecoming Queen and similar events offer money-making opportunities for the school photographer. (Top left photo by Robert Owens)

On the right is an example of an action football photo which does not specifically identify any of the players. Like the timeless building shot, this image can be used by the school at any time; an added benefit is that it can also be sold to any players whose uniform numbers identify the individual to family and friends.

The illustration below demonstrates that you should be aware of off-campus school activities representing important school programs which may not be documented by the school's staff public relations department—a potential money-maker for you.

Naturally you want to oblige, but these people usually don't know when to stop. You can handle the situation by explaining that you would love to give away prints but you simply can't afford it. "But I'll be glad to give it to you for my cost and I'm very proud that you want it."

If you are a teacher earning extra money with your camera, the rip-off artist will find you too. Handle it the same way.

There is one final headache you might encounter. Occasionally a school board will give a contract to a professional photographer based partially on what the studio charges for such work as class portraits and the like, and partially on what the studio will kick back to the board. Such actions are usually illegal, but some go on for years before legal action puts a stop to it.

But how do such practices affect you? If this

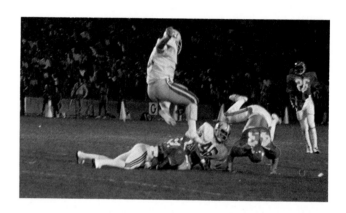

Below is a timeless photograph of a new campus building. These can be used in brochures and newspapers year after year.

is the way your school system does business—*most do not work this way!*—you may find somebody who asks you to kick back some of the profits or else stop taking pictures on the school grounds. Your age, your sex, and even the fact that relatively speaking you are engaged in a "nickel-and-dime" business will make no difference. When an administration has become corrupt, nothing is too trivial. They always want a "piece of the action."

My personal advice when faced with corruption is to stop school photography projects and if you are a student tell your parents what has happened. An outraged PTA can do wonders.

If you are a teacher, talk with an administrator or board member who is free from the corruption. There is a chance that you will eventually find a way to end such practices.

Keep in mind that most professional photographers will not stand for kickback schemes. Usually the ones who go along with it are small operations that are desperate for money. They are few in number and can be forced to mend their ways by an aggressive professional photographers association.

I know of one case in the Midwest where a photographers association documented the corrupt practices of a school board and took the information to a newspaper, resulting in the ouster of the board, firing of the cooperating photographic studios and elimination of a situation that had once seemed hopeless.

The problems you encounter will normally be only a few minor things that you solve with tact or plain common sense. Your years in school, whether as a student or a teacher, can be profit years. Decide what services you can offer. Get permission and get started!

Check the business pages of your newspaper to see what changes are being made by companies. New building additions, pollution control equipment and other alterations mean the company may be interested in before and after photos.

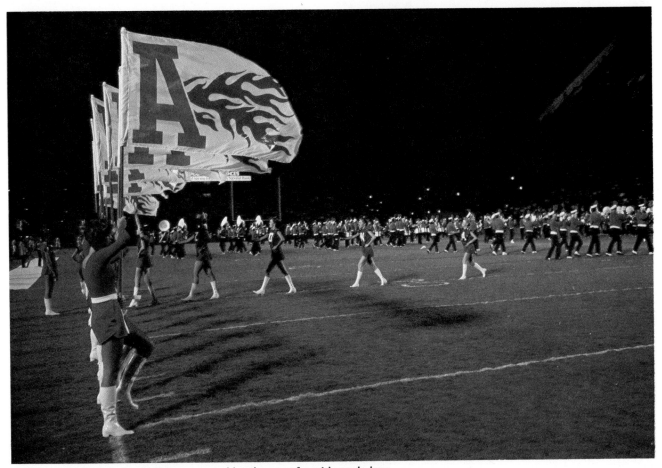

A different mood during halftime, created by the use of a wide-angle lens.

Religious Organization Photography

Church and temple photography is similar to school photography. Most churches and synagogues operate with far less money than they need.

"So why should I waste my time with photography for religious groups?" you may ask. "I know I can always donate my services if I choose, but this book is supposed to show me how to *make money* with my camera."

That's a good point. Though the religious organizations may be scrambling for money, you will be selling directly to the members who are usually far more solvent. If you know what pictures to take, you can find a ready market. You will need the equipment shown on List C at the back of this book.

PEOPLE PICTURES

Every religious group has some program for educating children. Generally this is Sabbath School or Sunday School classes, often held while the parents are attending services. Parents who send their children to such sessions are always proud of the fact that they are providing a good moral education for the youths. They will usually want a class photograph including their youngsters.

To obtain permission to photograph religious-school classes, talk with whomever is in charge of such instruction. Explain that there will be no charge to the church or temple, but you will offer prints for sale to parents. It helps if you offer to donate one print of each class to the organization.

Think you need a view camera to photograph interiors? Taken with a rangefinder camera, 21mm lens and a tripod.

Not only will it be appreciated, it can result in your getting a display of your work where the entire congregation can see it. This leads to more print sales and perhaps even offers of more work in or out of church.

The actual photography should be handled the same way you would a club. You will probably need extra lighting and you should try to get a location which allows you some room. If you are forced to work in the classroom, you will often find it so cluttered with desks and teaching aids that it makes a poor background. If you must work under such circumstances, you can sometimes overcome the obstacles by having the class stand near the blackboard. Never take the picture with the youngsters in their seats unless you have fairly sophisticated equipment with a wide-angle lens and enough lighting to ensure adequate depth of field.

If you are working in a classroom with the students in the front, and you are standing amid the empty desks, don't forget to check the lower part of your viewfinder. It is easy for parts of desks to appear in the final photograph if you are not careful. Check the entire viewfinder frame to be certain that only those items you want to include in the final print are visible.

Always take several photographs of each class, varying both exposure and focus. Your sharpest print will normally come from focusing on a point approximately one-third the distance between the person closest to the front and the person at the back. Keep in mind that to have heads that are large enough to be recognizable in an 8x10 print, you should stand back just far enough to get everyone in the viewfinder.

You should have sample prints no later than two weeks after you took your photographs. If you use a custom lab and trust the person who makes your prints, ask the printer to make one 8x10 of each different group you photographed. Instruct him to use the sharpest negative for each group and make a second print from a different negative if he notices anything unusual in the picture. Such as the frog Tommy pulled from his pocket just as you released the shutter. This will save time.

SELLING THE PRINTS

There are several ways to sell the photographs.

The best is to ask for display space on a wall or on a card table set up where both parents and children will pass. Use a sign-up sheet to get name, address, quantity and identification of pictures desired.

My feeling is that payment should always be in advance. If the parents order, advance payment should be no problem. However, in some cases you will find yourself limited to showing the prints to the children in each class. They will not have the money to pay you, nor permission to purchase prints.

If you must deal with the children, there are several approaches you can use. The least satisfactory is to ask them to go home, discuss the pictures with their parents, then return with order and money the following week. Your results will be limited at best. And how do you treat the youngster with tears streaming down his cheeks who wants a picture but lost or forgot his money?

A second approach is to have those who are interested give you their names, parents' names and home telephone numbers. You call each parent, explain about the pictures and ask if they will send the money the following week. This works better but requires a lot of your time.

The best approach when you are forced to work through the children is to have an information sheet printed, mimeographed or Xeroxed inexpensively. Send one home with each child and collect them the following week.

It will be cheaper to hand out the photographs during class than to mail them. Learn the *maximum* time it will take the lab to make the prints and return them, or figure out how much time it will take you to do the work if you are making your own prints. Then set the Sunday immediately after this as the date when you will give the prints to the children.

Church and Sunday School picnics can be another source of revenue. Get permission from the clergyman to attend the picnic with your camera. Make it clear that the photographs you take will be offered for sale to the parents.

Once you are there your work is very much like candid kids. Be sure to shoot games and the winners of drawings or prizes. Parents will buy not only their children's photographs but also their own if caught at the moment of personal triumph.

To sell picnic photographs, display them in

SAMPLE WORDING FOR CHURCH SCHOOL TAKE-HOME LETTER

Dear Parent,

 Your child's (Sunday School) (Sabbath School) class was photographed by (Your Name). Copies are being made for parents as a remembrance of this important part of your child's education. You will want to share these prints with relatives and friends for their increasing value over years to come.

 You may order prints of your child in the classroom group by using the order form below. Please mark your order and return this sheet with payment for the total number of prints ordered. Please send the order and check with your child next (Sunday) (Saturday).

 Your photos will be ready in _____ weeks and will be delivered to the (Sunday School) (Sabbath School) classroom.

Thank you,

PRINT ORDER

Please make the following prints of my child's (Sunday School) (Sabbath School) class:

QTY.	SIZE	PRICE	TOTAL
	5" x 7"		
	8" x 10"		
	11" x 14"		

Enclosed is my check in the amount of $_____ .

Name _____

Address _____

Phone _____

the church or synagogue during the next few weeks. You can be there in person or have a sign-up sheet. However you do it, make certain each print on your display is numbered and you keep a list of these numbers and the negatives they represent. See the chapter on preparing files for one approach toward organizing your work.

ARCHITECTURE

A religious group may have some sort of anniversary relating to its building. Sometimes this is a major anniversary such as 50 years or 75 years that is a historical event in the community. Other times it involves a relatively new building that took years to finance and will take more years to pay off. Whatever, such occasions are excellent times for you to make money with your camera.

Church and synagogue photographs are seldom taken and frequently in demand. They can be used for publicity, souvenirs, postcards and note paper sold to the congregation to raise additional money—see the list of companies which prepare such items at the back of this book.

Photography of a building such as a church can be difficult. Architectural photographers use view cameras that allow special adjustments to prevent distortion. When you photograph a building you can't just tip the camera back until everything is visible in the viewfinder. If you do, lines will bend and the image will be distorted.

It is possible to produce salable photographs of buildings with the equipment you presently own, providing you use care and thought when handling your camera.

Let's start with the exterior, where you may have the greatest number of problems.

When composing the shot, all vertical lines must be parallel to the vertical sides of your viewfinder. In other words, the edge of a wall extending from ground to roof must be kept parallel to the side of your viewfinder. If it is seen at a slight angle, such as occurs when you tilt the camera upwards, it will be distorted on the film. Sound simple? It is, except you are cutting off the steeple.

One solution is to move back. The farther from the building you stand, the more you will be able to get on film. A little elevation helps also. This can come from a tall ladder or even another building. I have knocked on the door of a home near a church and requested permission to use an

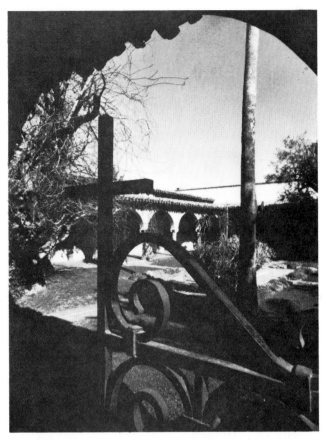

Look for unusual exterior images. I framed the gate and the overhanging arch around a church building. (Below) The church which hired me to document their facilities offers retreats located in a beautiful wooded area. The building housing the church members during these retreats was ugly, so I concentrated on the grounds for a promotional photograph.

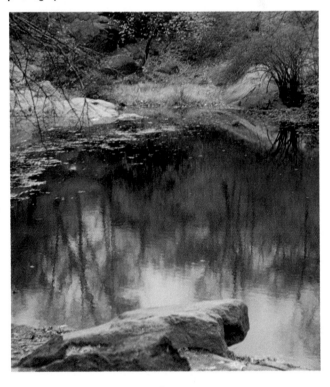

upstairs window to take a photograph of the building. The owners generally question my sanity but seldom deny the request. You may need someone at the church to vouch for you or the first building whose interior you photograph may be the jail.

Remember as you move about seeking a good angle that you must not tilt your camera or you will distort the image. Fortunately most churches and synagogues are seldom higher than two stories and have parking lots so you usually have room to maneuver.

Not every church can be handled in the manner described. There are those with steeples like the Empire State Building. There are times when you simply cannot take a picture of the building's exterior without using a view camera or a bulldozer to clear out the surrounding area.

Because you are not a full-time professional who must take every assignment, you can pick and choose who or what you photograph. You should take your camera to a building and see if you can take a decent photograph of the exterior *before* you offer to do it for money. You will not need to actually take the photograph. Just look through the viewfinder and see if you can get it all in without tilting the camera. If you can, fine. If you can't, forget it. There is no need to suffer the embarrassment which comes from attempting a job you can not fulfill with the equipment you own. Do it later when you have bought the camera or lenses you need.

INTERIORS

Wide-angle lenses for interiors are a definite help. A normal lens will force you to move back farther and in some situations such movement may not be possible.

If you want to try interiors with a normal lens you must learn to isolate images. Instead of getting the vast expanse of the congregation, you might concentrate on just the altar. Instead of taking the massive pipe organ, photograph the organist at the keyboard. Instead of photographing the library, photograph a member reading a book. Such pictures are nearly always more interesting anyway.

However, the splendor that can be recorded by having a wide-angle view of the interior makes an additional lens or two seem almost a must. If you can buy, rent or borrow one, you will be hap-

Stained glass windows can be a church's pride. If you see them, photograph them. Only the light coming through from the outside was used for recording this one.

30

pier with the final results. But your clients can be thrilled with the pictures no matter how much area you were able to cover.

There are several wide-angle lenses which work well for church interiors. The most common is the 35mm lens on a 35mm camera. Even the poorest 35mm lenses can easily handle interior photography providing you follow the same rules mentioned for exterior photography. You must keep all perpendicular lines parallel to the side of your view finder.

There is a special 35mm lens available for SLR cameras which take interchangeable lenses. This is known as a perspective-control lens. The most famous is the one made for Nikon cameras. This type of lens is also available for other brands, though it must be specially ordered by most camera stores.

A perspective-control lens is fascinating. You can move the lines something like a view camera. If you can't get the top of the church in an exterior photograph, keep the camera parallel with the side of the building and turn the knob which raises the lens. Suddenly the top is in the picture and your photo remains distortion-free.

Perspective-control lenses cost from $250 up, though large camera stores in big cities sometimes have used ones for less. See the chapter on how to buy used equipment. If you decide to do architecture work on a regular basis, they are worth considering.

Another wide angle is the 28mm. With this lens some optical problems can arise. A few older ones produce distortion even when you hold the camera correctly. When you try such a lens on an SLR camera, look through it at a wall of the camera store, holding it as if you were going to photograph the interior. Then carefully check the image up and down each side of the lens. Are straight lines slightly curved? If they are, choose a different lens. If not, you might double check by taking a few pictures to make certain your eye is not being fooled.

If you own one of the super-wide angles, in the 20mm to 24mm category, distortion may be a way of life. Some of these lenses create almost as much distortion as a fisheye lens, especially when the camera is tilted even slightly. Look through it to see if you can use it for interior photography. If you can, you're on your way.

There is a trick you can sometimes play with a distorting lens in the 20mm to 24mm range. Some of these lenses are non-distorting up to the edge and only the edge lines tend to curve. If yours is like this, you can use it for interiors by composing each photograph so that there is space left on both sides of the image you want to record. This space, equal to the area which will be distorted by the lens, is cropped from the picture when the final print is made. You do this yourself if you have your own darkroom or you can indicate the area to be removed by the custom lab by marking your contact sheet.

SELLING RELIGIOUS PICTURES

Before we go further, you probably have a question in the back of your mind. "Who is going to pay for these photos?"

The pictures will be purchased by the group of lay members who compose what amounts to a board of directors. Every church and synagogue has such a group and they almost always include some of the wealthier members of the congregation. They are the ones who will hire you and pay you from the funds they control or their own pockets. If the church has a special fund they feel they should tap for this purpose, fine. But if it doesn't and the board members want your work, they will chip in to pay you. You are not a top professional architectural photographer who can command a minimum of $1,000 a day. You are a talented freelancer whose fees will probably amount to from $15 to $25 a photograph. Although you may gross over $200 for your work, it will still be a low enough figure for them to hire you.

Use the pricing checklist at the end of this book to help determine what each assignment will cost. Then you will be able to quote an approximate figure for the work you propose. This figure should be close enough to the final charge that they will know immediately whether or not they can afford to hire you.

Photographs of religious buildings are never out of date. After you make your initial sales, file them for future use. Whenever the church makes new additions on its building or constructs a new building, or when there is an anniversary, the pictures will again be in demand.

I know of one case where a woman photo-

This church exterior is almost distortion free because I moved back to avoid tilting the camera.

graphed a small church that met in a school. Three years later the group built their own building, a small one, in an isolated area of town. Not only did she photograph the building and construction, she sold additional prints of the old school for use in news bulletins for the members.

Ten years later that isolated part of town was a booming population center and the church built much larger quarters. Again the photographer recorded the event and this time she sold pictures of both the old school meeting place and the original church. They were used in the local bulletin and also in the magazine published by the denomination's national headquarters. Although her original sale was for a half dozen prints, she eventually sold that church group more than 50 photographs spanning a 13-year period. If a photograph is salable once, it may be salable again and again.

TECHNICAL ANSWERS

Churches and synagogues generally have even illumination in those areas where the congregation gathers. Many of the buildings are equipped with controls to adjust the intensity of the light, so extra lighting is seldom needed.

Interior photography requires a light meter. A hand-held meter is best in my opinion but you can use your camera's built-in meter if you don't have a separate unit.

Your photographs will be taken when the congregation is not present as it is unlikely you would ever be asked to photograph during a religious service. You will have freedom to move about and adjust conditions to suit your equipment. Find out where the lighting controls are for the area you plan to photograph. Adjust the lights until they provide approximately even lighting. This is

assuming that the client doesn't want you to highlight one particular area such as a new organ. If highlighting is desired, simply boost the illumination slightly in that section only, perhaps one f-stop. Then expose for the highlighted area.

Once you think the lighting is the way you want it, take your light meter and read the illumination in each section that will be included in your photograph.

If you have a hand-held meter, use the incident-light attachment if it has one. With this attachment you stand in the spot where you will be taking the picture and point the meter, complete with the incident-light adapter, at the camera. Repeat this throughout the section you will be photographing.

Assuming you are using negative film, either black-and-white or color, you will get a good photograph if all the readings are within two or three f-stops of each other.

You need a tripod but any tripod which holds your camera will work OK. A tripod in the $20 range, the type you are most likely to own, will be satisfactory.

Before positioning the tripod, move around the area you are to photograph, *periodically* looking through your viewfinder.

There was a time when I advocated looking through the viewfinder while moving around. I followed my own advice once, maneuvering around in a church, bending and twisting and searching for the best angle while looking through the viewfinder. I tripped and fell head first into a pew. Since then I stop moving while looking through the viewfinder.

Once you find the best angle, set up the tripod and attach the camera. Stop down to at least f-11 for good depth of field. If the shutter must be set for slower than 1/30 second, you need a cable release for the shutter. Prices start at $1 to $1.50. I am a firm believer in getting the cheapest made even though, in theory, the more expensive releases last longer. What the manufacturers fail to mention is the fact that cable releases are never owned long enough to fall apart. They mysteriously disappear from your gadget bag.

Focus approximately a third of the way into the area you want to be sharp. You should take several frames, varying the focus point if there is any doubt. You should take at least three exposures for every focus setting. One exposure will be exactly as read from your light meter. A second exposure will be one stop over and a third will be one stop under.

If you release the shutter by hand, press the shutter slowly and gently. Even on a tripod the camera can be moved so the photo is blurred. That is why I say use a cable release for any speed slower than 1/30 second.

If you are using a single-lens-reflex camera, the mirror movement adds vibration. If your camera has a control to lock up the mirror, use it after focusing. The less vibration, the sharper the photograph.

Occasionally the light in the church is not adequate. There will be important areas which are so much darker than the rest of the room that details will be lost in shadow. You need extra light.

Use the clamp-style floodlights I mentioned for group photographs. Place them so they illuminate the shadowed area, keeping the lights out of the photograph. Sometimes you can clip them to the back or seat of a pew, reinforcing them with standard masking tape or Gaffers' Tape or duct tape. If your normal floods are too bright, you can use lower wattage bulbs.

A second approach is to fill-in with flash, aiming a small unit at the spot to be illuminated. If you use electronic flash, you can vary the lighting by using one or more folds of a handkerchief over the front of the flash. This will reduce the light output.

Never use the handkerchief trick with regular flash bulbs. If the cloth should contact the bulb as it flashes, the intense heat will scorch the material or set it on fire. The same is especially true for floodlights which get dangerously hot seconds after they are turned on and stay that way until turned off.

An alternative approach is one you can use if your exposure will last for several seconds. This is known as *painting with light* and it takes a certain amount of practice.

After the shutter is opened (use a locking cable release), aim a floodlight at the area in shadow and move it continuously so the light falls evenly on the darkened section. You keep the light moving so there is no spotlight effect. The

motion is much the same way you keep your hand or a tool moving when dodging in the darkroom.

It's important to bracket exposures, varying not only the time the shutter is open but also the time you are painting. Each interior requires different treatment, but once you have tried painting a few times, you will find yourself accurately guessing just how much extra light you need.

If the church wants color photographs of the interior, you have another lighting problem. The illumination may combine daylight with tungsten, the daylight frequently filtering through stained glass window. There isn't any way to correct such mixed-up lighting with a filter on your lens.

My approach is to use daylight film, letting the interior appear a little warm in those areas illuminated by tungsten. Daylight film exposed indoors takes on a slight reddish (warm) cast which most people find pleasing. If you use indoor film, the daylight coming through the window causes a bluish cast which most people don't like.

If you are going to use flood bulbs with daylight color film, most lighting equipment manufacturers recommend blue bulbs which are supposedly balanced for daylight. These are to be used in rooms that are already partially illuminated by daylight. I find they generally make everything too blue. My solution has been two bulbs. One a standard 3400°K or 3200°K photoflood, the other a blue bulb of equal strength. The resulting color seems closer to reality.

At this point you should not offer slide work unless you have the slides made from the color negative film. Transparency film tolerates little error and lighting is critical. You will need a lot of special lighting equipment which is costly.

(Above) I discovered a large window behind the church alter. This partially silhouetted photo sold well. (Below) Studies of church congregation members can make moving photo stories. The Miller family's faith in religion enabled them to work together to save their daughter from a bedridden life after she suffered brain damage in a car accident. This photograph shows the family members together and physically active. I became aware of the family's situation partially through their religious activities.

Is your town having a celebration? Become the community photo historian for the event. Talk with the Mayor, City Manager or City Council about obtaining the job. Photos can be displayed at City Hall, in banks or shopping centers.

Sports Photography

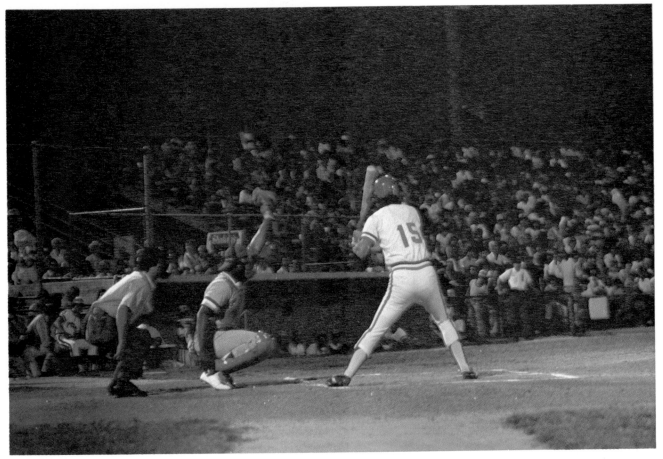

Baseball games can be documented from the field with normal and medium telephoto lenses. Permission to photograph can come from the team's publicity director or from the head of the school's sports department.

When you think of a sports photographer, you probably think of a professional with camera equipment worth 2½ times the mortgage on your house. He takes 20,000 photographs at every sporting event, 12 of which will eventually be printed. His earnings for those 12 pictures, however, will be four times what you gross in a month on your regular job.

You can make money in sports photography. You may not be able to take the exciting action pictures you see in sports magazines. These often require expensive lenses coupled with a motor-driven camera and a lot of luck. But the market for such photographs is limited. Most buyers are magazines which use staff photographers or hire the best talent the country has to offer. It's unlikely you could make a sale to them. However, there are still ways for you to earn money with your camera in this exciting field. Use equipment list B and the Optional Extras list at the back of this book.

The money you can make comes not from the professional athletic teams but from the amateurs. You can go after tournament bowlers. Little League baseball teams, country-club golfers and similar "athletes." These are people with varying skills who play for the fun of it. Many are beginners, but they share a common love for the games in which they participate. More important to you is

the fact that they also like to be photographed with their team mates.

Sports photography equipment need not be sophisticated unless action is taken. A light meter—either built-in or hand-held—is a must. Interchangeable lenses are desirable but not essential.

TOURNAMENT BOWLING

Bowling teams offer the easiest opportunity to break into sports photography. Every large bowling alley has teams which meet regularly. They bowl at the same time each week and have a set number of games per season. Generally team play starts in the fall or early winter and extends through May or June.

Your first step in bowling-team photography is to go to the alley and talk to the manager. Early afternoon is a quiet period. If the alley seems busy when you arrive, ask when there will be a convenient time to stop back. If the manager doesn't like you, he won't let you work there. Be courteous, making arrangements at his convenience.

Before you talk with him, look over the facilities. Make certain there is a well-lighted area somewhat separated from the lanes where you could take a team picture. If there is none, see if there is room and light enough somewhere else. If not, you will have to set-up a portable studio complete with lights and perhaps a back-drop. You should check this before you talk with the manager, for he will want to know just how much of his facility you will be using.

The manager will often be willing because it adds a little pizazz. The team members will enjoy your presence and feel important. If the manager wants a fee or share of the profits, negotiate the best deal you can or try another place. Your best argument is that a photographer's presence adds excitement and helps his business. Always offer to supply him with a print of each team for his bulletin board.

When the manager agrees to let you take pictures, and most will, your next job is to contact the bowling teams in person on the nights when they bowl.

If you don't have business cards by now, get some. You don't need fancy designs, multiple colors or photographs printed on the cards. A simple, basic card will do quite nicely.

Plan to arrive at the bowling alley *after* the

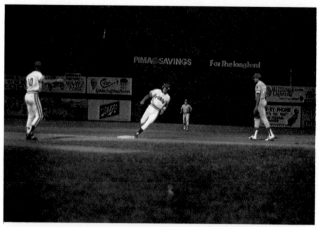

Know the focus for an area between two positions where a player might steal a base. You can then aim at that position—and shoot fast—without having to go through the focusing process.

teams have begun to bowl. There is a law I call *The Rule of Beer and Buying*. A photographer's sales to an amateur athlete will rise in direct proportion to alcohol consumption—the athlete's not the photographer's.

When the bowler first arrives at the alley, he is tense, nervous, still not relaxed from the cares of his job and excited about the competition his team will be facing. Once the bowling begins and the beer starts to flow, he relaxes. He will be happy and responsive to the photographer who wants to take his picture.

The basic approach is to contact the teams the first week. Generally the team captain is the one to see. Explain that you will photograph them the following week and they will be under no obligation to purchase any prints. You only want assurance that they are interested in buying team pictures. State a price to be sure the players know what will be involved. The checklist in back of this book will help you determine what to charge.

You can offer two types of photographs. The most desirable is the team photograph. This photograph of all the players grouped together is easy to take and easy to sell. If you are only going to offer one type of photograph, this is the one.

The second approach is to offer individual photographs of the bowlers made while they play. These can be candid photographs, assuming the light is bright enough so you will not have to use

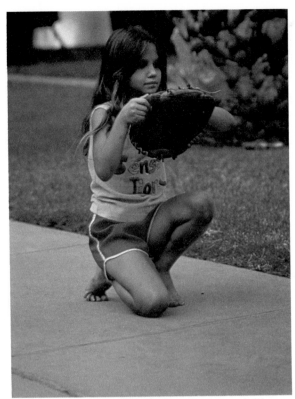

Tucson photographer Randy Lowell captured this "liberated" baseball player on film. Such pictures have great appeal to family members.

strobe flash to fill any shadows.

I am a firm believer in starting with team photographs. If most or all team members buy the prints, you can suggest individual photographs. These can be taken unobtrusively at an appropriate time.

Group photos can be taken at several locations. At the lane the team is using for bowling, have the captain sitting behind the scoring table and the other grouped around him. You will have to either step back along the lane or use a wide-angle lens to get everyone into the photograph. If you step on the lane, you must either be wearing bowling shoes or your stocking feet. If you are like me, any pair that has been worn more than once is bound to have holes in the toes. Be confident: Bowlers have holes in their socks too.

A second approach is to take the teams to a separate part of the alley away from the lanes where play is going on. Choose a well-lighted area or use flash held above the camera and aimed slightly downward to eliminate harsh shadows.

If you photograph away from the lanes, be aware of the background, even if not sharply in focus. If something is going to show in the background, make certain it is related to the sport.

A third approach is the miniature studio. You bring your own background and lights, set them up, then photograph the teams. This requires more space than the other two approaches and can be awkward. You can buy the seamless paper used by professional studios in widths of from 50 to over 100 inches and in lengths to suit. The cost will be approximately $15 for what you need. A support stand costs another $35 to $70 but is very convenient.

Some photographers buy a large portable projection screen instead of using seamless background paper. This serves double-duty when they want to show slides. The drawbacks are that it must be wider than you might normally purchase for home use and you will not be able to take full length photos of the players.

For lights, use the clamp floods mentioned earlier. If you use portable flood lights, remember your extension cords. Extension cords are hazardous for people passing by so route them thoughtfully and lay rubber mats over them or secure them with duct tape. For this reason your makeshift studio should be in an isolated section of the bowling alley. If it can only be erected in areas where many people will be passing, you will be wise to forget this method of earning money. The few dollars you will lose by having to skip this part will be well worth avoiding the risk of a law suit.

Bowling photographs should be taken in black-and-white except by arrangement. Standardize on a fast film such as Tri-X. The pictures will be enlarged to no more than 8x10. Even if you shoot action at ASA 800 or ASA 1200 with longer development, the final prints will not be objectionably grainy. Cropping will have to be limited so make certain that what you see in the viewfinder is what you want in the final print.

Once you have sold group photographs, you can sell the individual shots. The light at the lanes may be dim and flash may not bother the players who are paying you for their pictures, but it may bother everyone else. If you can work at an end lane with your flash aimed towards the wall, this is not a problem.

There are several approaches to available-light

Photographs taken inside gymnasiums require high speed film. I prefer to use daylight films despite the slight warm tone that results from the tungsten lighting. Ektachrome 400, either pushed to ASA 800 or shot normally, can be perfect here to produce a salable image. (Right) Robert Owen, a photographer who knows that the key to sales is to picture a winner, caught this potential "hero" in the act. Parents and athletes alike will buy such photos.

photos of the players which you can use. One is to stand on the alley or to one side while photographing the bowler starting an approach or at the moment he releases the ball. This type of posed photograph allows a relatively slow shutter speed making it ideal when the light is low.

A second approach, assuming you have adequate light for a 1/125 second exposure, is to stand to one side and photograph the bowler in movement. Pan with the bowler, moving your camera as the bowler moves, keeping the image in the same part of the viewfinder. Remember that a subject moving horizontally to the camera, as the bowler will be doing in this instance, requires a faster shutter speed than someone moving toward the camera in a straight line. The high shutter speed and panning are essential.

A good method is to take the photograph at the moment the ball is released. Prefocus near the

foul line, press the shutter button as the ball is released from the bowler's hand. At that moment all *body* movement has stopped and even a slow shutter speed will result in a good photograph. The arm and the ball may be slightly blurred, but that makes an interesting picture.

Occasionally you will be asked to return at the end of the season to photograph parties held by winning and losing teams. You may be asked to photograph dinners and the presentation of awards. Naturally you will feel flattered by such a request and know you can easily handle the job with your camera and a flash. It is an easy assignment that seems to be an ideal way to pick-up some extra money. Unfortunately, it can be a money-loser.

With the bowling season over, the bowlers are no longer in such a generous mood. It is one thing to sell a print of a man with his buddies,

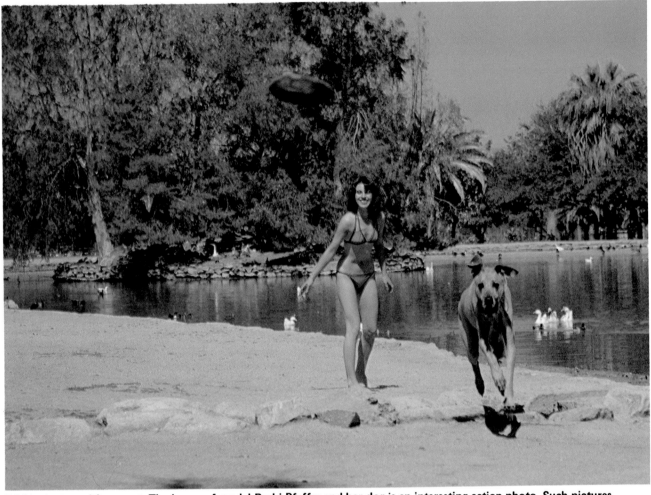

Frisbee is an exciting sport. The image of model Barbi Pfeffer and her dog is an interesting action photo. Such pictures can be sold to the people involved as well as to the managers of major frisbee contests held around the country.

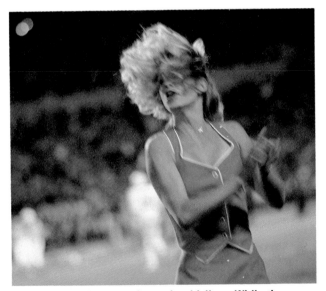

Women are no longer only on the sidelines. While they are probably most visable as cheerleaders, good shots of them with their team sports equipment, as in these Robert Owen photos, may also be good potential sellers, especially to teams interested in good public relations promotions.

each of them drinking beer and all of them trying to impress one another. It is something else to sell a picture to a man when the season is over and his wife is saying "For months you've been spending our hard-earned money on your bowling night out with the boys. Now it's my turn to get that new dress and maybe we can take that vacation to see my mother like you've been promising!"

If you are asked to photograph one of the end-of-season parties, get cash in advance. You should agree to take the job for a set fee which will cover your time, costs and profit. You will supply a photograph to each team member, either showing them as a group or individually. Naturally the award winners will get a picture as they are handed their trophies, ribbons or whatever else is used to honor the players. An additional photograph of the award winners grouped together and holding their honors should be included for the owner of the bowling alley to display.

Using the checklist at the end of this book, determine your costs for such a project, then figure your charge. The money should be paid to you the night of the banquet and you agree to deliver all prints to the team captain who will have the responsibility to distribute them. Do not promise to deliver or mail them to the individual members. This takes too much time and costs too much money.

GOLF

Golfers are also a ready market for your camera. Men and women who play golf are in the habit of spending money on the game. The slight additional cost of a photograph will not be resisted, making this an excellent way to work.

Before you can take photographs on a golf course, you must get permission from the course or club manager.

Request permission to approach golfers just before they tee off. Explain that you will not disturb the golfers while they are playing, nor will your pictures create a disturbance.

Once you have permission, and generally it will be given, plan for an early arrival at the course. If you go on a weekend, golfers will be on the grounds from daylight until dark-thirty. Two to four golfers will be playing together and you should offer to take a picture of the entire group rather than each individual. A person may feel

that it is vanity to buy a picture of himself, but it is an act of friendship to buy a photograph that includes fellow players.

Golf photographs are easy. Group the players together, frame them in your viewfinder, focus and shoot. You can use 125 speed, black-and-white film.

Assuming you are in sunlight, have the players turn their backs to the sun. The exception is when they are *all* wearing hats which shield their eyes. If everyone is squinting into the sun, the resulting photograph will show several pained faces, not something that is easy to sell.

Because the camera is facing the sun, your light meter is going to be fooled by the brightness which surrounds the players. If you expose for sunlight, their shadowed faces will be too dark to maintain detail in the final print.

To take a proper reading, walk up to the players and aim your light meter so it reads directly from a face. If you have a built-in light meter, set the exposure controls while standing by your subjects. Most built-in meters are the battery-operated, cadmium-sulfide type. Be careful not to aim at the sun. These meters can be "blinded" by harsh light and lose sensitivity for as long as ten minutes.

If you have an incident light meter or an incident meter attachment for a hand-held meter, you can take a reading by standing where the golfers are going to pose, then pointing the meter towards the camera position.

Pay careful attention to shadow areas on the golfers' faces. Faces will darken when a player's back is to the sun, but darken even more if the player is also wearing a cap. If only one or two players in a group are wearing caps, take your reading from one of their faces. If you expose for the darkest areas you will be recording, you will capture all detail in their faces. This technique is for black-and-white film. Fill flash will eliminate the shadow problem and improve the overall quality.

With golf and bowling photographs, I feel you should take just two exposures, assuming you have enough light so you can use a fairly fast exposure. The second photograph is an insurance policy which guarantees a slightly different set of expressions from the first.

If you have a camera that uses interchangeable lenses and you can get a telephoto lens for it,

Don't overlook gyms. This photograph of Kathy Miller was taken inside the gym where she is regaining the full use of her body after an automobile accident. Fluorescent lighting results in a green tint if not filtered, but this is obviously not a problem here.

you might also consider offering action photos of the golfers. These are popular with golfers playing in amateur and pro-amateur tournaments.

Action golf photographs take practice. It's essential that you have a lens that lets you get far enough away from the golfers so they are not distracted by you. The sound of your camera's shutter can be disturbing.

Start by going to a public golf course or to a private course where you have taken enough posed pictures to be known. Follow the golfers from a distance, keeping out of their way. Photograph them as they are putting, perhaps from a low angle. Wear clothing which you won't mind getting dirty so you can lie in the grass.

Try photographing as the golfer tees off, perhaps taking a second shot as he watches the direction of the ball. Try to capture not only the concentration but also the elation which comes from realizing that the ball actually landed where it was supposed to.

Keep in mind that there are other players on the golf course. You must stay alert for golf balls being hit in your direction. Always carry a gadget bag for equipment you are not using at the moment so the lenses are protected from a flying ball. You are on the golf course at your own risk. If you are hit by a ball, it is your own responsibility. It is unlikely that either the player or the club would be held liable for such an accident.

Do you own a movie camera with variable operating speeds? If you do, there is yet another way to earn money on the golf course. Make a sample film as follows:

Take your movie camera to the first tee, positioning yourself to the side of a golfer so you can record his entire swing. Start filming as he prepares to drive and keep filming until he has completed his swing.

Your film will have to be taken at high speed,

preferably around 54 frames per second. Some motion picture cameras go as high as 70 frames per second and this is even better.

When you get the film back, project it at normal and slow speeds. At either operating speed the film will be slow motion since the original film was made at a much faster rate. Study the picture carefully to see if all the movements of the golfer are clear. The grip and the way in which he or she swings the club should be readily visible. You may have to take more than one film before you find the right camera location.

Don't worry about the type of camera, just about the variable operating speeds. Both 8mm and Super 8 are fine for this work. Although it is often the more sophisticated Super 8 cameras which offer the variable operating speeds, many camera stores have used 8mm cameras such as the Bolex with all the speeds you will need. These generally sell for under $100. I know some photographers who have traded in their Super 8 cameras for the older units. They got the camera, film and a large number of accessories without paying extra because the Super 8 had a much greater resale value.

You can use any lens for this type of photography. All you have to do is adjust your position in relation to the golfer so that he and the swinging club completely fill the frame.

If your top operating speed is faster than 24 frames per second but slower than the 54 mentioned, try it anyway. There is a chance it will work. With normal filming speeds, however, the movements will be blurred when seen in slow motion.

Once you have a usable movie of a golfer in action, take the film and projector around to the golf professionals employed at country clubs in your area. Ask if they would be interested in teaming up to provide a golfer analysis service. For a fee of perhaps $25, you will take a black-and-white film of a golfer's swing as he tees off. The professional will review the film and provide a critique of the amateur's swing, showing him how he can improve.

When you make arrangements to work with the golf pro, be certain you have an equitable split of the money. All your costs for film and processing should be covered before any split is made. If your costs are $5, for example, that leaves $20 to split. You each need the other and, since you are equally important to the project, you should make an equal split of the money.

For you to make the highest profit, try to film as many golfers at one time as possible. The ideal arrangement is to set up a schedule for the weekend. You will film several golfers at five or ten-minute intervals at the same location. They don't have to be actually playing, just driving the ball in any area where it can be done safely. Buy a piece of slate board and chalk the name of the golfer teeing up. Film the name for a second or two, then film the golfer immediately after. Keep a separate list of names and addresses.

When you have a paying customer, give him the film as well as the critique, so he can study it over and over again.

BASEBALL AND FOOTBALL LEAGUES

Little League teams, Pop Warner football and similar organized sport activities for young people are also potential customers for your talent. Team photographs will be purchased by parents and coaches. These are made outdoors, in uniform. There is no lighting problem, and the film can be relatively slow: Plus-X is a favorite of mine. Any lens you own will be fine because you are outdoors and can move back to get everyone in the picture.

After you have sold team photographs, offer parents action shots of their children. You need a telephoto lens of 135mm to 200mm to capture the action and excitement of the game. When you buy a more elaborate camera or can afford additional lenses for the camera you do own, you can try this additional money-making project.

Your photographs should concentrate on individual players rather than trying to capture the overall excitement of the game as newspaper and sports photographers might do. The pitcher during his wind-up, the look of the batter just after he hits the ball, the catcher flipping off his face mask and reaching up to catch a high ball—these are all images that a parent or child may buy. If a player is sliding, get his face as his foot strikes the base. A picture from the opposite angle showing the opposing player tagging him with the ball would be perfect—for the other child's parents. In other words, show each child *successfully* playing the game.

Football games provide exciting opportunities for action on the field during regular play and during halftime, as well as with bands, cheerleaders and mascots on the sidelines.

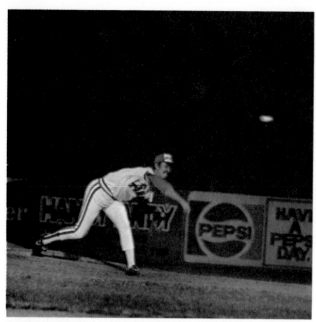

Try to anticipate action. By releasing my shutter at the moment the ball was set in motion, I was able to make this photograph of a ball in flight.

There can be some delightful Little League photographs which could win you prizes in camera-club competitions but never sell to a parent. That riotous picture you took as Johnny was rounding third and his pants fell down or the photo of Bill, so wound up in the excitement of the game that he forgets to catch the ball, are delightful—to others. But Billy and Johnny were embarrassed and will not want a record of the experience. In all likelihood, the parents will not want such photographs either and might be offended that you took them.

To learn about organized teams in your area, check with the sports writer at your local newspaper or the athletic director of your area schools.

Although team photographs can be taken with slow film, action photographs require minimum shutter speeds of at least 1/500 or 1/1000. Carry both Plus-X and Tri-X or equivalent when you take action photographs. There are tolerances in shutter speeds of cameras. Often a 1/1000 rating is actually 1/750. The opposite can be true, of course, and occasionally a 1/1000 reading will be 1/1250. This will not seriously affect the exposure of black-and-white or color negative film but

you should know it can happen. That is reason for using the fastest speed your camera allows because it may be slightly slower than specified and your action shots may be blurred. There is no need to shoot higher than 1/1000 though, even if your camera can.

Action photographs require a knowledge of the game. If you don't know what is going to happen next or where the action is liable to take place, you will miss some of the best pictures. Before photographing any sport, go to your local library and read about it. Learn the rules of the game and get an idea how it is played. Famous players have written books of tips on how a player can improve. These are among the best guides available to prepare you for where the action is liable to be taking place.

I had the misfortune of having what many people consider a deprived childhood. Sunday afternoon football was not part of my life. I was short, fat, uncoordinated, and grew up knowing next to nothing about the game.

When I went to college, I joined the school newspaper as a photographer. I was thinner, more coordinated, but still ignorant about football. Naturally, one of my first assignments was to go out and cover a game. I bravely went along the sidelines, recording anything interesting and missing many photographs because I was ignorant of where the action might come. After one particularly miserable afternoon in which I was caught either with the wrong lens at the wrong time or at the wrong end of the football field for most of the action, I developed my negatives and left them for my editor, an avid football fan.

By chance, I had a shot with close to a dozen different fouls visible in the picture. One player was holding the pants of another. A second player was kneeing an opponent in the stomach. Someone else had grabbed a player's helmet, and so on. The coaches hadn't seen them, the officials hadn't, and I certainly hadn't. But the camera did and the picture went on to win some prizes. However, lucky photographs are rare events.

As with other sports photographs, don't offer action photos of individual players until you have seen the reaction to your team photographs. With team photographs you use only two or three frames of film and you need just one sample print for all the players. With action photographs you

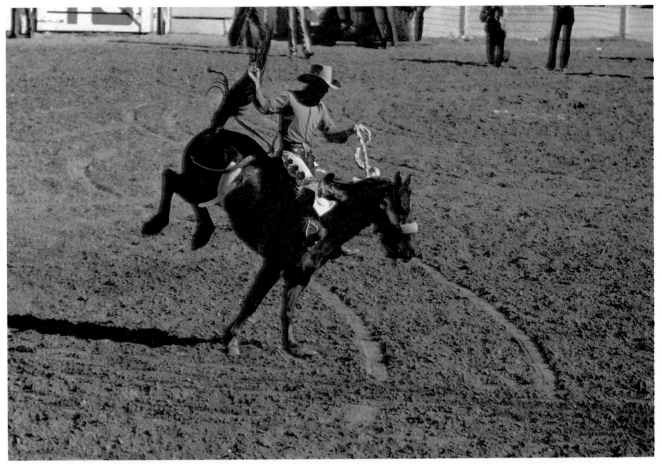

In this humorous rodeo photo of a bucking bronco, it looks like the rider is holding up the tail. It is unusual enough to appeal to both sports magazines and area newspapers where the rodeo takes place. Don't forget the individual participants as well!

usually need several pictures of each player to get one that is particularly desirable. You also need proofs. This represents quite a bit of money which should not be spent until you know there is a market.

If your community has a weekly newspaper, you have a chance to make additional profit from your action sports pictures. Take a few samples to the editor and suggest running four or five as a photo feature. The pay will be modest, but you will have published work, a by-line and more than enough profit to go out and celebrate your good fortune.

Sports photography is fun and exciting. With a little planning and some aggressive selling, you can be a part of it.

Theatrical Photography

A 90mm telephoto got me close to The Carpenters, allowing depth of field to record both brother and sister.

Of all the ways you can earn money with your camera, to me none offers so much variety, excitement and enjoyment as theatrical photography. There is something about the world of entertainment which holds a special atraction for many photographers.

Theater photography is as much a way of earning money in small towns as it is in New York City. You may not find giant productions close to where you live, but opportunities for theater photography still exist. See Equipment List C, and Optional Extras list at the back of this book.

Consider the photography of productions held in a school auditorium, public meeting hall or community theater. It involves amateurs lured by the attraction of becoming stars—if only for a few moments—in front of friends and neighbors. It also involves tomorrow's professionals who join little-theater groups before moving on. And it involves the professionals of today, often working with amateurs in summer stock productions with surprisingly large budgets. In some cities there are full-time professional groups such as the Cleveland Play House, and the Arizona Civic Theater in Tucson.

Even if you lived in a production center like New York, you would still have to start with the amateur companies, building up skills, credits and an impressive portfolio in much the same way an actor earns credits through participation in such groups.

Several types of little theater groups play in

small communities across the nation. The first is the totally amateur affair which often uses the local high-school auditorium for its productions. Generally these groups meet in the evenings during the fall, winter and spring. The productions are seldom complex, the programs usually require a small cast and limited stage area. Light comedies and melodrama are regular fare. Occasionally an ambitious group will try a musical, but such productions are rare. The casts are generally made up of housewives, businessmen and school teachers, all working for the love of it rather than money. Ticket sales pay for renting the auditorium, costumes, props and the photographer who does the publicity photographs. Do you hear a flourish of trumpets?

A second type is the semi-professional group. These are usually in slightly larger cities. They use a public auditorium or even a small theater they rent on a year-round basis. The cast is composed of amateurs with some who are seriously thinking of a future career in the performing arts. They hold more elaborate productions, from Shakespeare to musicals. They have larger budgets and the director is often a full-time employee. Their money comes from admission charges, fees paid by members for the privilege of working and learning with the group and, occasionally, outside endowments from foundations and patrons.

The third type commonly found around the country is the summer stock company. They appear in anything from standard theaters to converted barns, with both talented amateurs and professionals, often drawing big names from theater and motion pictures. Some or all of the cast members are paid and the groups have relatively large budgets. Name professionals such as Paul Lynde, Tony Randall and Eva Gabor earn $10,000 a week and more working with summer stock companies. Publicity photographs for such groups are used locally and often gain national attention in newspapers and magazines. Quality summer-stock photographs can be a quick way of building a portfolio that will result in your being hired by major professional companies.

A fourth type of theater photography, somewhat different from the other types mentioned, is of professional groups playing one- or two-night stands in auditoriums and night clubs in your area. It is often possible to photograph from the wings of the theater, taking pictures for sale to promoters, fan magazines and occasionally the performers or their agents.

The equipment needs for theatrical photography will vary with the services you offer. The camera must have a lens of at least f-2.8 and it must have variable shutter speeds. A light meter, either built-in or hand-held, is essential.

As you get into more elaborate work, you will use interchangeable lenses. I have used both extreme-wide-angle optics and lenses as long as 300mm when photographing stage productions and performers. The more you have, the more you can offer. Let's look at what you can do with different types of equipment.

LOCATING CLIENTS

Little-theater groups have two needs when they hire a photographer. The first is photographs to send to local newspapers for publicity. In small towns such theater groups are often considered important to the community's cultural enrichment. The paper will print candid photographs taken during casting sessions, rehearsals and the production itself. The paper may also run short illustrated articles about people in the plays.

In larger communities or in areas where several groups compete, newspaper photography space becomes quite limited. The editor is looking for one picture which dramatically or comically shows some aspect of the play. Generally this photograph will include one to three actors framed so their faces are large enough to be recognized— even if the print is run small. Full cast photos of lavish productions are seldom desired because it is impossible to reproduce them without using a lot of space.

In addition to publicity, the cast members will buy photographs of themselves on stage.

Radio stations have regular promotions to boost their audience. Many of these involve personal appearances of station personalities and similar visual events. Talk to the Program Director or station General Manager about working part time, photographing the promotions.

Everyone likes to be in the spotlight at some time in his life and amateur theatricals provide that brief moment of glory.

A first step toward photographing amateur theater groups is to check with the entertainment-page editor of your local newspaper. If there is no entertainment editor as such, there will be someone on the staff whose job it is to review movies and other theatrical events occurring in your community. That person will be inundated with requests for publicity from amateur groups and can tell you where to find them.

Check both adult and youth groups. Some areas have programs by children in the early evening or on weekends, without charge for an audience of friends, parents and relatives. The group itself will not be able to pay for your services, but you can bet your prints will be enthusiastically purchased by parents, Grandma and Grandpa.

SHOOTING TECHNIQUES

The nicest part of dealing with a totally amateur theatrical group is that they are glad to have you photograph them. You will usually be given every cooperation possible. Lighting will be altered during rehearsals to suit your needs and you will probably be allowed to work from the stage as well as from the audience position.

If you are working with just one lens, you must concentrate on isolating segments of the stage. Don't try to take a panoramic view of the entire stage and cast.

Even with the best lighting, you will seldom be able to use a shutter speed much faster than 1/60 second with ASA 400 film. This means you must work for peak action. If someone is dancing and leaping, there is a moment when movement stops. The dancer has reached the high point of the leap and has not started to drop back to the stage. At that instant, the moment of peak action, you can take your photograph without worry that it will be blurred. I once photographed ballet dancers with my camera on a tripod and the shutter set a 1/8 second because the light was so low. By photographing only the peak action, 35 out of 36 photographs were razor sharp. The one exception occurred when my timing was slightly off and the shutter was released as the dancer started to move again.

If you are able to work from the stage during

This entertainer at the Hyatt Hotel in Phoenix, Arizona was photographed with a 90mm lens. There was adequate depth of field, even with a wide lens opening, to allow a high enough shutter speed to capture movement.

When working from below the stage watch out for distortion. The slacks seem much larger than normal but by exposing for the light striking the upper part of Karen Carpenter's body, the distorted area fade into darkness. Not a salable photo because it looks like she's eating the mike.

a rehearsal, there will be two approaches you can use. One is to take pictures as the action is happening. You maneuver around the actors, keeping out of their way, taking photographs candidly and observing the same peak action approach that you would from the audience. A problem may be limited depth of field. The distance separating the actors is generally great enough that, when you are on stage, your depth of field will not be adequate to keep everyone sharply in focus.

Or you can stage the photo session. Attend one rehearsal strictly as an observer, noting humorous or dramatic effects in the play. Stay alert for high points which will be visually interesting. At the next rehearsal, instead of working candidly, pose the actors and actresses, recreating those high points you noted previously.

If the actors are not close enough for everyone to be in focus, move them and yourself so you get the depth you need. Their positions may be different from the actual play, but the photographs will be perfectly acceptable for publicity.

Occasionally amateur actors are not able to recall their mood or expressions when a portion of a play is taken out of context during a posed photo session. Have them go through three or four minutes of action just prior to the action you want to record. This helps you get the mood quality you would get during an uninterrupted performance.

TECHNICAL ANSWERS

For black-and-white, I use ASA 400 Tri-X exposed at ASA 800 or ASA 1200 when the light is very low. When exposing at a higher than normal rating, there are some precautions to insure quality.

Many photographers and custom labs use a standard developer such as D-76 when developing Tri-X. If the film is rated faster than normal, they vary the developing time according to the manufacturer's instructions. The higher the rating assigned the film, the greater the grain and the higher the contrast. At ASA 1200, using D-76 as the developer, shadow detail becomes extremely limited as the gray scale is drastically reduced. This can result in some very unflattering photographs which are less than satisfactory.

The alternative is to use a developer designed for a film rated at higher than normal speeds. Special developers such as Diafine, Accufine, Micro-dol-X and H&W Maximal, help utilize the inherent

high-speed potential in black-and-white films. They contain a chemical agent, frequently Phenidone, which makes silver-halide particles able to take more developing than is possible with a conventional developer like D-76. When the film is exposed at ASA 1200 and developed with a special formula for use with that speed rating, a close-to-normal gray scale is retained in the negative. There will be an increase in grain, but the negative will have near-normal contrast.

If you are going to develop the film yourself, or if you are using a custom lab, be sure that one of these special developers is used when you expose at a higher than normal rating. Custom labs occasionally charge a little extra for this service but it is well worth the money.

Color photography can be a definite problem although there are several high-speed color films available. The first question you will have with color is, what kind of lights are illuminating the stage? Some stages have tungsten lighting which means you should use indoor film, Type B. High Speed Ektachrome Type B is an example. It is normally rated at ASA 125, but labs will special process it at speeds of ASA 320 and higher. Kodak's labs, which normally only handle film at rated speed, will process High Speed Ektachrome Type B at ASA 320 providing you pay an additional fee.

Other stages use carbon-arc lighting similar to daylight. This means you use a film such as High Speed Ektachrome Daylight with is normally rated at ASA 160 but which you can expose at ASA 400 or higher. Kodak will process it at ASA 160 or ASA 400. Custom labs will routinely handle it at ASA 600 or faster, for additional charges.

If the lighting is mixed, I use daylight film. If daylight film is exposed to the wrong light, the colors will take on a warm tone which is usually pleasing and will not hurt your sales to the cast. However, if you expose a tungsten film to daylight type lighting, the film takes on a cold or bluish tone making the cast look rather sickly. The entire effect will be very unpleasant.

Another advantage in using daylight film is that you can get higher speeds from it. High Speed Ektachrome Daylight is rated at ASA 160, or ASA 400 when pushed by Kodak.

Some labs, a few of which are listed in this book, sell motion-picture color film in specially loaded cassettes for 35mm cameras. This film is

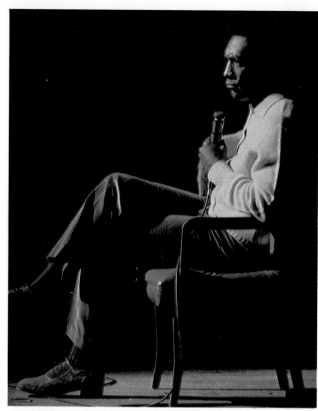

Comedian Bill Cosby was photographed with a 300mm lens in concert. By working from the wings, I was able to brace the camera against a wall to hold the long lens steady with 1/60-second shutter speed. High speed film is a must in this type of situation.

rated at ASA 100 and is designed for exposure to tungsten lighting. It can be exposed to daylight with a filter, then processed normally. Some of the labs make color corrections when they process. They will let you expose the film to daylight, electronic flash, blue flashbulbs or incandescent lighting. They will also let you use speeds of ASA 100 as well as ASA 200 and ASA 400, with the latter two carrying an extra charge for processing. You must expose the entire roll at the same ASA rating and use the same lighting.

After processing you get negatives for prints as well as transparencies. This saves the expense of getting internegatives from your slides. Each roll gives you the negatives and the slides, a rather miraculous little trick. Sources of film and processing are listed in the back.

Noted character actor Russell Collins in costume. Taken near dressing room using Victorian prop chair, abandoned screen and costume from a French play. The incongruous can often be effective.

The more support your camera has, the steadier you will be for slow exposures. You can use a tripod, but I feel that tripods are out of place in theatrical photography unless you are stuck in the back row and must use a 300mm or longer lens to get anything usable.

One support device which I find indispensable is the unipod. By placing your weight on the unipod and balancing yourself with your feet spread apart, your legs and the unipod form a support similar to the tripod. The main difference, aside from the fact that a unipod is less expensive, is that it's very easy to maneuver with a unipod attached to your camera. While a tripod is clumsy, awkward and requires special adjusting, the unipod can go anywhere with ease. I have even turned my camera on its side and jammed the unipod against a wall for support while doing photography from backstage.

Another device, harder to find, is the shoulder pod. This is a curved piece of metal or plastic shaped like a rifle stock. One end fits against your shoulder and the other holds the camera. I have frequently used one with a 135mm lens for photographs taken at 1/15 second.

When you work with more advanced theatrical groups, you will need more equipment than just a single camera and lens. You will often need telephotos to isolate dramatic scenes. Remember it is best to avoid cropping with small negatives such as 35mm, especially when you are rating the film at a higher ASA number than normal.

Another advantage given by the additional lenses is the fact that more advanced theatrical groups like unusual camera angles and techniques. They might want pictures taken from an overhead walkway, for example, delighting in the drama of the high angle. They will also appreciate special effects such as multiple exposures and the dramatic lighting produced by a harsh flood. The more professional the company, the more they will want you to photographically interpret the plays they are producing. They will want you to capture the essence of a production through creative photography, not just a straight snapshot record.

Special effects don't always require expensive purchases. You can get along quite well by creating effects with inexpensive items.

Have you ever noticed a star effect which occurs when a camera photographs a bright light? It may be a spotlight behind a singer or it may be the reflection of light from the sequins of a dress. Instead of being an accurate recording, the camera picks up the light as dramatic stars, the result of using a special filter that can cost $10 or $15.

Because such a filter can add to the salability of your work, you may want that effect. For a temporary or low-cost substitute, find or buy a small piece of window screen material. The cost will only be a few cents. Hold this screen directly in front of the lens, pressing it against the lens shade. Focus through the screen and you will notice that the screen is not visible in the viewfinder. However, whenever the camera lens is pointed toward a bright light such as the reflections from sequins, the same star effect will be yours.

Another effect professionals use results in

the center of a picture being sharp with the area surrounding it being soft and dream-like. This is especially dramatic for romatic scenes or subjects.

You can get this effect with a clear glass filter such as a haze or skylight filter. Leave the center clean and smear a small amount of petroleum jelly around the outside. The petroleum jelly is always applied to the filter. *Never apply petroleum jelly to the lens! It cannot be removed!*

The inexpensive way is to take a piece of clear food wrap, stretch it taut over the sun shade and hold it in place with a rubber band or tape. Then poke a small hole in the center with a knife or the point of a scissors, enlarging it so that it is about a third the entire opening of the shade. Remove the flap of material that will result. Remove the sun shade from the lens while doing this, then replace it when everything is ready. If your sun shade is permanently attached to the lens, use extreme caution not to scratch the front of the lens.

Next, smear a small quantity of petroleum jelly on the food wrap area that surrounds the center hole. When you look through the lens, you will see the same effect.

One word of caution. Be certain to wash your hands after applying the jelly so small amounts remaining on your fingers will not get on the camera. If your work will prevent you from getting near soap and water, carry a few packets of pre-moistened towels which are sold under a variety of trade names. These are often included free with carry-out chicken dinners. They can remove the petroleum jelly almost as easily as soap and water. As an added precaution, I always carry an extra dry cloth which I use following the application of a pre-moistened towel. It's an added bit of insurance.

There are other tricks you can use. If you want to add an over-all color to a photograph, buy sheets of colored gelatin or rolls of colored cellophane. When stretched taut over a lens, you have achieved, for pennies, the same effect professionals purchase expensive glass filters to obtain, although the optical quality is not as good.

More advanced tricks, such as multiple images, do require special optical glass. Write for the free catalog available from the Edmund Scientific Co., 300 Edscorp Building, Barrington, New

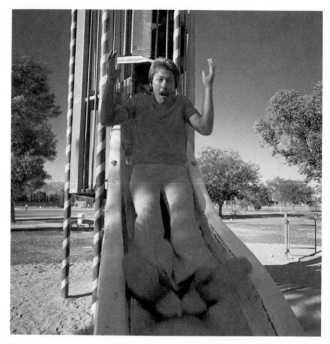

How do you capture an actor in an amusing way? Take him outside and put him on a slide. This is actor Michael Parrent.

Jersey 08007. This has thousands of gadgets including inexpensive prisms and other types of optical glass which can be held in front of the lens to obtain multiple images. Holding it may be a nuisance, but your cost will be one-tenth what you would pay for a ready-made optical device custom fit for your camera.

Even if you are allowed to set up extra lighting for theatrical photography, my advice is to avoid electronic and regular flash at all costs. Certain types of stage make-up can appear quite unnatural when flash is used. The problem is magnified with some color-negative films. I once photographed a lovely blonde actress with negative color film and electronic flash. She was made up for a part and we were taking the photographs shortly before she was to go on stage. Her expressions were perfect, and the pictures were hideous. The light and film had recorded the make-up so that it looked just like it was—a grease-based coating on her face. Had I tried to sell such photographs, she could have taken me to court. They had turned a beautiful young woman into a clown.

If you are using flood lighting, the easiest way is to use two or more 500-watt flood bulbs on

The Carpenters, though this time with a 135mm lens. Depth of field was shallow. Only Richard Carpenter is sharp. Total effect is not so good as with greater depth of field of 90mm. Both lenses had same lens openings and were focused on the same spot.

each side of the stage. There are 1,000-watt bulbs but the cost for holders becomes considerably higher than for the 500-watt bulb clamp holders. Remember to keep them aimed downward at a slight angle to avoid large shadows directly behind the cast. These lights should be used in addition to the regular stage lighting. Keep in mind if the stage lights are carbon-arc lamps, a combination of blue and regular flood bulbs will give you the best light for daylight film.

Watch where you run the extension cords. There is a chance that someone moving quickly, thinking about his part rather than where he is going, will trip over them. It's best to set up lights only when the actors will be on stage during the entire photographic session.

SALES

Fully professional companies require a different approach to selling. The majority of the actors have been in the business long enough that they no longer want photographs of every performance. This is not to say they are free from vanity. They have just reached the point where they don't need to prove they have been on stage. They may want an individual portrait which I will discuss shortly.

In professional companies, your primary sales will be to the director, public relations manager or whomever else handles promotion. The pictures will be used for newspaper and magazine publicity as well as printed programs for the audience.

Because today's professional community-theater actor may be tomorrow's matinee idol, you should take a few extra photographs of the individual actors and actresses in addition to the pictures needed for promotion. Keep these in your files, cross-referenced by name, date and location as discussed in the chapter on photographic files. Then, should one of them move on to national stardom you will have photographs that fan magazines and general-interest publications may buy. Stories about the making of a star or about his work during the early years of his career are always in demand. The extra time it takes to make the additional photographs could pay well in the years ahead.

SMALL GROUPS

Performances by well-known professionals are arranged by local promoters, often in connection with a radio station or similar business. To photograph these performers, contact the pro-

moter whose name will be mentioned in newspaper or billboard advertisements. Explain that you are a freelance photographer and request permission to photograph from backstage during one of the performances. Explain that you will work strictly with available light. If you have any trouble, the co-sponsor, such as the local radio station, can often be of help.

Occasionally there will be problems which prevent you from photographing certain personalities. I was allowed to roam backstage during a Bill Cosby concert, the only restriction being that I not use artificial light of any kind. However, the same promoter refused me access to a Liza Minnelli concert because she had a clause in her contract which stated that the backstage area had to be free of all people except those directly involved with her performance.

Another time I spent several days photographing Peter Nero during rehearsals for a concert. A few weeks later I asked to photograph Robert Goulet and was refused permission. He had recently had some candid photographs used in a very unflattering article and was not allowing any pictures. He was aware of the work I had done for Peter Nero and the fact that my reputation was excellent, but still unwilling to take a chance with any photographer.

LENS AND EXPOSURE

Backstage photography of individual entertainers or small groups generally requires telephoto lenses, preferably high speed. You will be far enough away from the center of the stage that a 135mm lens is about as short as you can use. At Bill Cosby's performance, for example, any lens shorter than 200mm resulted in a tiny figure made almost invisible by the vastness of the stage. A 300mm gave me nice, tight cropping and a 400mm, which I had not brought along, would have enabled good head-and-shoulders portraits.

For musical groups with three to five people performing, a 135mm is often ideal and occasionally you can use a 90 or 100mm lens. However, if you want to isolate just one or two of the performers, you need a long telephoto.

Photographs of entertainers playing short engagements present serious lighting problems. The light will invariably be a harsh spot and there will be no way for you to take a light-meter reading before the performer goes on stage.

If you are using a hand-held meter or if your camera has a meter that does *not* read through the lens, you won't get an accurate reading. The meter will be seeing not only the spotlighted performer or group but also the vast blackness of the stage that surrounds them. The meter reading will call for far greater exposure than the subject needs, resulting in washed-out pictures.

The only meter of value in this situation is a spot meter, which few photographers own. If you live in a big city, your camera store might have one you can rent. Spot meters take light readings of a very narrow angle, from one to seven degrees depending upon the meter. A viewfinder shows you exactly what the meter is reading. Aim the meter so you see the performer's face. You will get a good exposure.

If you have a behind-the-lens meter, you may have the same problem as with a normal hand-held meter. Assuming your meter is of the averaging or center-weighted variety, a normal or even a short telephoto lens—90mm to 135mm—will still read so much darkened stage that your pictures will be overexposed. To meter, put on the longest telephoto you have and frame the subject. If you still see a lot of dark area, you will need up to two stops less exposure than the meter tells you to use.

If your behind-the-lens meter is of the spot or semi-spot type, make certain the area being read is limited to the figure on stage. Generally this will be the case with any lens of 90mm or longer. With some cameras using this type of meter, it works with the normal lens. Even with a built-in spot meter, a wide angle lens will read too broad an area and result in overexposure.

Meters are not perfect, of course, so you should bracket exposures. I make one exposure exactly as the meter dictates, a second exposure one f-stop wider and a third one f-stop smaller. If you are working wide open to start, vary shutter speed to bracket your exposures.

It is possible to work without a meter, though never quite so satisfactorily. Film manufacturers supply information about available-light indoor exposures on the information sheet enclosed with film. Such information is only given for high-speed films but these are the only ones you will be using.

Kodak guide books provide the latest infor-

This is a refreshing view of a Middle Eastern dancer. This type of entertainment is quite the rage, and should be considered for publicity shots. Most dancers appear indoors in clubs, however, so be sure to have the right equipment and permission of the management before starting your shot.

mation on "guess" exposure under stage and other low-light conditions. If your dealer does not stock them, write to Eastman Kodak Company at 343 State Street, Rochester, New York 14650. They will answer questions directly or send you a list of publications which will help solve your particular problem.

SALES

After photographing "name" entertainers and groups, you will have several potential sales. One, of course, is to the promoters. Even if the booking agents are not interested, the co-sponsor, such as a radio or TV station, will often want display prints for the office walls and for publicity.

Another source is the entertainer's agent. You can get his or her name through the booking agent. They are interested in unusual high-quality photographs of a client performing.

Another source, if the entertainer makes records, is the record company. Photographs are often needed for album covers. Covers are almost always color photographs and, in general, 2¼x2¼ is preferable to 35mm. However, send what you have, after first checking with the company to be sure there is interest. For black-and-white you should send 8x10 prints. Both black-and-white and color will be considered for album backs. The photos used on the back of the album are smaller and any size transparency is fine.

Record companies in general want to see *transparencies only* when you send color. It is easier for the printer to reproduce a picture from a transparency than from a color print. If you have color-negative film, either get transparencies made from your best negatives before sending the work off or just make black-and-white prints from the color negatives. Any good custom lab, including those listed in this book, will make black-and-white prints from color negatives.

Another potential source of income is from the fan magazines. Buy a few copies to see what they are like or read about them in *Writer's Market* and/or *Photographer's Market,* the annual guides to writing and photography markets published by Writer's Digest Books, 22 East 12th St., Cincinnati, OH 45210. Before sending any photographs to fan magazines, tell them what you have. Include a self-addressed, stamped envelope for reply. Only after they express interest should you submit any work. See the chapter on photo files for information on handling and mailing.

SUMMER STOCK COMPANIES

Summer stock groups offer all sorts of possibilities for sales. First there are the standard publicity photographs. These are sent to newspapers and have many of the side-sale possibilities that come when photographing an entertainer.

There are sales to the members of the company other than the "name" star. In most cases these are not full-time professionals. They will have as much interest in your photographs as the strictly amateur groups. You can sell scenes from the play and photographs of cast members working with the "name" star. It's not unusual to sell six prints or more of each actor shown with the star. "Aunt Ellie just *dies* every time she sees HIM on television and here I am with HIM on stage."

If you are allowed to attend a few rehearsals, you can increase your sales by photographing the stage crew with the "name" star. They may not

be appearing in front of the audience, but they will be thrilled to show friends photographs taken with someone famous.

There are further advantages to working with summer stock groups. Some are connected with universities or have obtained fine-arts grants from foundations, schools or individuals. These groups often have programs for children or special training classes for advanced drama students. If you have the summer free, you might find yourself hired as photographer-in-residence to both teach photography and to document the work of the theater group. The pay may be low, but it is an excellent summer job for a student who is a skilled photographer. Besides, you will get all your film and chemicals paid for by the group, not to mention the extra sales of prints you can make on your own.

Then there are the local newspapers. Behind-the-scenes photographs of rehearsals make excellent feature picture stories. Take a few 8x10's to the editors and you will be surprised how many will buy them.

Many summer-stock theaters are in communities that are considered art colonies. There are small art galleries in the immediate vicinity and even the theater itself may have a display area in the lobby. These are perfect for selling your dry-mounted 8x10, 11x14 and 16x20 prints. These can be of the various productions and general scenics you feel would interest the public. Naturally, your name, address and telephone number will be prominently displayed.

After your first year of working with a summer-stock group, you will have a file of photographs you can use for the opening production the following season. A display of prints taken during the previous year will be ideal decoration for the theater on opening night of the new season. Naturally the prints are for sale. Some of these can also be offered to area newspapers for a photo feature on the summer-stock group's history.

Your pay will come *either* from the summer-stock group *or* the newspaper, but not from both. If you are paid to produce publicity pictures, these should be sent to newspapers without charge. Only those pictures taken outside the scope of your employment can be sold. No matter who

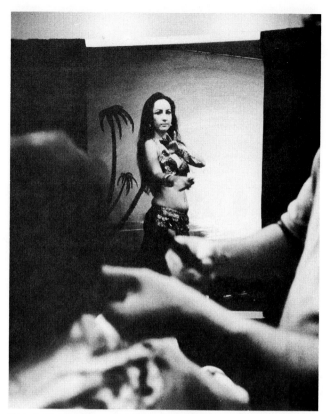

This belly dancer entertains customers in a barber shop which is actually a private club. I took this photograph with a wide angle lens to show the barbering going on while she was performing.

pays, always request a credit line for your work. To clip photographs with your name at the bottom is not only a big thrill, it will help you get assignments. To many people, that by-line means you are a true professional no matter how much money you earned from the photographs.

THEATRICAL PORTFOLIOS

There are still other areas of theatrical photography. The more serious actors will be thinking in terms of a show business career. Others may be seeking jobs as singers, models or as actors for television commercials. Every city with a television station will have some locally produced commercials, and little-theater actors are among the hopefuls seeking such jobs.

These people want photographs to impress potential employers with their looks, talent, and experience. They will buy everything from theatrical poses to portfolios. And who is the first person they think of for such work? Who else but the

photographer who did such a nice job with the little-theater group.

There are two ways you can photograph theatrical portfolios. One is in a studio in your home, discussed in the following chapter.

The second approach, which can be done anywhere, is to go on location in your city. Use available light and the objects and backgrounds you can find walking your city's streets. If you are near the country, a rural setting can also be used.

For location photography I have a tendency to use every lens I own, seven different focal lengths, though almost any equipment can be used successfully.

One precaution is, never get too close to your subject. In the next chapter you will learn that the standard lens for portrait work is approximately double the normal focal length. This allows a tight head shot at a distance of from three to five feet from your subject. No matter what lens you use, moving in closer will result in distortion. The roundness of a face might be emphasized, for example, making a thin person seem fat. Distortion can be used creatively, but usually not in photographs designed to flatter the appearance of the subject.

I frequently use wide-angle lenses for theatrical portraiture to take in both model and surroundings. For example, a photograph of a tough-looking youth, hat cocked low on his head, lighting a cigarette in an alley would be perfect for wide-angle coverage. The lens takes the alley, perhaps a fire escape and some trash cans. It helps to place the actor in a setting which enhances the effect of his appearance. The photograph helps set a mood which a studio-type picture of the man in a similar outfit might not achieve.

Or you might have a pretty girl in a bikini running through the woods. A wide angle could be used to frame the girl with tree branches and flowers. Instead of a stilted glamor pose taken in a studio setting, you have a photograph filled with life and excitement.

Perhaps you have a couple enacting a scene from a melodrama. The man is the villain, the girl is tied to the train tracks. With a wide-angle lens held low along the tracks, the photographic technique is also melodramatic.

Many professionals duplicate such scenes in a studio using equipment like rear-screen projection systems with lots of floor space and props. For you to do such work at no expense you must go on location, relying on careful composition of your subject and the surroundings.

When shooting portfolios for actors and actresses, have them make frequent changes of clothing. They may use costumes or just select from their personal wardrobes. Most singers have fairly extensive wardrobes. If the actor with whom you are dealing lacks a variety of clothing, ask him to borrow costumes.

Under no circumstances should you have to worry about finding adequate clothing, such as from costume rental stores, for the person you are photographing. You are selling your services as a photographer, offering quality and a creative approach—nothing more. You may have to scout possible locations for pictures, but you should never offer to supply clothing needs.

Occasionally an actor or actress has a particular role in mind and wants you to take photographs that show his or her potential for such a part. Someone interested only in musicals will want to be photographed singing and dancing in a variety of locations. The areas you select should be brightly lighted and have a feeling of happiness. They might be in a shopping center, garden, busy street or other location that seems appropriate.

For someone interested in dramatic roles, individual photographs might be taken dark, somber settings. Some near sunset in shadowed doorways. Others in alleys or at night under the harsh lighting of a city street. Deep shadows create a far different mood than the sunshine you used for the actor seeking parts in musicals.

An actor's portfolio should contain no less than ten 8x10 or 11x14 photographs. Generally the more serious someone is about acting, the less

> Visit neighborhood crafts shops. Craftsmen like photos of their handiwork and such pictures can often make good feature stories for local daily and weekly newspapers.

money he has. Time is spent seeking roles and studying for parts. Jobs unrelated to acting are only a means of subsisting and the actor often works the least possible number of hours outside the theater. Unless supported by family, they live a hand-to-mouth existence which does not leave much money for photographs.

When you agree to handle an actor's portfolio, discuss in advance what it will cost. Learn how much money the actor can really afford to spend and don't be afraid to ask for payment in advance, before you make the photos.

Although 11x14 prints are more dramatic than 8x10's, 8x10's are cheaper and generally preferred. Actor's budgets can be stretched further with the smaller size, so they can buy more prints.

Some performers need large quantities of 8x10's to pass out to potential employers. Go-go dancers, night club and bar entertainers, for example. They will want 50 or more prints from the same negative.

Even if you have your own darkroom, it is best to turn over mass production of prints to a commercial lab. They are better equipped to provide both quantity and consistency of images from print to print. Prices are low, usually less than the cost for doing it yourself if you consider the time you spend. All labs mentioned in the listing in this book can handle quantity printing from the same negative, though their charges will vary. Get price quotes before deciding which one you will use. There may be a local photo finisher who can do the job, saving you time and postage.

The markup for each print of a large order made from the same negative is always smaller than normal single-print markup. For example, one lab charges $3.20 for a single 8x10 but as little as 70 cents each in large quantity. With normal

Many low-budget television stations, especially non-network commercial stations, hire advanced amateurs to work as film editors. Such jobs are often part-time and can lead to work as a cameraman.

Back stage can be exciting in a theater. I caught these actors and actresses preparing for their roles at the Saguaro Dinner Theater in Tucson, Arizona.

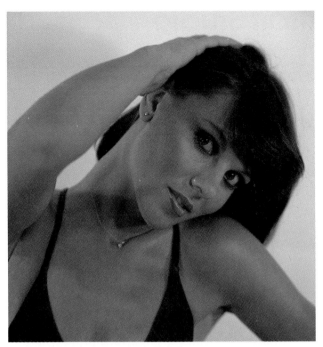

A wide angle lens and white background makes these the types of photographs individuals can use for acting or modeling portfolios, or for publicity releases with name and contact information printed on the bottom.

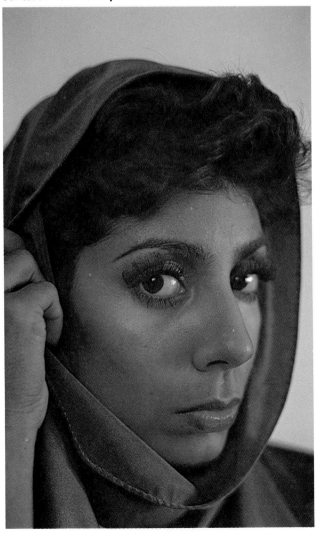

markup for that single print, you might charge up to $15. But when you order adequate quantity to insure the low price, you might mark-up only to $7 to $10. This is because your costs are far less than if you ordered an equally large number of prints, each made from a different negative.

A moment ago I mentioned go-go dancers and similar entertainers in bars and small night clubs. This is an additional area for making money with your camera but one which is often hard to enter. These girls have a need for photographs, both face and full figure (clothed). These are circulated among the club owners in the different cities where the girls seek work. Few of them are hired for more than a month at a time, after which they must move on.

Don't attempt to approach girls working in these small clubs and bars until after you have done other theatrical or model photographs. Then talk with the owners, explain what you are doing and leave samples of your work together with business cards.

Return to the club in a week if you have not heard anything. The girls will be willing to listen to what you have to say, both because they have seen some of your work and because your approach was cleared through the club owner. Once you have done one or two girls' portfolios, word will spread. Soon you will find many girls seeking your services as a photographer.

Another approach is through the booking agencies located in your community or the nearest large city. If they like your work, they will refer clients to you.

One word of caution before you get involved. You must accept these girls as professional entertainers without making a moral judgment on the way they earn their living. If you can't, don't seek their business. Neither you nor they will benefit.

> Become your city government's portrait photographer. Offer to take official portraits of city officials for display in City Hall. Naturally your name will be included when they are hung, adding new business and making you seem to be the most prominent photographer in your area.

The Home Portrait Studio

The living room was torn apart. Scribbens, my miniature Schnauzer was sleeping at the girl's feet. Lights were scattered about the seamless paper which had a hole in one side. Yet look what tight cropping in the viewfinder produced. It's not where you take a photograph. It's how you take it.

Now we come to the most controversial part of this book—the home portrait studio. The question is whether or not an advanced amateur, working in his home, can actually operate a portrait studio. Many "experts" say such a studio is not practical, and I agree that its potential for the amateur is somewhat limited. However, it can be done; even full-time professionals are using this approach. Equipment List C will get you started.

One of the most successful portrait and wedding photographers in the country is Bob Garrett who runs Bob Garrett's Home of Photography. He does portraits and weddings on the ground floor and in the garden of his home in Columbus, Georgia. The interior has been designed to make dramatic backdrops and his work is excellent.

Loren Selman is a Cleveland police officer who runs a photography business on the side. Loren got his start in high school. He converted the basement of his home into a studio, using inexpensive floodlights and a twin-lens reflex on a tripod. His clients were primarily neighbor children but his work was good enough to receive local newspaper publicity.

Even in New York City, the center of professional photography in the minds of many people, the home studio is popular. Many photographers, including those specializing in advertising, have large apartments with one or more rooms used for studio space and living in the rest. The cost is far less than rent in a business building and they have the added advantage of no commuting.

But getting back to your particular situation, look at what is involved and what you can realistically offer. Even if you decide the work in establishing a home studio is more than you can handle, the information in this chapter will help you with both model and theatrical photography.

EQUIPMENT AND SET-UP

To handle portrait work, you need a camera which uses film larger than 35mm, or a 35mm camera with a longer-than-normal lens—85mm to

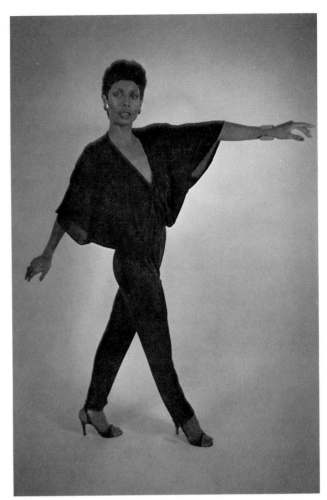

So who can afford a posing stool? Both images of Pat Herrera are effective without props.

150mm. With a camera using 2¼x2¼ or larger film, you should ideally have a lens of longer than normal focal length for that format. But it is possible to crop the picture when printing to obtain a telephoto effect with the normal lens.

Contrary to what people think, the camera does lie. It distorts images, changing them according to the type of lens and the degree of curvature. The closer you hold the lens to your subject, the greater the distortion. Portraits should never be taken closer than around 3½ feet and a distance of five feet between camera and subject is even better.

A secondary problem is the need to fill the frame with the image. If the subject only fills half the frame of a 35mm negative, you will have to double the amount of enlargement to make a cropped 8x10. This increases grain and calls atten-

tion to any lack of sharpness. For this reason, a wide-angle lens cannot be used for straight portraiture. To fill the frame, you have to move in so close to the subject—often 18 inches or less—that the lens distorts the face.

Even a normal lens is not good. It can be used, but you must still either get too close or crop. The distortion will be nowhere near what it is with a wide angle, and it may not even be detectable to the casual observer. But when the photograph is compared with one taken with an 85mm or longer lens, the distortion is readily apparent.

The 126 Instamatics should not be used for portrait work unless yours is one of the rare models which take interchangeable lenses. Non-interchangeable lens rangefinder cameras are also out, despite the fact that their optical quality is generally excellent. With the home portrait studio

Construction of a studio. Cup hooks screwed into the ceiling, secure nylon cord run through the seamless paper roll. Total cost, not counting the paper—30¢.

you have entered a field where suitable equipment is a necessity.

With cameras using film larger than 35mm, you can use the normal lens providing you keep it around five feet from your subject. The subject's head still will not fill the frame, but the portion of the negative to be enlarged after cropping will be at least as large as a full frame image on 35mm film. Even the least elaborate twin-lens reflexes, for example, are suited for this type of work.

You need three floodlights. These can be clamp lights or lights with stands designed for this type of photography.

My personal feeling is that you should buy complete light outfits consisting of a stand, the bulb holder (often a clamp type), a reflector and flood. Extension cords must be purchased separately.

You also need some sort of background for your photographs. This can be a roll of seamless paper, a large projection screen or even a corner of the room. I have never lived in a home that had an interesting corner for a photography so I usually use seamless paper. I have used a projection screen for many successful head-and-shoulders portraits.

Seamless paper must be suspended in some way. The simplest commercial seamless paper holders are also the most expensive. Holders are available for $25 to $45, depending upon type.

My seamless paper holder is two heavy-duty metal cup hooks and a length of strong twine or nylon cord. The hooks are installed at opposite ends of the wall. The cord is tied at one end, dropped through the hole in the seamless paper roll, pulled through to the other side and tied to the opposite hook, suspending the paper. The paper can be rolled and unrolled with ease. Total cost for the holder—less than a buck!

"Poverty breeds creativity." When you want to make money with your camera and you lack the budget for accessory equipment, find ways to make an inexpensive substitute.

If you lack the money for the seamless paper or just want to save $15, go to a fabric store. There you will find a section of remnants—short pieces of material on sale for a fraction of their original cost. Many a time I have picked up pieces of black or white cloth large enough for backdrops.

Never buy patterned fabric for backdrops or warm colors such as red or orange if you are going to take pictures in color. Patterned pieces distract

the eye, calling attention to the pattern rather than the subject. With warm-colored material, the eye is drawn to the reddish tones rather than to the subject. This is distracting and unprofessional.

If you decide to use a fabric background, you can use my $1 seamless paper holder for your support. You may want to put two sets of hooks in the wall, the second set at a height which will allow the material to be hung as a backdrop for a standing subject. This will make it useful for model work.

You need a stool or chair for your subjects. This can be any stool or chair you have around your home. Just be certain the back is low enough to be invisible in the photograph.

Now that you know how to set up a home portrait studio, where do you put it? My preference is the living room. Others use the recreation room, a basement, attic or even an unused bedroom. It only needs to be an area where you can clear the furniture out of the way. Nothing is left up on a permanent basis. I find it takes about ten minutes to dismantle my equipment to make a room "livable" after I am done with a photo session. Only the hooks are left in the wall, but they are invisible to anyone sitting in the room.

FINDING CUSTOMERS

Now you are ready. Where are your customers and what are you going to charge?

Your studio is going to provide a local service. You will be working primarily with the people who live in your neighborhood, attend your school or work with you on the job. You offer a convenient location, the relaxing atmosphere which comes from dealing with a friend or neighbor and a price that is competitive with smaller studios. You will not compete with the top professionals because you cannot compete with them—at least not yet. As for the 99¢ portrait offers by studios, they are not regularly available, they are limited in the poses and they are often inconvenient. Most people will pay a little more for your personalized service.

Among adults, limit your work to friends, relatives and acquaintances whose personal vanity you know. Unless you or your spouse is trained in retouching, you cannot risk photographing the elderly and others who may not view themselves as the camera sees them. To your clients, there is no such thing as a flaw in their appearance. There

is only a flaw in the photographer who cannot make them as beautiful or handsome as they think they are.

Go knocking on doors to let your neighbors know you are in the portrait business. You need business cards and the perseverance to keep returning to people until they actually make an appointment for a sitting. If you are in school, the school newspaper is a great place to advertise. Weekly newspapers are also good. If you are a parent, the PTA is a place to begin talking up your service. Once you have taken a few portraits, some of the sales work will be unnecessary because your reputation will spread by word of mouth.

Talk with co-workers, post notices on bulletin boards and advertise in the company newsletter if one exists. It should not take very long to get results.

TECHNIQUE

Once you have a client, how do you take the photograph? Let's start with lighting.

When it looks right, it usually is right. I arrange my lights to get the best effect with the person I am photographing and never worry about "standard" arrangements. However, my methods result from many years of experience. I will show you the "classic" ways of lighting which you can use as a guide.

In general, one light should be stronger than the others striking your subject. This is called the *main* light and is the brightest either because the flood bulb is more powerful than those used in your other lights, or because it is placed closer to your subject than the other lights. How you position the main light will affect the quality of the final photograph.

There are several positions in which the main light is commonly placed. One is in front—slightly left of the camera. This produces quite pleasant lighting effects, even without additional lights.

A second approach is to place the main light high and to the side so it is approximately at a 45° angle to your subject. If the lamp is too far to the side, lighting becomes harsh, splitting the face into two parts with one side devoid of detail.

Having the light overhead or underneath the face creates adverse conditions. Lighting coming from directly below the face tends to make your subject seem like a character from a mystery or

PORTRAIT ORDER

Client _____

APPOINTMENT

Address _____

Date _____

Time _____

Phone _____

Place _____

Individual ☐

Location ☐

Group ☐

Studio ☐

Party ☐

Home ☐

CHARGES

Hourly $ _____ Min. $ _____

Sitting Fee $ _____

Night Rate $ _____

Rush Fee $ _____

Expenses $ _____

TOTAL FOR SERVICES $ _____

Plus normal charge for prints.

PAYMENTS

		Date Rec'd
Hourly Rate	$ _____	_____
Sitting Fee	$ _____	_____
Proofs	$ _____	_____
Prints	$ _____	_____
Special	$ _____	_____

TOTAL PAYMENT $_____

(Reproduce your business card here.)

Signed _____

Date _____

What can one light do? Let's try taking it around Carol's head.

horror film. Overhead lighting creates deep shadows, especially in the eyes and under the nose. These problems can be eliminated with a fill light but unless the fill light is near the same strength as your main light, the shadows will still be a problem.

There is a position to the side and towards the back of the head. This creates only an outline of the side of the head, producing a silhouette for most of the face. It has little use in portrait work.

If you want to reduce mild shadows, supplement your main light with a reflector on the opposite side to fill the dark areas with additional light. There are many commercially made units, including silvered umbrellas, which you can buy. However, reflectors of almost equal quality can be made at home for next to nothing.

Cover a large piece of cardboard—11x14 inches or larger—with aluminum foil. Smooth out the foil as best you can and you have your reflector. Corrugated cardboard is best for this purpose because it doesn't bend easily. If the cardboard is wider than the foil, overlap two pieces of foil.

If you wish, you can substitute white cloth, including remnants. You can also stretch the cloth on a wooden frame. The cloth is stretched taut on the frame, then tacked to the wood. Light can be

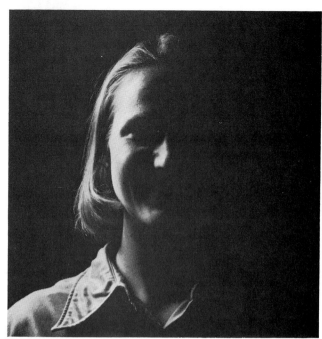

Continuing around Carol. An exercise showing how much can be done with a light and how different lights can highlight specific features.

reflected from the cloth to fill shadows or the light can be directed *through* the cloth to soften shadows. This is diffused lighting and is softer than the direct flood. Lighting angles are kept the same as discussed.

Your second light is a fill light to reduce or eliminate shadow areas on your subject. It is less powerful than the main light, generally through keeping it a few inches to a few feet further away from the subject than the main light. I always maneuver this light to find the most pleasing result.

The third light is a "hair" light placed well above the subject. It is never more powerful than the fill light and often half the strength. For example, the main and fill light are each 500 watts and the hair light is 250 watts. The hair light illuminates the head, bringing out the hair and separating the subject from the background to add depth.

Several lighting arrangements are considered "classics," such as Rembrandt lighting. The diagrams show approaches taught by photographic schools. These are good to know and can always be used with excellent results. However, I remain of the opinion that when a photographer tries to "go by the book" when lighting his subject, the results will often be technically perfect but esthetically wrong. Each person must be lighted to enhance his or her features.

I start with one light, maneuvering it until I am pleased with the way it falls on my subject's face. Next I place the fill light to eliminate the shadows I don't want. Finally I switch on the hair light, and angle it to best advantage.

Because flood lights are quite harsh, you may find that the "best location" causes your client to squint. When this occurs you must either reposition them, beam them through the cloth stretched on a wooden frame described earlier or bounce them from a reflector so only reflected light reaches the face. For this latter technique you position the reflectors at the same angles you would normally place your main and fill lights. Then turn the lights around so they are beamed directly at the reflectors. This reflected light will be weaker than direct light but less harsh. If you can't position your lights directly without the subject squinting, reflected lighting is your only choice.

If your subject is wearing glasses, there may be a problem with glare from the lights. There are several ways to overcome this difficulty. One, of

PROFILE LIGHTING—Camera pointed at dark side of face. Make sure fill light is strong enough to bring out some detail in shadows.

3/4 FACE LIGHTING—Camera pointed at lighted side of face. This type of lighting is generally the most flattering, and the one your customers will most likely buy. All features are well lighted and easy to see.

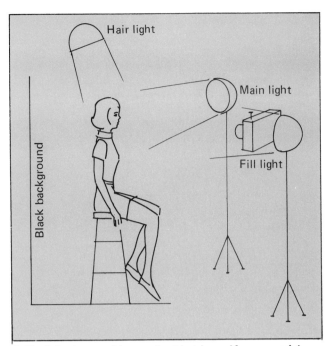

REMBRANDT LIGHTING—Camera pointed at dark side of face. A black background is your best bet here. If your model has black hair, adjust the hair light to separate her head from the background. Fill light should be just strong enough to bring out some detail in shadows.

Most living rooms will make a passable portrait studio. Just move the furniture out of the way, select appropriate lighting and background, then fire away.

Light above enhances hair. Light below looks like Dracula but eliminates unwanted shadows when used with other lights.

course, is to move either the camera or the lights until the glare disappears. This can put the lighting at a bad angle.

A second approach is to tilt the glasses at a slight angle on the nose. This often changes their position enough to eliminate any reflection while still appearing natural.

If all else fails, the only answer is to place a polarizing filter over your lens. A polarizing filter eliminates most glare on non-metallic surfaces. Such filters generally sell for $10 to $20, but are necessities if you are going to do much portrait work.

Portraits can be offered in either black-and-white or color, but I feel you would be wiser to stick with black-and-white when you begin.

When you decide to start offering color, you will face the problem mentioned earlier—slide film is available for tungsten lighting but color negative in roll-film sizes is usually daylight type. Color negative film is best and results in prints at lowest cost but you will have to make some adjustments to use it.

You can use blue photoflood lamps combined with daylight to get illumination suitable for daylight films. If the prints are more blue than you like, mix blue floods with normal type for the illumination quality you want. Never use blue floods by themselves.

You can also use a filter over the lens of your camera with the tungsten illumination you already have. If you are using 3400°K lamps, use a Kodak filter 80B. With 3200°K lamps, use an 80A. These filters reduce the effective speed of the film to about one-fourth the daylight value as the film data sheet will show. If this forces you to exposure times that are too long, compensate by using more light.

If you use slide film, you have the choice of Type A (3400°K) or Type B (3200°K) as discussed earlier. Under most circumstances these require an internegative to be made at a lab before you can order a print.

However, there are alternative processes, such as Cibachrome and Ektachrome reversal papers which make prints directly from transparencies. The results are excellent, but the color rendering and contrast may be quite different from the Type C print offered by labs. It is best to compare the two, including cost, before deciding which approach to use. In some instances, companies offering prints directly from slides may charge more than those using internegatives. If your budget is limited and you and/or your client cannot tell the difference, go with the internegative.

An alternative is ECN 5247 motion picture film respooled for 35mm use, assuming you are using 35mm equipment. This film is not currently

available for larger cameras. The film can be exposed with tungsten bulbs (3200°K) and provides both a positive and a negative. The only drawback is that only a few labs handle the film. See a partial list at the end of the chapter on special films. The negative, which looks like the negative obtained with standard Kodak negative films, does not print in exactly the same way. If a lab has not specifically prepared to print such a negative, the print is often poor. This means that even after processing, only a few labs can make good prints. This is a nuisance but one which may not bother you. The processing time for some of these labs is long. Send them a sample roll or two before guaranteeing delivery of pictures in a set amount of time.

The black-and-white film you use should be fine-grained and relatively slow. I like Plus-X and the H&W Control Film rated at ASA 50. H&W was originally available throughout the United States, but only a handful of dealers currently stock it. It is the highest speed, ultra-fine-grain film presently offered in the United States. It was originally a high contrast copy film but, when developed in H&W Control developer, it provides a full grey scale and 35mm images which look as though they were taken with an 8x10 view camera in terms of sharpness. For price and purchase information, write The H&W Company, St. Johnsbury, Vermont 05819.

If you use a custom lab for your portrait work, you should show your clients an enlarged contact sheet and one 8x10 print for samples. I like to use a 20-exposure roll for each person, though this is not really necessary. If you can schedule enough sittings in the course of a day, you might choose to use a 36-exposure roll of film, taking 12 pictures of each person. Most studios take four views with a large negative camera, but their photographers have years of experience. They know what kind of photograph they have. You will need to take more photographs than they do to be assured of success.

There are many posing tricks you can use to enhance your work. If your subject's eyes seem slightly closed, have him lower his head a little. This will make the eyes appear to open wider.

Music can help a subject relax. Have a radio in the room or a record or tape player with a good

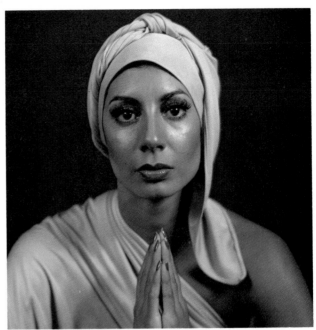

I produced this image of Pat Herrera wearing a turbine in a home studio, against a black background. Illumination consisted of just one light and an umbrella reflector.

selection. Let your subject select the music rather than playing just what pleases you.

Small children should be encouraged to bring along a favorite toy. You might let them play with it on the floor for a candid pose. With extremely young children try taking the toy from them when they first arrive, putting it someplace out of sight. Then sit the child on the posing chair, adjust the lights, focus and get ready to release the shutter. At that moment have the child's parent produce the toy and start to give it to the youngster, keeping it just out of camera range. The happy expression on the child's face will make for a perfect picture. But be ready. There is no second chance! The child will insist on the toy that was shown to him and will become upset if he doesn't get it right away.

If someone is nervous when looking at the camera, try to have another person in the room, standing to one side of the lens, just out of the picture. Have this person carry on a conversation with the subject.

You will need a clean bathroom where your clients can check and repair their appearance. Be sure there is a box of tissues and a jar of cold cream as well.

Men should be asked to shave no more than an hour before facing the camera. If you have an electric razor, put this in the bathroom along with the cold cream and tissues.

Make your appointments at least a half hour apart. This will usually give plenty of time to devote to each client. Some people will arrive early and others will require more than 30 minutes to obtain a good photograph, so you should have a place where people can sit while waiting. This can be any room other than the one in which you have made your studio. A few magazines of broad interest can be kept there for people to read. Don't have controversial or adult-only magazines to which parents might object. Remember that many of your clients will be children and their parents want to be certain your operation is "wholesome."

Family portraits are difficult or impossible to do in the small home studio. You can handle a couple by having one person seated and the other standing directly behind, adjusting the lights so they both are properly illuminated. But your space is likely too limited for family photography.

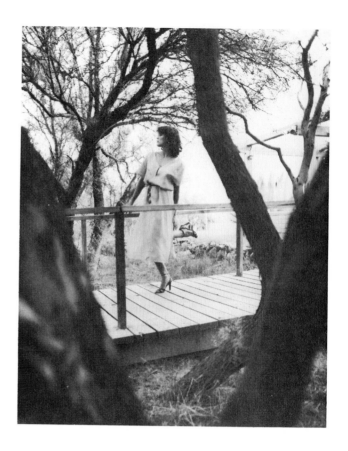

The answer during pleasant times of the year is outdoor photographs. They can be made in the family's back yard or in a nearby park or country setting. Sometimes the grounds of museums have attractively landscaped areas. Stress the idea that outdoor portraiture is natural and results in more meaningful photographs. This is true. Outdoor portraits mean profit you'd have lost if you turn down the family picture for lack of inside space.

Outdoor photographs should not be formal. It may be necessary to have everyone sitting on the grass or along a low wall. The family should be dressed so they look nice but casual enough that they will not mind if they get a little rumpled.

Young children get restless quickly. Work fast, constantly changing your angle, taking a picture, and moving again. You often have no more than five or ten minutes to work with small children in an outdoor setting. After that, curiosity or boredom takes control and they wander away. When forced to stay with the others they often become uncooperative. Tempers flare and your session is over.

When photographing two or more people, it is possible to use your regular lens because you have to move back at least the five feet mentioned earlier to get everyone in the picture. Sometimes

72

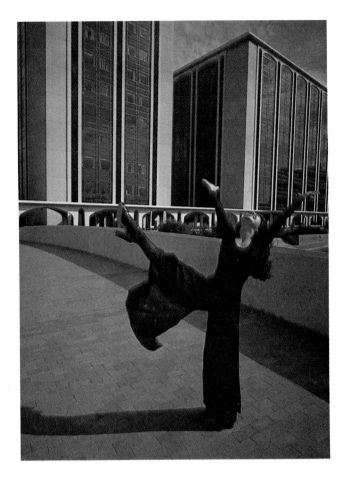

a wide angle is necessary, though this is rare. If you decide to accept group work, find good locations in advance. Wherever you go, it should be nearby, convenient and large enough to get the family away from other people.

Decide in advance what you are going to offer. Will you provide prints up to 11x14? 16x20? Framed? How about wallet sizes, too?

Write to the labs listed in the back of the book, as well as any others you might know about. With their price lists you can figure your costs for different package plans. You might offer one 8x10 and a dozen wallet size. Or a dry-mounted 16x20 print with two 5x7's. The larger prints are for the wall and the smaller ones can be kept in frames at home or office. Page 191 provides a list of companies offering frames and photo mounts you can include with your sales.

As I mentioned earlier, the home portrait studio may not be practical for you. It represents an investment in time, space and money which you may not wish to make. It requires the most aggressive selling of any project in this book.

With ordinary equipment and floor space, you will run into barriers which you can either accept as limitations or find some way to work around. For example, without retouching you will have to limit your clients as mentioned earlier. If you find someone qualified to do retouching, or learn to do it yourself, a 35mm negative isn't large enough to work with. So you enlarge it, or have it enlarged. Eventually it becomes clear that to offer a full range of professional portrait services you need the full range of professional equipment including a large-format camera.

You may find enough enjoyment and success in portraiture to justify more equipment and floor space, or you may decide to keep it a minor sideline among your photographic services. Or you may decide it's not for you at all. As I said, this is the most controversial chapter in the book. Nevertheless, portrait work is rewarding for many photographers and they all got started some way.

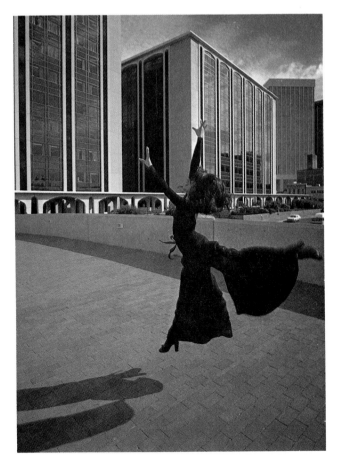

Home studios need not stay inside. I took one model out to a nearby ranch one nice day, while another model was captured on film outside an office complex. Take advantage of your immediate surroundings to add variety and different experiences to your subjects' portfolios, as well as your own.

Model Photography

When you think of photographing models, you probably think of big-name photographers working out of New York or Los Angeles. Many amateurs would give anything to have the opportunity to trade places with such photographers, if only for a day. Photographing beautiful girls has got to be one of the most enjoyable ways to earn a living. Unfortunately, you live in Deadatnite, Indiana, or Restinpeace, Ohio, and model photography seems about as remote to you as a safari in Africa.

The fact is, model photography is possible for you in Deadatnite as it would be if you were in New York. The chance for an amateur to earn extra money photographing attractive girls is usually *greater* in small communities than in the big cities. True, you will not be photographing movie stars and cover girls. But the girls will be pretty, often beautiful, and some may go on to fame and fortune with your pictures in their portfolios.

Although you may not have realized it, models are used in just about every community in the country. I will be speaking primarily about young women models because they are in far greater demand than men, older women, or children. Models are used by department and specialty stores to model clothing and jewelry. They pose for store advertisements, pamphlets, newspaper inserts, and television spots. Other times they are used to introduce new products or represent companies at trade shows and conventions. The major difference between small-town models and the ones in Los Angeles is the small-towners model on a part-time basis. There are seldom enough jobs to keep a girl employed more than a day or two at a time.

There are model schools, model agencies, beauty schools and charm schools, all of which have girls seeking photographs of themselves. Sometimes a school wants before and after pictures to show a girl how she changed her appearance. Other times a girl needs a portfolio as she begins knocking on doors to seek modeling jobs.

None of these girls have any experience so

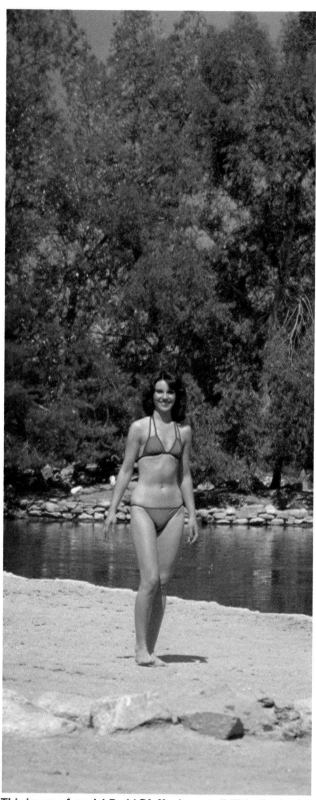

This image of model Barbi Pfeffer has possibilities for both fashion and glamour.

Location shots can be made anywhere: Fashion show photos offer excellent potential for sales to department stores, clothing manufacturers and the models themselves; Anna Harvey was documented in an outdoor setting—one which might sell to a clothing manufacturer or local tourist office, and Pat Herrera is in a more sophisticated fashion pose.

there is no way they can use photographs made by professional photographers as experienced models do. Such photographers are not interested in producing a model's first portfolio. If they use a girl for an assignment, often they will give her a print from the session to use when seeking other jobs. But their fees are so high that no beginner can afford to hire them to produce her first portfolio. That's where you come in.

Every girl interested in modeling must have sample pictures. These show her with different poses, clothing and hair styles. They show her versatility and are given to account executives, photographers, fashion directors and others.

YOUR SAMPLES

Your first step toward becoming a model photographer is to prepare a sample portfolio. Even you need one. Use your sister, your girl friend, a fellow student, a secretary or anyone else you know. Follow the approaches discussed in this chapter and prepare six to ten different prints. Keep in mind that your model does not have to be beautiful. She should be attractive and responsive enough to your camera that you present her in a truly favorable way.

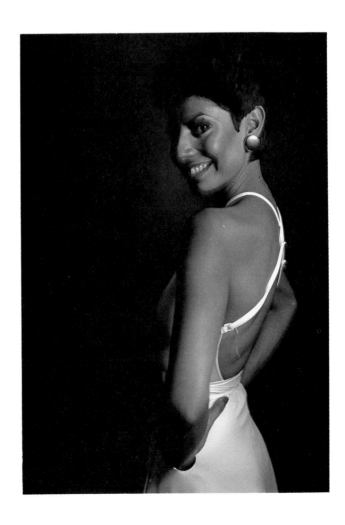

FINDING CLIENTS

Once you have your portfolio, check the Yellow Pages to see what modeling, charm and beauty schools are listed. If there are none in your community, the nearest large city is bound to have at least one.

Many of the girls who graduate from such courses never get a modeling job, but almost all are convinced they need just one big break to make it to the top. They will spend a small fortune on pictures, a make-up kit and, often, a one-way ticket to the "big city."

You may think that by taking a new model's portfolio you are being a leech helping to nurture a hopeless fantasy to gain extra income. The fact is, I have yet to meet a would-be model who was not aware that the chances to make it big were very limited. Yet every year some reach the big time.

Girls who enter modeling, if only long enough to go to a school, are living with a dream. Your pictures represent the last part of their preparations. Once a girl has them, that dream just might become a reality.

When you arrive at the modeling school, you must present an image of professionalism. If you are male, don't stand there staring at any pretty girls who happen to be in the office. A photographer must be objective about his work, separating social life from business. Your purpose in being there is to offer a needed service for what may prove to be a sizable amount of money.

If you are female, don't spend time comparing your looks with the girls in the office. Be objective about your work. Over the years, most model photographers have been men. One of the "textbook" reasons given was that models tend to be more open with men, especially if they need to look seductive. However, the excellent work of the few women photographers in this field has shown the old beliefs to be pure nonsense.

I have found that the majority of girls interested in modeling as a career are extremely insecure compared with those who do it part-time as a lark or who use it to get into the entertainment field. They are models or modeling students partly because they want to be told they are beautiful and desirable. They are just as flattered by a woman photographer's attention as that from a man. There is no difference in the quality of work produced by men or women photographers.

When you see the school director, explain that you are interested in shooting portfolios for beginning models. Say you are a free-lance photographer and you can spend more time with each girl than a full-time professional might do. Show your work and leave business cards and a sample portfolio for the director to show students. Request permission to talk with the students yourself.

I have always found that if I can talk with student models, I can get business. You will have almost as much success if the director shows your work when you are not present because the girls tend to feel that whomever the director recommends must be good. However, it is better if you can make a presentation yourself.

TECHNIQUE

There are two ways to photograph a model for her portfolio. One is in the studio you may have for a home portrait business. Even if you never tried to sell portraits, you may want to build a studio as soon as you have model portfolios to shoot.

The second way is outdoors, on location. Going outside provides a wide range of backgrounds and props. With suitable locations you can photograph the entire portfolio without using a studio.

It's possible to photograph a model with just your regular lens if you observe the five-foot rule. You will take only medium and full-length photographs, eliminating the often enchanting face close-up. The model will probably not notice this defect when she selects her pictures from your contact sheet, but I prefer to include a face photo. For that reason I didn't photograph models until I owned a 90mm lens in addition to the normal lens for my 35mm camera.

The first time I photograph a model I like to work in fairly soft even lighting—such as under a shade tree or in the entrance to a building. I let her wear anything she likes, concentrating only on photographing her face. With only a normal lens you will have to take partial figure photos, but at this point you don't have to worry about her pose. You will only be studying her face. Specific poses will not be needed until the second session.

Move the camera to record her from above,

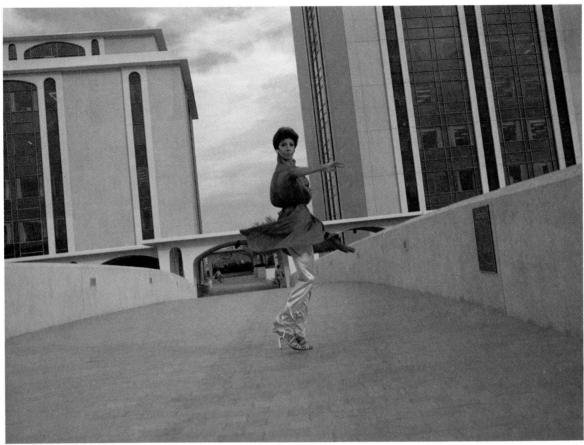

When doing location photography, you must be aware of all elements. When I focused on Pat Herrera, ignoring the surroundings, my angle was bad and buildings seem to be falling. A shift of angle for both of us when I became aware of the perpendicular lines of the building, and the second picture was perfect.

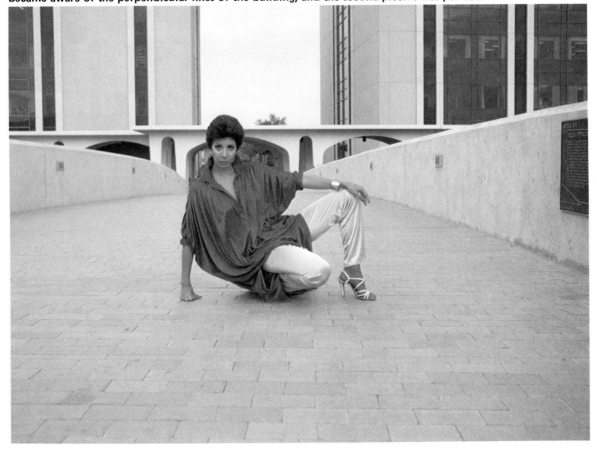

below and every conceivable angle. Have her raise and lower her head, twist, turn and generally alter her position to get as many different angles as there are frames on the roll. This takes just a few minutes of time and is often done when I first meet her. Frequently some place just outside the school is fine for this. The film is processed and a contact sheet made before any further sessions.

Once the processed film has been returned, use a magnifier to study the images. Use at least an 8x. 10x is even better. I use both and also keep a larger, low-magnification glass because it is easier for others to use. The higher the power, the smaller the lens and the more difficult to use if you are unaccustomed to it.

Look closely at the face in each photograph, noting the camera angle and the resulting effect. Is the nose too large in some of the poses? Is it too crooked? What about the eyes? If they are deeply set, what angles seem most flattering? Does her face appear fat in some of the pictures and thin in others? Try to see what happened with each view, making note of the frames that show her at her best. Check expressions, too. If she was nervous during that first session, she may look a little tense. If so, try very hard to put her at ease next time. A model must appear natural even under the abnormal circumstances of having hot lights baking her and a camera staring at her. This is not easy and you should help her all you can.

Schedule a second session to show her in as many moods and poses as possible. There should be "wholesome" poses, sexy poses, formal poses and anything else her wardrobe and your combined imaginations can conceive. Using simple props can also be a help.

For example, suppose you want to take a formal photograph. The model is wearing a long dress or formal pants outfit, her hair carefully prepared as for an extremely elegant affair. To this you might add a pair of opera glasses and a small folder of paper to look like a theater program.

A casual photo with the model in denims or similar clothing can be enhanced by having her lay in the grass, holding a wild flower. Sometimes you can get a rather moving facial expression by telling the model to pretend the camera is her lover who has just given her the wild flower as a present. Ask her to thank him with her eyes. Not all girls can handle such a request, but those who can will have

Watch head movements. A shift in angle can make a drastic change in facial appearance.

Golden age homes, recreation centers and similar areas may be interested in offering a course on photography. If you like teaching, this is a good way to earn some extra money.

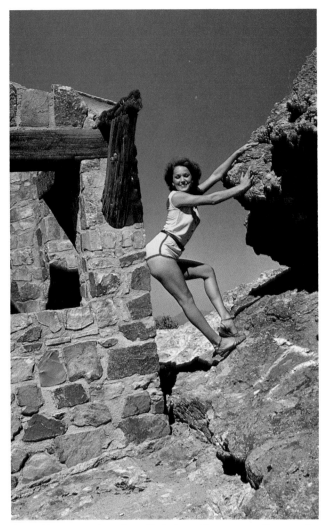

Anna Harvey on location. Note how the surroundings and color add to the impact.

Automobile body repair shops are good customers for before and after pictures of badly damaged cars they have worked on.

a photograph they will show with pride for many years.

Take advantage of the elements, including rain. Most models are as crazy as photographers. They will go along with almost anything for the sake of a good picture. Asking a girl to pose in torrential rain will not result in her telling you that you are out of your mind. Instead she will probably just ask where you want her to stand and what you want her to wear.

Before you go out in the rain, make certain you can keep your camera dry. You might have a friend hold an umbrella over your head, or you stay under a shelter, using a telephoto lens. Buy an inexpensive plastic cover to protect your camera.

Try photographing the model running through the rain. Or have her stand, drenched to the skin, in a sexy or funny pose. Her hair will be limp, dripping with water and her clothing will cling to her body. Make certain you warn her in advance so she can wear something that will cling but not be ruined by the water.

She might be laughing or coquettish or, perhaps, about to kiss an unseen lover—the camera. If your model looks directly into the lens, mentally turning it into a very special person, this attitude will be conveyed to the viewer who may feel that *he* is that special someone in her life. This is the major reason for using attractive women to sell products for men. The man looks at the ad and thinks he will get a girl like the model if he buys that bottle of Smellwell.

If you are working in the snow, take advantage of the harsh whiteness of the sunlight. Perhaps your model can wear black or dark clothing so you can produce high contrast against the snow.

Look for trees covered with newly fallen snow. Notice how the bare limbs have beautiful, delicate lines, almost like an oriental painting. A photo of the model under one of these trees can be beautiful.

Have the model take several changes of clothing when you go on location. You can stop by a restaurant or service station where she can change in the ladies' room.

Sometimes a strong contrast of clothing and location can be interesting. Try posing a girl in a formal by an old fire escape or in a bikini in the middle of a formal garden.

Michael Parrent and Anna Harvey in casual and sophisticated poses.

Use foliage to frame her, photographing through flowers, bushes and trees. Sometimes I have a bikini-clad model lay down in the middle of a wide expanse of grass or wild flowers. Then I stand above her, photographing with a wide-angle lens. I might shoot from a low angle so the photo looks like she is rising from a carpet of flowers.

Your model should have several changes of hair style if possible. If she has long hair, it will be easy for her to give it some variety. With short hair she may need to use a wig. Be certain the wig appears natural.

You can alter a girl's appearance by framing her face with her hair. Move it across one cheek or even photograph through a few strands.

It is essential to use a light meter if you want the best possible effects. The incident meter, or

incident attachment for your hand-held meter, provides the best exposure information.

A reflected-light meter is seldom accurate for flesh tones, though with black-and-white film you will have enough exposure latitude to compensate. A light-skinned girl will give a reading approximately one f-stop underexposed. A girl with dark skin will often give a reading that is one f-stop overexposed. If you use color which you will probably not be doing for a portfolio, use a neutral-gray card in the same light as the model and meter reflected light from the card. If you don't have a neutral-gray card, grass gives about the same reflectance. You can calibrate your palm as a substitute metering surface. When in doubt, bracket your exposures.

The film manufacturer packs an emergency

"light meter" in every box of film. It's that little sheet of paper which provides all sorts of information about the film, its exposure and processing. The chart lists various outdoor lighting conditions you are liable to encounter. It gives you an approximate camera setting to help you get a good photograph without a light meter.

Break the rules! Place the model between yourself and the sun and catch varying degrees of silhouette. Take advantage of lens flare by shooting into the sun and letting the flare enhance the photo.

Indoors, where you have more control, you might have the model turn her head rapidly from side to side or up and down so that you can catch her hair in motion. This is also effective in a swimming pool or lake when her hair is wet. When she tosses her head back, after first letting her wet hair hang down her face, the resulting image depicts flowing motion. The water seems to form a continuous line from the pool to her hair. Many successful advertisements have used this technique.

Use a chair, cushion or any other props you can imagine when working indoors. Remember, with controlled lighting, you can create many effects not possible outdoors. You can accent different parts of her body with the light, getting just the degree of intensity you need by moving the lights closer or farther away.

Some tricks of the trade are handy with any type of model portfolio. One is using reflectors to add fill light both outside and inside.

Indoors you can prop reflectors against chairs, books or any other object. Angle them to reflect the lights into shadow areas you want to eliminate, but keep them far enough from the model so they are not in your photo.

Outdoors you will have to make do with whatever is handy. This may mean propping the reflectors against a tree or wedging one end into the ground. In winter, snow often serves as a reflector of sorts.

Try using a large inexpensive mirror. Glass companies can supply such an item or you might find one in a discount store. It doesn't have to be good quality and may even distort some. Just be sure it is large and cheap.

Take the mirror along when you work with a new model or an inexperienced one who is trying new poses. Prop it upright next to your camera so

A good model is willing to act as crazy as the photographer's imagination demands. Parrent went "bananas" for the most effective photographs.

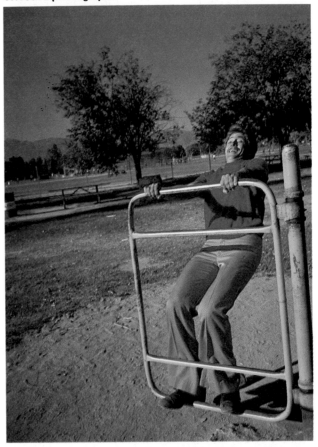

that the model can see how she looks when she faces your lens. This will help her to correct any faults with less coaching from you. If you use it often, you may want to build a cheap wooden holder for the mirror.

Occasionally you will encounter a girl who is either so vain or so insecure that she can't take her eyes off the mirror. She will either be constantly shifting her position, never satisfied that she looks good enough to be photographed, or she will stare at herself, actually absorbed with her own beauty. The only thing to do is to put away the mirror or lay it face down.

Many books tell you to use fill flash when working with models outdoors. Such lighting can be useful if you have mastered it. Unfortunately it is often wrongly used because of inexperience or because lighting conditions are simply not right. You will be better off using the reflectors I have described because you can see exactly where the light is going.

When you first start working with a model, it is sometimes difficult to create poses for her. Unless the girl is a dancer or unusually well trained by the modeling school, she will probably have no more idea about how to pose than you will. Several possibilities are open to you.

Get a book of dance photographs from the library. Ballet photos, for example, show many graceful body positions.

Clip magazine ads showing girls in different poses. Show your model the clippings, letting her imitate and improvise from them. One idea stimulates another and a dozen clippings will provide ideas for several hours of poses.

There are also glamor photography books with attractive poses. However, these are not available from many libraries and they often cost too much to purchase until you are certain you have enough work to warrant the expense.

You need some skills other than just taking pictures when you work with models. Make-up is something you need to know about. You will not be applying make-up, but you may need to guide her in her approach. I have seen beautiful girls ruin their appearance by putting on make-up to imitate some admired celebrity. This often has disastrous effects, especially if you work in color. Too many beginning models equate glamor with mountains of "paint" on their faces. It's your job to re-educate them when necessary.

Some photographers who do model portfolios keep a complete selection of hypo-allergenic make-up in shades for every racial type they will be photographing. This is not very expensive because you don't have to buy the top "name" brands and ensures that necessary corrections can be made before the session. Keep plenty of cleansing cream and tissues on hand.

The model should start with a foundation to match her skin tone. She should not put powder over this base, though she may add a very small amount of blusher to her cheeks for accent. This is kept *very* light so it seems natural instead of giving her clown-colored painted cheeks. With black-and-white film, a mistake in make-up is not always that noticeable, but with color it can be disastrous.

Lipstick should be applied sparingly. The model should use a lip brush and accent with lip glosser.

Eye make-up is a matter of taste. Some people like to see wild eye colors. Others prefer a more natural look. I feel that the eyes should be accented without the make-up being too obvious. If the model is hired by someone who wants her eyes painted purple and orange, she can paint them purple and orange for him. But if her first portfolio shows purple and orange eyes, potential clients may feel she is incapable of using make-up properly and will hire someone else.

The model should outline the upper eyelash line with eyebrow pencil or liquid liner. This should *not* be repeated on the lower lash because it will make the eyes look slightly closed and rather harsh. If her eyes look slightly closed without any make-up added, pose her with head lowered so the eyes open wider.

False eyelashes are of great value to a model if she can apply them correctly. However, natural lashes can be improved with the application of two layers of mascara.

Eye shadow, if used, is applied to the lid, then blended with a brush or fingertip. The color should relate to the wardrobe she is wearing. I prefer that a girl not wear shadow.

Frequently, beginning models have some connection with a clothing store or the fashion sec-

Runway work requires that you capture whatever happens on film. Be prepared with the proper film and equipment—and be alert!

Variations on a pose. Note how the versatile Alison goes from a sex symbol to the pretty, demure, girl-next-door.

tion of a department store. Perhaps they sell clothing or do occasional modeling at store fashion shows and luncheons. Because of their connections, they can borrow clothing to use for posing. But, even though the girl is responsible for what she borrows, you should take some precautions.

Do not ask the girl to pose in borrowed clothing if the pose selected could damage the outfit! Everything must be kept clean and dry, even if that means working indoors with a bathing suit or rainy-weather outfit.

When you transport borrowed clothing, be certain it can be carried without being wrinkled. If you are driving, hang it on the clothes hook inside your car. If it must be laid on the seat, place clean cloths or an old washed sheet underneath the clothing *and* on the floor beside it. There is always the chance that a sudden stop will cause the clothing to slide off the back seat onto the floor.

When pulling clothing over her head, the model may get lipstick stains on it. To prevent this, she should place a tissue between her lips

A change of make-up and the full-face Alison is an altogether different person.

before pulling anything over her head. If she has applied full face make-up, ask her to hold one end of a towel between her lips, then drape it over her head while changing clothing. If make-up is to be applied after the clothing is on, she should cover her neck and shoulders with a towel while making up. Guards placed in the armholes of a garment will prevent perspiration stains.

OTHER OPPORTUNITIES

Model *agencies* have fewer girls desiring photographs. One advantage with agencies is if the models who already have portfolios like your samples, they are likely to use you when they want to make changes in their portfolios. Many of these girls will be working regularly as models, and will have more money for your services.

Charm and beauty schools like to keep students constantly aware of their appearance, changes in weight and posture. They want high quality before-and-after photographs showing the improvement in a girl's looks when she has learned proper make-up and posture.

Other schools use photography to teach the

girls poise under pressure. The camera makes them self-conscious and forces them to apply what they have been learning. A picture is also something they can take home with them as concrete proof that the course was worth the money.

Some large modeling schools have a photographer on retainer. The school pays the photographer to show the students what will be expected when they pose for photos. This also gives them experience in facing the camera. If your sample portfolio is good, you can get the job. Most modeling schools meet evenings and weekends so such work may not interfere with your regular employment.

There are all sorts of side possibilities for earning money. Your weekly newspaper or Sunday supplement may be interested in a photo story entitled "The Training of a Model." This would follow a girl through her training and her first job. Start with a girl who has an assignment, then work backwards. Have her sit in with a class of beginners, photographing her as she "learns her lessons." Both the girl and the school will be delighted to set things up for you once the newspaper has expressed an interest in the feature. The publicity will mean as much to them as the extra pay for the story means to you.

If you get a model release from each girl, you may later sell pictures from your files as described in the chapter on stock picture sales.

Advertising can bring you more model business. Place an inexpensive ad in local high-school and college newspapers stating that you take model portfolios at low prices. Include your telephone number and, if the ad rate is low enough, a photograph of a pretty girl. You can also advertise in the classified section under the "Personals" heading.

Sometimes modeling schools have wall space they will let you use to display your photographs. Include your name and telephone number as a prominent part of the display.

Model photography can provide a very steady income. After a year or two you may want to take advertising space in the Yellow Pages of your telephone directory, just like the full-time professional photographers. Be certain your ad is placed in "Models" or "Modeling Agencies" section, not under "Commercial Photographers." No one is

going to wade through the list of commercial photographers searching for one who takes model portraits.

COMPOSITES

A "composite" is similar to a portfolio and is another service you can offer. Basically a composite is a single sheet, sometimes folded, with several photographs of the model. Two to ten different prints are reproduced on the composite, often the same ones that are in the portfolio.

Commercial printing shops that advertise offset printing or lithography can do the whole job for you. You deliver glossy prints which will be returned undamaged, along with whatever copy you will want to have typeset and printed with the photos. You should make a sketch showing how you want the pictures arranged and where the printed words go. Identify each photo with a letter or number on the edge of the back or in the border, using a soft lead pencil. Do not write on the back of the actual picture area as it will show. On your layout, draw a rectangle for each photo and put the identification in the rectangle.

The printing process requires re-photographing your prints through a screen to convert the image into tiny dots so it can be printed on a printing press. This is done by a "process camera" and there is a charge for each time the process camera is used. The prints can be photographed in batches with the entire batch enlarged the same amount, obviously. If you are planning to use some large photos and some small in the composite, it may pay to deliver different sizes so they can all be shot at the same time on one negative.

Visit a couple of print shops and discuss this kind of printing until you understand what you need to do, what they will do, and what the charges will be. The price for each printed sheet drops rapidly with larger quantities, so get estimates for 100, 500, and maybe even 1,000. The quality of paper used also influences price, so look at paper samples and choose accordingly.

My approach has always been to discuss the composite and portfolio separately. I feel that the portfolio charge should cover your time for taking the photographs. Furnishing a composite is gravy. Mark up your printing expenses by at least $10. Doubling the cost is not unusual if the printer's price is low.

Don't forget the model's family. If you take an unusually attractive photograph, the parents may be delighted to spend $35 to $40 for a giant enlargement. This would be at least 16x20 and, preferably, 20x24. You might include a frame if lab cost and frame add up to half your charge or less.

Other benefits result from working with models. If a girl likes her composite or portfolio, she will think of you when she has other photographic needs. If she gets married she may ask you to take the wedding pictures. This additional work can result in your earning far more money than when you first worked with her.

I have avoided mentioning men, older women and children until now because, except in the largest cities, there simply is not very much work available for them. Sadly, many agencies and schools encourage such people to register or take modeling training even though the work is almost nonexistent. You may be asked to handle the photography.

My personal feeling, if you live in a small town, is you should talk with the people and explain the limited opportunity. In the case of children, talk with the parents. Suggest they settle for a single portrait which they can purchase in quantity to pass out on interviews. Tell them honestly that there probably is not very much work available for them in the immediate area. Never let them feel that the work doesn't exist because they are incompetent as models.

Get them to understand that, though they may be the greatest old man, old woman, child or whatever in the country, so long as they can only work in the immediate area it is unlikely there will be enough jobs to warrant the cost of a portfolio. For a couple of dollars they can buy a rubber stamp with their name, home address or agency address and telephone number. They can use it to stamp the back of prints they give away.

Only after leveling with them would I consider doing a portfolio. If they still want it after being told the facts of modeling life, you may as well make the profit.

For men and older models, your approach will be similar. Character should be stressed more than looks. However, they should be photographed to appear as attractive as possible. Character actors who want to stress an unusual or unattractive fea-

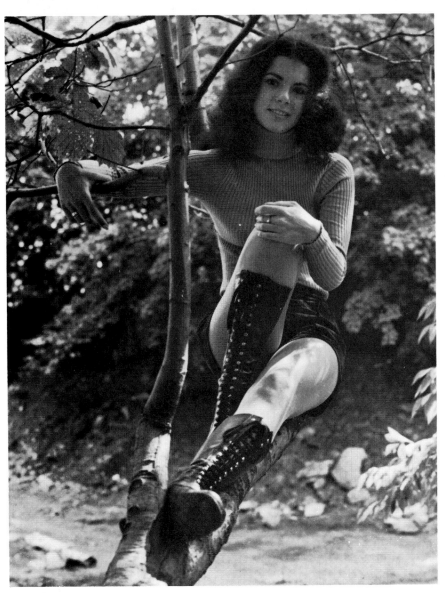

Here are two experiments I feel worked. While Lynn's extended leg in the top shot shows a bit of distortion, it is not objectionable when prints are not larger than 8x10. In the other photo, I wanted to diffuse the image and give it some feeling of depth by shooting through leaves.

ture will let you know that they are not interested in a good-looking photo.

Model photography can be exciting fun and a money maker. The more modeling schools and agencies in or near your community, the greater your profit potential. When you are known and established you may find that you are devoting most of your time to it.

PRICING MODEL PHOTOGRAPHY

There are two services. One is the portfolio, containing approximately ten or more different photographs generally either 8x10 or 11x14 which the model can carry with her to show prospective clients. A standard photo album is usually used, though in large cities there are stores that sell special albums with custom carrying cases specifically for this purpose. If you supply the album, stay with the standard photo album, leaving in only as many pages as you have photographs. A model can have an effective portfolio with as few as six prints, provided the blank extra pages are removed. Most photo albums are designed to hold a minimum of 12 pictures with fillers available to expand them. Leaving the blank pages in the album is amateurish and will tell the client that the girl is just a beginner.

The second need the girl will have is for a composite which has two to four or more photographs of the girl. It is purchased in quantity and passed out to prospective clients.

The simplest approach is to have your lab take from two to four different photographs of the girl, place them together and take a copy negative of the four so they can be printed photographically on one sheet of paper. Then 100 or more copies are made at a per-print cost that is a fraction of the normal charge for an 8x10 or 11x14. However, even with the reduction this can be fairly expensive.

The alternative is to deal with a commercial printer of stationery and similar items. He will provide several hundred composites for as low as $35 to $50 using standard paper with four or more photographs. Generally he will print on one large piece of paper which, when folded in half, has an overall dimension of 8x10. There might be one photograph per side or from two to four photographs per side, depending upon what the girl wants and how many different usable views you have taken.

Almost any printer can handle the making of a composite, though you should get bids from each one. If the printer is not familiar with this kind of work, borrow a sample composite from one of the model agencies to show him. When he sees what you are after, he will be able to quote a price.

Occasionally a printer will not do a good job with the composite you ordered. The photos may be too light or too dark, generally the result of improper inking. If you don't feel it is of high quality, refuse to pay until it has been done over. Anytime you order the composite for the model, she will blame you, not the printer, for any defects.

If the girl expects you to provide the composite or complete portfolio (you buy the album as well as providing the prints), you will now have your minimum expense for these services. The albums are bought from any photography store and from most stationery and art supply stores. They will run from $5 to $20 depending upon the size and number of prints they hold.

My own feeling is that you should let the model buy her own album and order the composite herself. You might guide her to the lower-priced printers and sources for inexpensive albums in your area, but I do not feel you should order these items for her. The reason is that once you have to tack the extra cost onto your bill, she will probably begin reducing her total order. These two items might cost her $50 or more in addition to what you charge for time and prints. Since you are trying to make as large a sale as possible, it would be best if you did not have such high-cost items on your bill.

Since there is no typical model, it is impossible to provide a typical budget. For some girls and their parents, modeling is a lifetime goal that is more important than college, a new house or a fancy car. The family will spare no expense getting the girl's teeth fixed, her hair done, her wardrobe enlarged and whatever training will help her find success. Such a family may not be "made of money," but you can bet they will find the cash to pay you for every quality picture you take of the "little darling."

Then there is the girl who is using modeling as a means to an end. Perhaps she wants to earn a little extra money, or maybe she wants to go into fashion or retailing. Perhaps she has a dream of

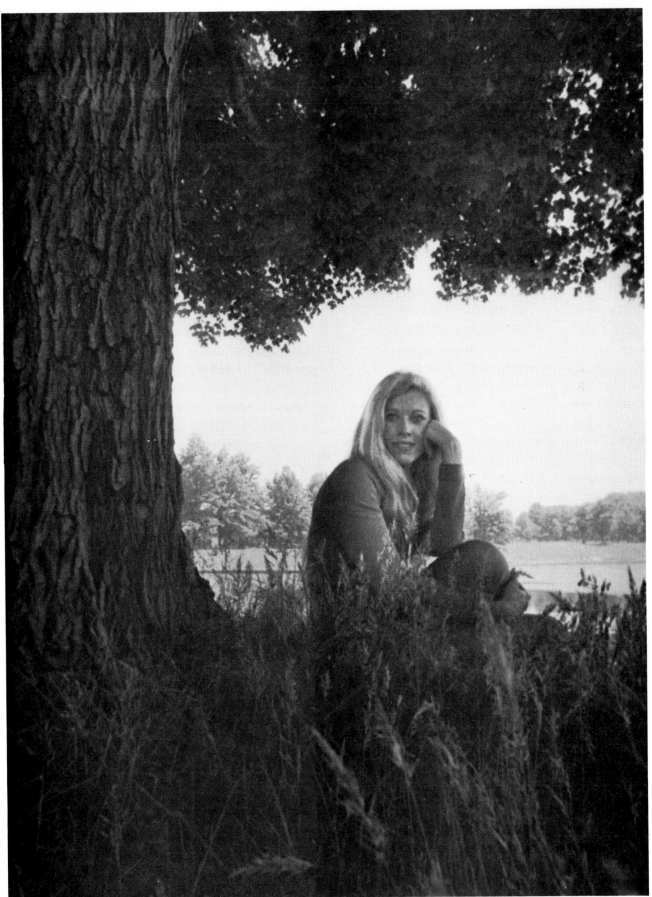

It's not which lens you use but how you use it. One of my favorite "portrait" lenses is the 21mm. Here it is placed in the grass to frame Alison who sits only a few feet away.

using modeling as a stepping stone to the entertainment world. Whatever the case, she usually recognizes that there will be certain expenses along the way and has budgeted accordingly. She will also be willing to buy as many quality photographs as you produce.

Finally there is the type of girl mentioned in the chapter on theater photography. She works part-time or at irregular intervals, earning just enough to cover the necessities of life. She also needs your services, but her funds are almost nonexistent.

It is obvious that one price range will not suffice with every type of model. You must have a variety of approaches.

The first approach is to offer a set of ten or twelve 8x10's for a set price such as $100. You may or may not include an album, but the price does not include the production of a composite. You guarantee no minimum number of pictures from which to choose and take only as many as you feel will be profitable. For example, say you offer 12 prints and an album for a cost to you of $40. One 36-exposure roll of film and processing costs you $5 to $6. Therefore, if you use just the one roll of film, your total cost will be approximately $50. This means you have $50 left over to pay for your time or to cover both time and the cost of an additional two or three rolls of film.

My feeling is that you should earn a minimum of $15 an hour profit for your time and, preferably, at least $25 an hour. I also think you can assume you will take one roll of film per hour.

Under these circumstances you can make a nice profit by using two or three rolls of film in the course of from 2 to 2½ hours of time. This will give the girl the opportunity to change clothing and for you to work either indoors or out and at several locations.

You can use contact sheets when having the girl select the pictures she wants, assuming you give her a choice. Most of your images will completely fill the negative, so a large low-power magnifier will enable her to evaluate the photographs quite easily. These lower power magnifiers give her a view of the entire 35mm frame's surface area rather than just an isolated portion of the contact print. With 120 film you will not be able to give her a magnifier higher than 4X. The greater the magnification, the closer the lens must be held to the picture to put it in focus and the less area you can see on the picture.

A second approach is to charge only for time and expenses. The girl tells you what she can afford and you work accordingly. If you charge $15 an hour and the girl can afford $25 for your services, she can buy approximately one hour's time and one roll of film. The prints are extra, perhaps purchssed at a later time. This approach is ideal for the girl with a limited budget. She can hire you whenever she has a few dollars ahead, working an hour now, another hour next week, perhaps two hours in a row a month from now, etc. This portfolio is assembled slowly, as the girl can afford it.

A third approach is to charge by the print, with a certain minimum number of prints guaranteed. This means that you will be assured from $100 to $150, depending upon your charge. You would then plan your time and film accordingly. $100, depending upon your charge. You would then plan your time and film accordingly.

Keep in mind that no matter how many prints you *think* you can sell, base your time and the film used on the number of prints you *know* you can sell. Then, if you sell more photographs than planned, the difference between the selling price and your costs will be just that much more profit.

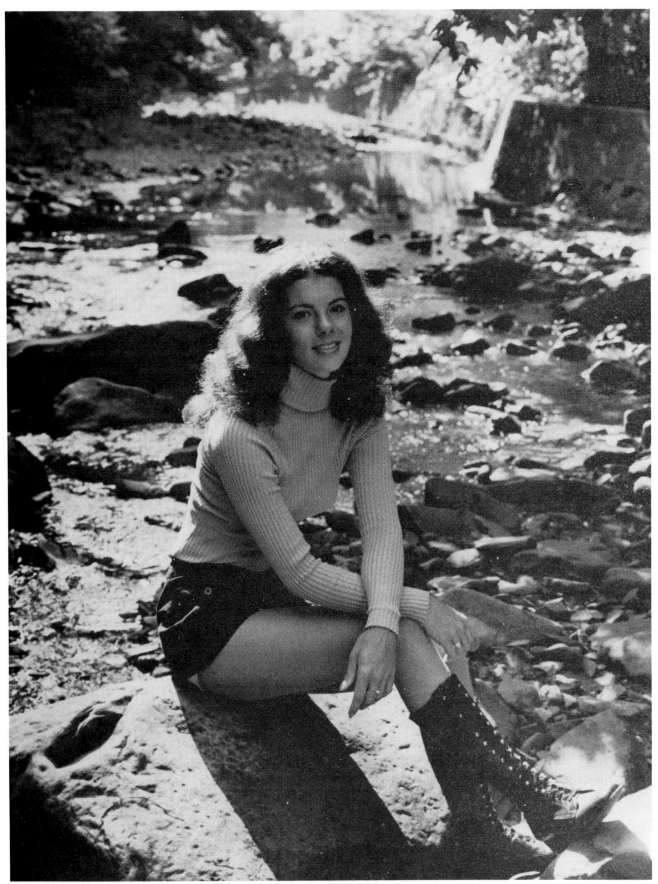

Model photographs must be perfect. Every detail must be checked while working and when examining prints after the session. This lovely photo of Lynn must be retouched because of the slight bit of slip showing on her right leg. Lynn could not have noticed but I should have.

Small Businesses

A good example of a shopping center photo with high sales potential. The puppet show is shown as well as the crowd of people watching it. Such prints get the puppet show new contracts with other malls. They also can be used by the mall management to convince store owners that promotion money being spent is drawing new customers.

Today shopping centers are like miniature communities. You can buy a suit or a dress, do your wash, see a movie, go to a restaurant, hear a concert or arrange for a vacation in Europe. But shopping centers and local business are something else for the alert amateur photographer. They are profit centers where you can earn extra money.

Most shopping malls have one or more large department stores on the grounds, but the majority of businesses are small specialty shops. These are usually too small for the average advertising agency to seek them as clients. Such stores promote themselves, usually through a small newspaper advertisement written either by the manager or with the help of the advertising department of the local newspaper. Occasionally the shop may join in a group ad with other stores in the mall. Businesses not located in shopping centers hustle to compete. All small businesses in your town are potential customers for your photography. You'll need Equipment List A, B or C.

WINDOW DISPLAYS

Take a look at the stores in your area. Examine the window displays, then go inside to see how the merchandise is arranged. If the window display is elaborate and unusually eye-catching, you have a prospect. Window displays take time and imagination. A successful one will lure passers-by into

Audience close up with part of show detail may even be used by a neighborhood newspaper.

the store to make purchases they might have been planning to make somewhere else. The store, and especially the person who created the display, will be interested in having a permanent record of each window design.

A photo can be used to record the displays that prove most successful in bringing customers inside during the course of a year. Or it can be used to show a manufacturer that his products were specially promoted. No matter what the reason, if you can offer a quality 4x5 to 8x10 window photograph at a reasonable price—$5 to $15 in black-and-white and $10 to $25 in color—you can make sales.

ADVERTISING PHOTOS

Many small stores are eligible for advertising refunds from the manufacturers whose products they sell. If they promote a certain line of products such as "Crognagle Cough Drops" they get a certain amount of money from the Crognagle Manufacturing Company. The store advertises both itself and Crognagle—Crognagle pays part of the cost. Although this money is available, many small establishments don't take advantage of it because the owners don't have time to prepare the ad. They don't have an advertising agency and the advertising departments of newspapers, radio and television stations, are more interested in soliciting larger accounts.

You can offer a liaison service for the small businessman. Use your camera to photograph the store and products to be promoted. This might be a photograph of the complete line of Crognagle Cough and Cold Remedies or just a close-up of a box of Crognagle Cough Drops. A set of photographs is then taken to the newspaper or local television station where the advertising department will write copy to turn your still photos into commercial messages. You should furnish the basic information or perhaps a rough write-up approved by the business owner.

Much local TV advertising is not very expensive. Rates are often close to the low rates charged for radio. In addition, with the store using still photographs instead of trying to create a sound-synchronized, filmed commercial, production costs are kept to a minimum. The total fee is well within the budget of most businesses and the TV commercial is likely to be more effective than a radio spot.

With newspapers, an advertiser has the choice of using type only, type with drawings prepared by an artist, or type combined with your photographs. Photographs are ideal for newspaper use and the cost is low.

The store owner then sends copies of his advertising bills to Crognagle and they send him money.

Sometimes you will find there are no cooperative advertising arrangements with manufacturers. A store will advertise anyway just because it's good for business. If you see products displayed in an unusual and imaginative way, get permission to photograph the display. Then write the manufacturer of the products asking if the company would be interested in buying pictures of this unusual marketing approach. Describe the display as best you can in as few words as possible. You can direct the letter either to the company president or the advertising manager.

There are also magazines known as trade journals. These cover every facet of wholesaling and

I made the handsome profit of almost $2 a print photographing these display cases several years ago. Both my rates and my skills have increased since then, but this is typical of the work amateurs can easily supply.

retailing for almost any business imaginable. Many of these magazines pay $5 to $10 and more for a photograph of an unusual business approach related to their field. Sending them a print, after first sending a query, often results in a sale. A checklist at the back of this book shows you how to go about contacting manufacturers and trade journals.

To take photographs of stores and window displays, you should have a tripod and a polarizing filter for your normal lens.

The polarizing filter eliminates glare from glass windows. Rotate it in front of your eye until you find the angle that gives least glare and then install it over the lens at that angle. If you are using an SLR, you can see the effect in the viewfinder.

I have yet to find a window so large I couldn't move back enough to get a good photograph with the normal lens. Shoot early in the day—perhaps on Sunday—so when you move back to get the window properly framed, people aren't constantly passing in front of the camera.

INTERIORS

Indoor displays usually require you to move in close with a wide-angle lens. Most stores have narrow aisles and when you photograph something, you may not be able to move it to a more convenient spot where you will have more room.

Lighting may also be a problem. Many stores, especially clothing stores, try for dramatic lighting effects. Some use spot lights. Others use stroboscopic lighting. Still others have fancy, rotating reflectors. The lighting is eye catching but with too much contrast for good photography.

If the room illumination is average and reasonably uniform, you can shoot on a tripod with available light. If not, flash is quick and easy except for problem cases such as shiny metal objects.

If you have to use flood lighting to cover a large area of the room, keep the lights close to you so you can prevent customers from tripping over them. If possible, photograph in the store after hours or during a period when fewer people are around. Be sure that no merchandise is near the hot lights. I once brushed a handkerchief against a flood for less than a second. In that short time the handkerchief smoldered and burned, a very embarrassing and potentially dangerous situation. Wherever the manufacturer's name appears

A hand-carved circus. Pictures are salable to mall and circus owner. I used a 135mm lens and Tri-X film rated at ASA 1600 for these pictures. No artificial lighting or flash was added and no special close-up devices were used. Anyone can handle this type of work.

on the product or display rack, it should be prominent in your photograph. If the product has texture, such as blankets or towels, side light it to bring out detail.

An incident-light or reflected-light meter is necessary. For the latter type, the neutral-gray card mentioned earlier will be a help. You will usually be working with negative film so you will have some exposure latitude.

RESTAURANTS

Most malls have cafeterias or sit-down restaurants. These vary from convenience stops featuring hamburgers and hot dogs to expensive establishments featuring gourmet foods. Each of these is a potential market for your work.

See the owner or manager and offer to take photographs for advertising and public relations.

If the restaurant is new, the overall facilities will need to be pictured for advertisements and, in the case of a chain operation, for use in the home office. Pick a time when the tables will be set but not occupied.

Some restaurants set-up in the morning, prior to serving breakfast or lunch, whichever is the first meal they offer. Usually the room is not ready until 15 to 30 minutes before they serve. This doesn't give you much time to work. Set up your lights and move as fast as you can, changing your positions and exposures.

The best approach to photographing restaurants is to go in a few minutes before they are set-up, either at night or early in the morning. I walk around the room, checking the different angles where I will place my lights. Then I arrange my equipment, waiting to plug in the lights until the waitresses have left the section I will be recording. My camera is on the tripod and I am ready to go. When the area is clear, I take the photographs, then move to a different section. I always have the head waitress or the manager move the waitresses out of the way while I work.

When the first customers are allowed in, I put away my lights but leave out the camera and tripod. Then I take a few more photographs with customers seated and ordering. I shoot so that I won't get recognizable faces. That way I can sell the pictures and they can be used for advertising without getting signed releases from the customers.

I use only available light and generally use

Light from food display helped to illuminate people with food on trays. Supplemental lighting would have been needed to show decorations on wall at left.

Tri-X or color negative film for this work.

The tips for good building photography mentioned in the church section are applicable to restaurants. Watch the walls and other upright areas such as screens and poles. Be certain they are parallel with the sides of your frame lines.

It is possible to photograph a restaurant with a fixed lens camera. I did a lot of work for Stouffer's Restaurants when all I owned was a 2¼x2¼ single-lens reflex and normal lens. However, I was forced to isolate small areas at a time and it was only a matter of chance that the restaurants had areas I could use. In other restaurants I really needed a wide-angle lens to capture enough of the dining area. For this reason you should own at least one wide-angle lens before you attempt this work.

Lighting a restaurant is fairly easy, even if you only own two or three clamp flood lights. Take advantage of the room lighting, being certain to turn all ceiling lights on before starting. When you have selected the area you will photograph,

Fashion shows held in malls can result in excellent sales of photos.

arrange your lights to fill in any shadows. You will not have to light the entire restaurant at one time. You will be using a tripod and can also work with rather dim lighting. Just use a time exposure and a cable release to ensure steadiness.

Lights can be clamped to the backs of chairs or even to the edge of a table. Screens that partition sections of the dining area can be used as light holders. If you own light stands such as mentioned in the chapter on the home portrait studio, these are even better. But the clamp lights will work, perhaps aided by some Gaffers' tape.

In cafeterias there are two areas to photograph. One is the dining area. Photographs can show the public enjoying the food. The manager may want photographs of the empty tables, too. There may be problems when photographing the public, but let the management worry about whether or not model releases are needed. Usually such pictures are used only to prove to the home office that

"business is booming and all's right with the world." There is seldom any interest in using them for ads.

The second area is the cafeteria line where you will photograph the food and perhaps some of the employees. I like to use a wide-angle for this, with enough depth of field to show the entire line. I sometimes include customers selecting food items. Take these pictures when the cafeteria first opens to be certain that most of the food is still available. If you wait until midway through the serving hours, some of the food sections will need replenishing and it will seem as though there is an inadequate selection.

Cafeteria lines can usually be photographed with available light using Tri-X rated normally. Strong lights are used to illuminate the food and enough of this light spills over onto the employees that additional floods are not needed. If the cafeteria does not have good lighting, use a tripod rather than trying to bring in floods. There will be pro-

If a group brought for store promotion doesn't draw a crowd, who wants them? Always take one picture which includes large numbers of people, even if the entertainers are almost invisible.

blems with glare from the glass food guards and you may have a difficult time finding a place to plug in your cords.

Cafeteria photography cannot be handled with just a normal lens. There are too many areas which require you to have greater depth of field than the normal lens allows. You will need a 35mm lens on a 35mm camera or a 65mm lens on a 2¼x2¼ camera, or wider.

It is doubtful that color prints will be desired, but if they are, use daylight film. If the restaurant or cafeteria has windows letting in outside light, or if they use fluorescent lighting, daylight film will be best. Ideally you should have a color-temperature meter and filters for altering the light. But with mixed lighting perfect color is impossible anyway. For your purpose, using daylight film with fluorescents will usually provide adequate results.

If you must add supplemental lighting, use a mixture of blue bulbs and standard floods dis-

cussed earlier. The photographs will be slightly warm-toned but still very pleasing.

PROMOTIONS

Various promotions are used to lure customers to the large shopping malls. Created by the mall management, these are paid for by the merchants. They may include a petting zoo, clowns, puppet shows or even a carnival attraction. Whatever the show, there is a chance to make some money.

The next time you hear about a promotion at a shopping center talk with the manager about photographing it. Generally the management will want such pictures for immediate publicity and for use when the event returns. There are events such as a petting zoo which appear at the same shopping center once or twice a year.

In some malls the attraction is a dimly lighted area requiring you to use both high-speed film and flash. Never use flood lights inside the mall itself

because there is too great a risk of accident. Even if the flash leaves an unwanted shadow, you will still obtain acceptable pictures.

Other times you can use high-speed film at its rated speed or pushed with special processing. Don't offer color photographs of such events because it is almost impossible to get adequate light.

Your photographs should use several different approaches. One will be the straight recording of the event. You will show the details of a wood carving, a close-up of a singing group, or perhaps portraits of performing puppets.

The second approach will involve the exhibit with one or more people reacting with delight. You might shoot the excited smile of a child petting a baby elephant or a tense child terrified that the wicked witch puppet is going to hurt the hero puppet.

Finally you will want an overview of the event. This will show the entertainment as well as people milling about it. Individuals are not important but you must take photographs which give the appear-

Many malls feature special exhibitions which they like to promote from year to year in brochures or newspaper releases. Some of the larger ones may even feature acrobats or circus performers. A single act, interestingly lighted—something generally not under your control—is most effective.

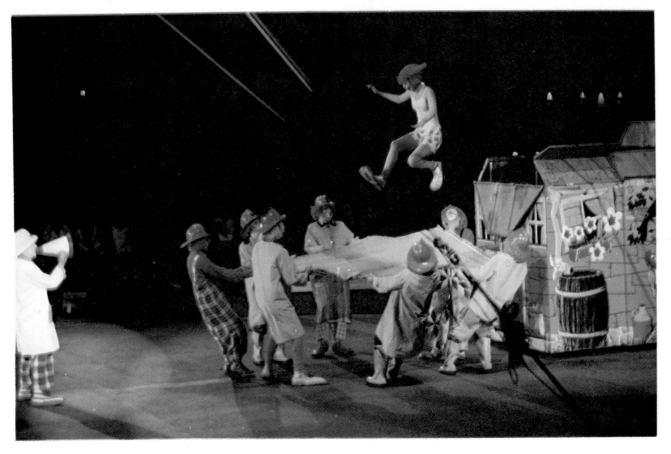

ance of a mob scene.

The reason for the three approaches is so you can offer your prints to more than one buyer. For the mall manager, you have the crowd scenes and the close-ups of the event. However there is also the potential sale to the exhibitors or entertainers. For them you have pictures which show close-ups of individuals reacting to the show, such as the child and baby elephant mentioned earlier. They will also be interested in the mob scenes to prove to other shopping centers that they have drawing power.

I make it a practice to never approach an exhibitor or entertainer until after I am certain the mall wants photographs. Most entertainers will be strangers to your city and wary of any business deals with someone unknown to them. They will cautiously ask to see the work after it has been taken, before deciding whether or not they will buy anything. Because you can not afford to work on speculation, this attitude will mean you take no photographs at all. However, if you are already working for the mall, you will be photographing the attraction anyway. Occasionally the mere fact that the mall has hired you will ensure sales to the group.

DISPLAY YOUR OWN WORK

Shopping malls can be good places to promote your work as well. Many merchants, and even the mall itself, will enthusiastically welcome photographic exhibits, either by one person or several members of the community.

There are two ways to handle such exhibits. The first is to deal with individual businesses you think might have an interest in your work. For example, once you have done wedding photography—another chapter in this book—you may decide you want to seek more business through sources other than your own personal contacts. Take some 8x10 or 11x14 samples of your best wedding photographs to jewelers, stores which sell silverware and other items given to newlyweds, and dress shops offering bridal gowns. Ask to display some of your wedding photographs, rotating them on a regular basis. Include your business card with the print display.

The prints you use should vary from 5x7 to 11x14 or larger, depending upon how effective they are when greatly enlarged. This variety is not only visually interesting, it also allows you to hang the photographs in any space available. Don't use 5x7 if the prints can only be hung considerably above normal eye level because the small size will be ineffective.

Always dry-mount your photographs for display. My preference is to use mounting board the same size as the print, though many photographers use the next larger size board. You can do it yourself or let a custom lab handle it. Information on dry mounting photographs is in Chapter 1.

If you have interesting scenics or nature photographs, banks, restaurants and movie theaters may display some of your work. The management might prefer that they be framed for added protection from fingerprints. You can buy frames or you can have them professionally framed. The latter approach is costly and not necessary.

No matter how you frame your prints, always use non-glare glass. Because this glass does not show glare as much as ordinary glass, its use helps people view the photograph.

Most custom frame shops charge a small fortune for non-glare glass when they supply it at the time of making a frame for your print. Fortunately there is an inexpensive way to obtain this glass. The 3M Company, among others, makes it in a variety of sizes, the most common being 5x7, 8x10 and 11x14—the same sizes you are likely to need. This is probably available locally through your area camera dealers. If you can't get it locally, write Porter's Camera Store, Inc., P.O. Box 628, 2208 College Street, Cedar Falls, Iowa 50613. Price depends upon size, but does not include that extra mark-up you usually find when working with custom framers.

Shopping centers can be money centers for the aggressive advanced amateur. You will need more sophisticated equipment than for some of your early projects, but your profits are likely to be greater and your opportunities wider. Grab your camera and start making the rounds. You'll be glad you did.

Filing, Storage and Stock Photo Sales

Photos of Karen in their envelopes. Code "B" indicates film is 35mm and folder numbers "448 and 449."

You have probably built up a large collection of photographs, possibly stored haphazardly in boxes, on the shelf of a closet or anywhere you happen to have room. Negatives are in holders or suspended in your darkroom. Contact sheets are not marked so you can find the negatives; and slides are still in trays, still in the boxes used to return them from the lab, or on the floor, being chewed by your puppy.

Although such disorganization is normal, the time arrives when you need to be able to find any photograph you have taken . . . right now. If you don't have a good system for locating a negative, you will probably never bother sorting through hundreds of pictures to find a print with resale potential. You will satisfy yourself with the few prints you sold when you first tried a project rather than following up at a later time when your client might make additional purchases.

If a picture is good enough to sell once, it can possibly be sold again and again. An advanced amateur who takes photographs for pleasure when not working on a money-making project is likely to have lots of potentially salable photographs. These may be scenics or general-interest prints. They are of no dollar value unless shown to potential buyers.

SET UP YOUR FILE SYSTEM

Numerous systems have been designed for storing negatives. You can buy special files such as the Nega-File line. These are well designed and

constructed to last a lifetime.

There are systems to hold your negatives in transparent holders with up to 36 exposures of 35mm film and up to 12 exposures of 120 film. The holders are placed in your contact printer and a contact sheet is made. The holders are pre-punched to fit a notebook. The contact sheet can be punched to go in the same notebook or stored and indexed separately. The contact sheet is assigned a number and the negative holder marked with the same number. When you thumb through your contacts, you can find the negatives by matching the numbers.

Most systems are good. They get your negatives out of the kitchen. Shocking as it may seem, there are some people—not photographers—who live with the delusion that the kitchen is for food.

I will explain my own filing approach. It is neither better nor worse than the others. It works for me.

No system, no matter how seemingly efficient, is any good if you must search through all your contact sheets to find a particular photograph! Searching through contacts is fine when you have not taken many rolls of film. But once you begin putting roll after roll through your camera, year in and year out, the number of proof sheets becomes overwhelming.

Prepare a card file system for your contact sheets to help you locate any photograph immediately. The cards are filed by topic, such as *Models*, by the name of the particular model and perhaps the location.

At first a card file might seem like a lot of work. If you already have many proof sheets it will take some time to organize your file initially. Once you have a system you like, it takes only a minute or two to add cards or make notations to bring the file up to date each time you get a new contact sheet. This small expenditure of time will save you hours of effort searching for an old negative.

I assign a letter and a number to each contact sheet. The letter refers to the size film and whether the negatives are black-and-white or color. For example, all 2¼x2¼ black-and-white negatives are filed beginning with the letter A. The first sheet is marked "A-1," the second sheet is marked "A-2," and so on.

My 35mm black-and-white negatives begin

with the letter B. I have "B-1," "B-2," etc. Color negatives have C and D notations; 4x5 negatives have E and F notations, and the few 8x10 negatives I own have G notations. By knowing the size of each negative when I look at my file card number, I have an idea of how much enlarging any particular photograph can take. If I need to make a 30x40 print of a church, for example, and all my church negatives listed on the file card begin with the letter B, I know immediately that I may not have anything on file that can be enlarged that much.

Negatives should always be stored in individual holders or in one-piece holders with individual sleeves for each negative. If the negatives are filed together so that they can touch one another, there is great risk of scratching. Even the best custom labs often return negatives that have been cut into strips of six and placed in a single holder. Buy a set of negative holders for each roll. There are many different types and every camera store has one or more varieties. A partial list of manufacturers and suppliers is in the Appendix at the back of the book.

When you assign a number to a contact sheet, write that number on the back of the contact sheet, as well as on the holders for the negatives. In addition, mark the date the pictures were taken on each contact sheet. All negative holders can be marked with ball-point pen or a grease pencil. Before marking, *remove the negative* from the holder because the pressure of the writing instrument may damage the negative. After the number is written, return the negative to the holder.

How you store your sleeved negatives and contact sheets is a matter of personal taste. I use manila envelopes designed for 8x10 negatives. I insert both the contact sheet and the several strips of negatives into the envelope, marking the outside of the envelope with the contact sheet number as well as a brief description of the photographs. These envelopes are stored in numerical order in a standard file-cabinet drawer. The average two-drawer file cabinet holds about 1200 contact sheets without crowding.

Each time I file a contact sheet, I mark 3x5 cards as mentioned before. To conserve space, I don't bother marking the negative frame number—such as neg #14 on roll A-7—as it is easy to spot

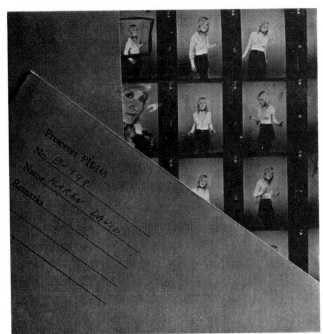

Karen again. This time it shows the other side of the holder with the description. Remarks might include whether or not there is a model release, the film speed or other information which I might feel belongs there. The file cards contain no description, just the subject and identification numbers.

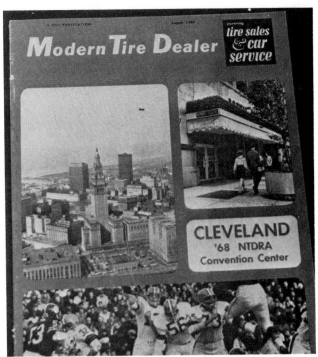

Upper right photo on magazine cover was taken a year or two before the magazine requested photos of Cleveland for a special convention issue. Thanks to my files I made an immediate sale and received other assignments.

the right frame when I look at the sheet.

Some photographers print their contact sheets on paper that is slightly larger than 8x10 and punch holes in the extra space so the sheets can be inserted into a ring notebook, The number of the sheet is marked on front or back. Use one-piece negative holders with individual pockets for each strip of negatives, also punched to fit the notebook. The contacts are followed by the negatives, all in numerical order. On the outside of each notebook, along the spine, mark the numbers of the sheets inside. For example, one notebook might include B-1 through B-50 the next B-51 through B-100, and so on. Find the number of the pictures in your card file, locate the contact sheet and negs in the notebook.

Transparencies present a different problem. Some photographers number each slide in consecutive order, beginning with "1" and going on into the thousands. They also set-up a card file similar to the one for negatives. They crossout numbers each time a slide is sold unless they sell duplicate slides and keep the original.

My method is to store transparencies in clear plastic holders which can take up to 20 slides each.

I group all the slides together by subject. For example, I have a complete notebook of slide holders containing only transparencies of an actress named Claudia. Another holds general street scenes from Akron, Ohio. In cases where I don't have enough holders to fill a notebook, I partition it into sections and include several subjects in the same notebook.

Holders of this type are expensive, around 35 cents each in small quantities, but they are so handy the expense seems minor by comparison.

An alternative is one of the many box or tray systems for storage, each of which *prevents* easy access to your work. You must either set-up a projector each time or dump them out, risking fingermarks and the chance that your dog will select your favorite slide for dessert.

Another advantage of pre-punched plastic holders is that you can hold one up to the light and examine 20 slides at one time. This speeds selection greatly. It is easy to remove a slide for enlarged viewing in an illuminated magnifier.

The holders also offer protection when mailing slides. Stiff plastic protects the work from fingers or spilled coffee. Remember that slides are

irreplaceable unless you have had a duplicate or internegative made.

Many types of plastic slide holders are available and some suppliers are listed here. I have learned the hard way that the more you spend for each holder, the better it is. I recently saw an ad for 25 holders for just $2.89—slightly more than 11 cents each. I have been taking quite a few transparencies lately so I ordered enough to hold 2,000 slides. Previously the cheapest I had found was around 20 cents each in quantities of 100 or more.

Price did make a difference. The material is thin, overly flexible and easily torn. My "bargain" turned out to be a waste of money because they will not last.

If you only need a few slide holders, you may not be able to order them by mail. Some photography dealers don't bother with such items, but another source is your neighborhood coin shop. Dealers in rare coins often sell them for coin holders.

VIEWERS

In addition to your file system you will need two magnifying lenses for studying negatives or contact sheets. One should be a large one of the type normally sold to aid people when reading. It will generally double or triple the size of the object under study. It's ideal for showing clients how photos will look when enlarged.

For your own use, you must have a high-powered magnifier which can show details, including the most important one—whether or not your picture is sharply focused. Eight-power units (8X) are readily available from camera stores and opticians. These just about cover a 35mm negative and provide adequate magnification. My personal preference is for the 10x and 20x magnifiers which are a little harder to find. A couple of sources are listed at the end of the book. In your own area, try optical supply stores, Army surplus stores, and camera stores.

You will also need viewers for enlarging transparencies. I have two units—an illuminated magnifier and a pocket viewer that is held up to the sky or some other light source. My illuminated unit provides a 12x magnification. The other unit is not as good but has saved the day when the batteries went dead in the illuminated magnifier.

There is a rule about illuminated viewers. When batteries go dead, you will probably not have spares on hand. If you have batteries, the bulb will fail. If you had the foresight to buy extra batteries and an extra bulb, the switch fails. I have found the average life of an illuminated viewer is about nine months.

SELLING FROM YOUR FILES

Once you have developed a system to find any photograph quickly and easily, you have created what is known as a stock file. It is also a gold mine.

As I mentioned earlier, any picture good enough to sell once may sell again and again. Sometimes the original client buys additional prints. Other times it is a totally unrelated source. I once photographed the birthday party of an elderly man—a giant family gathering of happy and healthy folks. In addition to candids of the people enjoying themselves, I concentrated on taking casual portraits of the man who was being honored. I was paid for my time and for a set of prints.

When I filed those birthday photographs, I figured my sales were over. There was nothing special about them that might appeal to a magazine or anyone else. I made out file cards thinking it was a waste of time, then forgot about the incident.

Several months later I received a call from the man who had hired me. His father, the guest of honor at the birthday party, had died. The photographs I had taken were the last showing him in good health and high spirits. The family wanted to buy prints of him alone and with his children and grandchildren. My second sale more than doubled the original profit on that job. A quick check of the cards I had so reluctantly filed enabled me to find the contact sheets and negatives in less than a minute.

Chance sales such as the one just described will happen, but they will be few. The best way to change your files from dust catchers to a gold mine is by aggressive selling.

Start by examining pictures you have taken. Do you have scenics of your community? If so, there are several possible sales. If your area newspaper has a locally edited magazine in weekend editions, this is a potential sale for quality black-and-white photographs. In the middle of winter

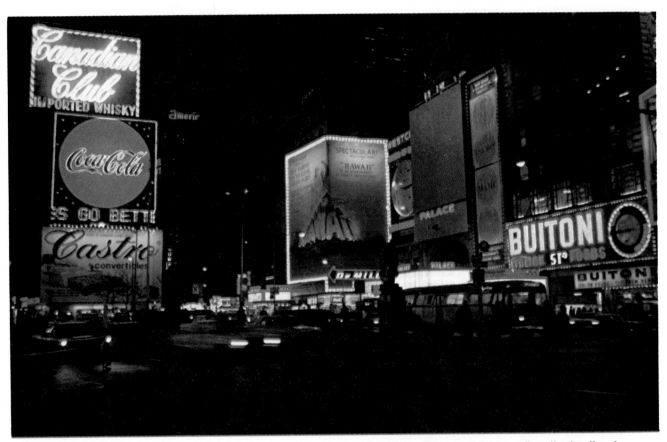

These photos of New York City at night and a new shopping area in downtown Tucson, Arizona, reflect "today," and are in my files. They offer good sales potential in the future, when those locations change, and architects, newspapers, magazines or historical societies may need these examples of the "before."

you might find the editor receptive to summer scenes to remind readers of how nice life will be in just a few months. In summer, on one of the hotter days of the year, the editor may want to "cool" the newspaper with some of your winter scenes. He will often buy "in season" as well.

Weekly newspapers are another market. They usually offer less money, but the exposure and by-line are well worth while.

Is your area a tourist attraction? Check *Writer's Market* for travel magazines including those put out by the airlines. They will publish your work if it is appealing and different. Also talk with some of the reporters on an area news-paper to see if you can team up for a words-and-pictures piece to bring you more money than the photographs alone.

Many state governments publish magazines or advertising brochures dealing with points of interest in the state. If you don't know who might buy your work, try contacting the Governor's office by letter. Ask to be referred to the people who buy photos of scenic attractions.

An increasing number of cities have promo-tional publications by the Chamber of Commerce or independent publishers. No matter what publi-cations are in your area, talk to the editor. Even if there is no interest in what you have on file, samples of your photographs may impress the edi-tor with your ability. When this happens you can get an assignment to photograph for a forthcoming article.

If you have color transparencies or negatives, consider the calendar and postcard market. Big calendar companies generally require transparencies made with large-format equipment, usually at least 4x5. 35mm or 2¼x2¼ work will not usually inter-est them. It is worth your time to query them about what you have in file regardless of size.

The main markets you seek are local, such as banks and larger businesses which have calendars printed with one or more photographs of local interest. Such purchases will usually be made by the firm's advertising manager. When in doubt, ask to speak to the president or vice-president's secretary. I have found that she will know who handles what. Otherwise you may get switched from department to department, wasting hours of time and bothering half the company.

Tucson's new government buildings. Once again, a file photo with a future.

All transparencies must be sharp, fine-grained, well-saturated color. There can be no cropping necessary on 35mm work and only minimal crop-ping of 2¼x2¼. Square or horizontal slides are preferable. High-speed color films should not be used for calendar work unless you want grainy special effects. They do not enlarge satisfactorily.

If the calendars are printed locally rather than by one of the big national companies, the printer may say it's "impossible" to reproduce quality color from even the finest 35mm slide. Special skills are necessary for this work and some smaller printing houses have never mastered the technique. However, magazines such as *Life* and *National Geographic* have proved that 35mm color prints beautifully.

Unfortunately, your client will probably change photographers before he changes printers. The client was pleased with your work or he would not have taken your slides to the printer. You can appease them both by having a 4x5 transparency made from your original. Have a custom lab make an internegative of your transparency, then make a 4x5 transparency from the internegative. I have had the humorous experience of a printer telling

me that only the 4x5 transparency I provided him could be printed properly. "Aren't you glad you used the larger camera? See how much sharper everything is than with the 35mm?" I never bothered to mention that it was the same Kodachrome slide enlarged through the internegative procedure.

Postcards are also a source of income, but this can be a strange market. Sometimes photography studios will specialize in producing and distributing postcards. These firms take scenic pictures and have them made into postcards. They furnish display racks and postcards to area merchants.

Other times printing companies arrange for photographs to be taken, then make the transparencies into postcards which they distribute. These companies pay the photographers who bring them photographs. Usually this pay is low, but the company buys only the right to make postcards from the photo.

Other times a company will hire a photographer by the hour or day, paying him a high rate to take pictures and buying all rights. As a freelancer with pictures on file, you should offer postcard rights only. Do not sell all rights to your work as you may get the chance to sell the same photographs to magazines or newspapers at a later time. If you give up rights to the pictures, the company to which you assign these rights will be the only one to benefit from future sales. Sell ONE-TIME REPRODUCTION RIGHTS or POSTCARD RIGHTS *only!*

Postcard companies can be located by checking the Yellow Pages. If there are no listings, find a drug store or dime store with a rack of such cards. On the back will be credit lines, usually the name of the distributor and the city where he is located. By checking with the information operator for that city, you can get the distributor's telephone number. Many libraries and telephone-company offices have phone books for other cities so you can look up phone numbers and addresses. You can call or write to see if there is interest in buying photos.

When the distributor is a photography studio, there may be no interest in freelance submissions. It is doubtful that any but the most unusual photographs could be sold to them. It's still worth asking!

The postcard business is usually quite small

These images are excellent for use in trade journals. The Indian jewelry was shot for a financial publication, and the architecture went into a magazine for architects. Most communities have buildings which are unusual enough that an architect or regional city magazine will purchase images documenting them for use in their publications.

in any one community, despite the fact that millions of cards are sold each year. There is very little competition, with one company generally supplying the majority of the outlets. However, if you have been turned down by a distributor in your area, take heart. From time to time competitors do try to expand into areas already serviced by

another company. If you check the racks regularly, you may find the name of a new distributor on the back of a card. A call to this company may result in sales.

You can sell postcards yourself! Many firms want custom cards for their own advertising. Restaurants often want color postcards showing their facilities or views people can see as they dine. This is especially true for restaurants located at the top of buildings or overlooking a lake or scenic area.

Go to unusual restaurants, hotels and similar businesses and offer custom postcards. If you have pictures on file that might fit their needs, you have perfect samples. If you have nothing directly related to their needs, find some as close as possible and show them a few prints.

If you are hired, you will charge several fees. There will be a fee for each photograph used to make postcards. This will usually fall into a range of $15 to $25. If pictures are taken to order, charge an hourly rate for the time necessary to do the work. Assuming you are taking scenic views only, this will be a straight time charge plus all expenses. When I do this, I charge one rate, such as $25 an hour plus $10 a roll if I retain secondary rights. If the client wants full rights, charge more—at least 2-1/2 times your normal hourly rate. This is in addition to a charge for each slide used as a postcard.

The third fee is a slight mark-up on the cost

Social Security Representative Lester Lewis travels the scenic Southwestern United States and Mexico during his vacations. He sells the 35mm color slides to calendar and post card companies for supplemental income. This b&w print is from a color slide.

POSTCARD COMPANIES

These companies produce postcards from photographs. They do not distribute photo postcards.

DEXTER PRESS, Route 303, West Nyack, New York 10994. Both color prints and color negatives can be sent, though transparencies are always preferred.

KOPPEL COLOR, 153 Central Avenue, Hawthorne, New Jersey 07507.

MCGREW COLOR GRAPHICS, Box 19716, Kansas City, Missouri 64141.

MWM COLOR PRESS, 107 Washington Street, Aurora, Missouri 65605.

of having the postcards made. Whether you use a local firm or one of the firms in the checklist at the back, add a few dollars mark-up to cover the time necessary to make all arrangements. This is an arbitrary figure based on the time it takes rather than a percentage of the charge for the postcards. Postcards must be ordered 1,000 to 5,000 cards at a time and this makes the bill relatively high. Charging a percentage mark-up in addition to the other charges you are making could price you out of competition. I prefer to set a figure adequate to give me a healthy profit for my time without sending the client into shock.

Always collect an advance fee equal to at least your printing costs before ordering postcards

for a client. This fee is collected after you show the photos you have taken for the client.

When you make postcards to order for a client don't agree to handle distribution. Normally the firm wants them for customers visiting the business. In a few cases, a restaurant or hotel manager thinks his cards should be available on the racks in area stores. That's his problem, *not yours!*

You are not in the postcard-distribution business. Often the racks are supplied by a distributor and cannot be used for the cards of any competitors. Other times you will wait hours trying to see someone. There is endless running around and elaborate bookkeeping, none of which will prove profitable if you can handle it at all. Your job is to supply pictures and arrange for the postcards to be made. Anything else is asking for trouble and must be avoided, even if it means losing a job.

If you run a part-time portrait or wedding business, your files will prove valuable for making sales. Photographic-supply houses sell blank postcards sensitized on one side so you can print on them. If you have your own darkroom, check your files for individuals whose portraits you took around ten months earlier. Print a small version of the previous portrait on the postcard. Then print or type a note. If your handwriting is like mine, it is only slightly easier to decipher than Egyptian hieroglyphics. Offer an appointment for an updated photograph. If there is no response after two weeks, follow up with a telephone call. Remember, the way to be successful is to develop repeat business.

A similar approach is used for people whose weddings you have photographed. A card sent to the bridal couple, usually with a photo of bride and groom together, suggests that the couple might like a first-anniversary portrait. This portrait will be used the following year on the card suggesting a second-anniversary portrait. Or perhaps a family portrait with the new baby. A card sent to the families of the couple can offer a framed enlargement from the wedding pictures as a nice anniversary gift. Or if the couple had a black-and-white album made from color-negative material to reduce expenses, the card might suggest that the family buy a color album for the anniversary gift. Again, telephone follow-up may be necessary.

If you don't have your own darkroom, talk with your lab about making prints on postcard stock. If they have none, you can order a small box which they can keep for your needs. This is cheaper than asking them to order it. Don't order the paper for the lab until you have checked with them. Then get an executive's name at the lab and have the order addressed to him. You don't want it used for other customers' work.

School photographs have tremendous resale value for reunions and homecomings. Contact the person in charge to see if the school will buy prints for display. These would be prints of the previous years' events, classes or whatever else you photographed.

Class reunions are celebrated five to ten or more years after graduation. Ten years may seem a long time to wait to sell additional photographs, but stored negatives last more years than you will. So long as your card file is maintained, it is no more trouble to locate a ten-year-old negative than one taken last week.

Watch your local newspaper or check schools for the dates. Reunions are usually held in fall near the start of the school year, or in spring near the end of it. Offer 8x10 and larger prints for display and your services as a photographer to record the event.

Church anniversaries are another source of income from pictures on file as discussed earlier.

Photographs of pretty girls have resale value.

At this point I had best define terms. When some photographers talk of glamour work, they are speaking of nudes. Although nudes are part of the glamour category, the term covers the gamut of pretty-girl photography. The glamour photographs you are most likely to have in your file will be what used to be known as "cheese cake." These are pretty girls, in bathing suits or abbreviated costume whom you have photographed for model

Community redevelopment programs need before and after photos. Get your money when you deliver the final work, though. Such programs have a tendency to be always low on cash and bills don't always get paid.

portfolios which you can sell if you have a written release.

Such pictures are occasionally desired for calendar art. They are more in demand by direct mail and other advertising agencies which operate on low budgets. These firms like to use a photograph of a pretty girl in brochures even if the girl and the product are in no way related.

Low-budget advertising agencies can't afford to hire a photographer and model for a low-cost mailing piece. The hourly rate for the model might be from $10 to $60 or more. Most photographers ask $35 to $100 and up for a single photograph, depending upon whether it is black-and-white or color and what was involved in shooting it.

Such agencies can afford to buy stock photographs, though, at a cost of around $35 minimum.

The problem is contacting these agencies to sell your file photographs. Check the Yellow Pages for advertising and public relations firms. You can contact them and show samples of your work, especially the photographs in the glamor line. With a little luck and much perseverance, you will probably make a few sales. However, there are thousands of such firms around the country and it would be nice if you could deal with all of them.

WORKING THROUGH A STOCK AGENCY

One way is to use a stock agency. A stock agency sells the photographs of advanced amateurs and professionals around the country. You send them your pictures and they select the ones they want for their files. Then they file them according to subject, just as you have done at home, and show them to agencies which request them. They have full-time salespeople and their clients are often worldwide.

Stock agencies generally pay you 50% of what they receive for black-and-white photographs and 60% of what they receive for color photographs. Their minimum charge to a client is around $35 and their top fee can run into several thousand dollars for a photograph used in a national advertising campaign. These agencies are located in major cities such as New York and Chicago. A listing is in the book *Where and How To Sell Your Photographs* by Arvel Ahlers and Paul Webb. This is updated periodically and is the best single source I know for such information.

Before you send your work to a stock agency,

The Paterson Negative Filing System, one of several systems using a notebook. These are ideal for very small filing needs and for very large ones. My approach tends to become somewhat bulky for file drawers when you approach 1,000 rolls of film. That seems like a lot until you remember you are filing for a lifetime.

you should know there are drawbacks. Most of the larger agencies have millions of photographs in stock. To make matters worse for you, the categories in which you are most likely to have pictures, such as models and children at play, are the same categories in which they may already have several thousand prints and slides. If they do take your work, your pictures will be buried to the point that the chance of selling one may be small.

In the past there have been few, if any, *legitimate* stock agencies which charge a fee to examine your work or put it in their files. Legitimate stock agencies derive their income from the sale of photographs. However, at least one new stock agency utilizes a computer for filing information about pre-screened portfolios remaining in their possession of the photographers. This resource, too new at this writing to be proven one way or another, seems legitimate, and a fee is needed to pay for the computer time. However, every firm should be checked with the Better Business Bureau and information about some of their repeat clients should be obtained before making a commitment. The chance that the majority of agencies charging fees are legitimate remains slim.

Write to a stock agency before sending any photographs. Briefly describe the type of photographs you have and ask if they are interested. At

the same time, ask about areas in which they may have requests for subjects which they can't fill or can fill only from a small selection of prints. If you send them quality photographs of the desired type, you will probably make immediate sales.

This raises another question. Is it worth the expense of taking photographs purely on speculation? A professional will tell you it is not. However, in the case of a stock agency, if you think you can do a quality job using only one roll of film or less, it might be worth a try. It will certainly help you evaluate the agency when you see what they do with this work. The expense is small compared to the cost of sending numerous prints from filed negatives.

Stock agencies are not likely to make a sale for at least six months and pay is often sent to you only twice a year instead of after each sale. It could be a year or more before you receive any money, assuming your work does sell. Some only communicate when a sale has been made or to acknowledge receipt of your work. This is frustrating and the subject of complaints by many photographers using agencies to sell their work.

You should also bear in mind that once your work is filed, the agency cannot give you regular reports on the number of times it has been submitted to clients. It costs them money to run through the files. Your work will be filed by subject, not your name. You should have your name and address on everything you submit, though the agency will code it so that they only need to check a number to find whose work it is when something is purchased. Most agencies, and I mean legitimate ones, will charge you a fee to go searching for your prints to give you a progress report.

Work filed with most agencies is never returned. It is kept forever or until sales are made. If a photograph has a broad enough appeal to be placed in the files in the first place, its sales value might last for generations. If you ever demand your work back, the agency will need a complete description of what you sent and will also charge a fee for digging it out of their files.

Does all this scare you? It should, a little. By studying the market lists included in this book and by contacting prospects in your area, you will probably sell more prints from your files than an

FILING SYSTEMS

Sometimes I think filing systems are almost as plentiful as photographers. Every time I think I have seen everything, a new company develops a slightly different way to store slides, prints or negatives. As a result, consider the following list incomplete. Check to see what systems your local dealer carries before writing to the companies listed. If you find one that seems to fit your needs and your budget, by all means use it because you can buy add-ons from local stock. The heavy-duty plastic types can take more abuse than the cheaper, ultra-thin plastic.

Some companies offer products for filing both negatives and transparencies and, with some of the products, you can even make contact sheets while the negatives are still in the holders. If you can't find what you need locally, try:

PLASTIC SEALING CORP., 1507 North Gardner Street, Hollywood, California 90046. Heavy-duty file sheets for all popular sizes.

PORTER'S CAMERA STORE, INC., Box 628, Cedar Falls, Iowa 50613. This is not a manufacturer but a store which happens to carry a wide variety of file systems. They will send you brochures and literature describing the various products.

20TH CENTURY PLASTICS, INC., 3628 Crenshaw Blvd., Los Angeles, California 90016. Plastic holders for slides and prints in all sizes to 8x10.

NEGA-FILE INC., Edison-Furlong Road, Box 78, Furlong, Pennsylvania 18925. Sleeves for negatives and prints, and specially-designed file units for nearly everything.

PATERSON NEGATIVE FILES/Braun North America, 55 Cambridge Parkway, Cambridge, Massachusetts 02142. A system allowing negatives and contact sheets to be stored in the same binder.

FRANKLIN DISTRIBUTORS, Box 320, Denville, New Jersey 07834. Multi-use slide sheets containing no polyvinylchloride materials; offers long-term protection.

agency can. However, agencies do have wider contacts than you could possibly obtain. A truly unique photograph is bound to sell more often and for more money when handled by a stock agency than when you market it yourself.

One final word of advice. If you have a transparency that is precious to you, have an internegative made before sending the original to a stock agency. In that way you can still have prints or additional transparencies made. The same is true for any slide which you sell to a client who will not return it. This assumes you only sold ONE-TIME RIGHTS.

MAILING YOUR WORK

When you mail slides or prints, be very careful how you package them. Even custom labs occasionally package prints so poorly that the edges of the prints are damaged in the mail.

My personal preference is photo mailers—envelopes with two pieces of corrugated cardboard inside. These are sold by many companies and are available through most photo stores, a few chain drugstores and discount houses. They are also available by mail from some of the suppliers listed at the end of the book.

I always select a photo mailer larger than the prints I will be mailing. For example, I send 8x10 prints in mailers designed to hold 11x14 photographs. Most mailers are slightly larger than the prints they are meant to hold, but I find that this additional space is seldom adequate to keep the prints from moving about and getting damaged. With oversized mailers, I can put the prints in an envelope between the two sheets of cardboard, centering them so there is room all around. Tape the envelope to one piece of the cardboard. Then use masking tape to seal the two pieces of cardboard together, making a photograph "sandwich." The prints won't shift very much in the mailer and should arrive safely at their destination.

I put slides in one of the heavy-duty plastic holders designed to hold 20 slides, and use a photo mailer. I use the plastic holders whether I am sending one slide or a hundred. Sending slides in boxes such as used to return them from the processing lab is an invitation to disaster. Nine times out of ten they travel safely, but on that tenth trip every person in the Post Office takes a few moments from his busy schedule to tromp on the box,

throw it against the wall and then drive over it with a truck. Photo mailers with plastic slide carriers rarely bring out this hostility.

To ensure return of your prints or slides, enclose a self-addressed, *stamped* envelope of adequate size to hold the cardboard and photographs. I use the same size envelope as the one selected for mailing the prints, first removing the additional two pieces of cardboard, then folding the second envelope and adding it to the "sandwich."

The return envelope must have your name and address printed on it as well as sufficient postage. I always use an inexpensive return, such as 3rd class, but send the work either First Class or Air Mail.

The reason for mailing First Class or Air Mail is as much psychological as for speed. Although many editors will not care how work is sent, others may think that if it is not sent First Class you do not really respect it. It may not happen often, but why risk such an attitude?

PHOTO MAILERS can be easily made at low cost by purchasing heavy manila envelopes in the sizes you need. Cut your own corrugated cardboard from boxes you can pick up in any store. Some professional studios buy corrugated cut to size. It's always slightly larger than the photos to be protected—such as 8½x11 for 8x10 or even smaller prints. The pros' trick is to use *four* pieces of corrugated. Two pieces have corrugations running at right angles to those on the other pieces. This makes a tough-to-bend sandwich which is almost bend-proof. The extra postage required is a small price to pay for the assurance of getting your pictures to their destination intact.

Be sure to buy your envelopes *after* you've measured the size required to house the photos and the four thicknesses of corrugated.

Buy a rubber stamp: **PHOTOGRAPHS, Please do not bend.** Stamp both front and back of the envelope.

An advertising and public relations firm used my file pictures of a university area for part of the illustrations on this brochure. I eventually received more than $1,500 worth of requests for file prints or photographic services from this one agency alone.

This is a photograph of a new building in downtown Los Angeles. By not including people who might be wearing stylized clothing, I have a timeless image which can be used until the face of the skyline changes.

When taking photos of girls for file, watch what you take. The full length view of Alison becomes dated when skirt lengths change. A tighter shot of her upper body might be salable for generations.

Health spas may be interested in hiring you for before and after photographs of clients.

When mailing to another country, including Canada and Mexico, return postage cannot be included. United States stamps will not be accepted for returning your prints to this country. However if you fail to include postage, most editors will not return your work. The cost is more than they can or will afford.

Buy International Reply Coupons from the Post Office. They can be exchanged for postage anywhere in the world. Unless you know the rate in the other country, it is a good practice to include International Reply Coupons to equal the postage you put on the package when it left the United States.

Many people are hesitant to trust the mails with film, negatives or prints. For years I have relied on custom labs outside my city for processing my film and making prints. I sell to magazines around the world. So far I have lost a total of one roll of film in the mail. That roll was sent in a regular envelope of the type designed to hold a letter. Had I used a heavy-duty envelope as the Post Office suggests I might not have lost even that one roll. Custom labs will furnish suitable heavy envelopes on request.

I have found that First Class is excellent. I recently had a rush order which I sent from

This is an excellent picture of Marla Mariam and her dog, BonBon. Marla is a successful businesswoman whose blindness makes her an unusual story. Photo stories such as this one can be sold for several years from the pictures on file.

Arizona to California by First Class, Special Delivery. The package was returned the same way. Total time, including lab printing time, was less than I could get from local labs. The negatives were mailed and prints returned in slightly over four days. For an extra charge I could have gotten them sooner. Local labs wanted five full days to do the same work.

DETERMINING A PHOTO'S STOCK AGENCY POTENTIAL

1. Does the photograph have a wide appeal? A pretty girl in a bathing suit will sell for years to a wide variety of clients. A picture of your mother-in-law getting a sun burn on the beach will not.

2. If you have spot news photos, will they be of interest nationally? What about a few days after the incident? A photo of a car wreck might sell to your daily paper but it would be just one of many in a stock agency's files. However, if that wreck involved a well-known person the picture would have world-wide sales value.

3. Do you have model releases for people pictures? You must furnish this information with the photograph, though *never send the release.* If a release is requested, send a photocopy. You will need the original for your files. Glamour photographs usually have no sales value without a release. Other photographs might. When in doubt, send them and let the agency decide.

4. Do you have a different approach to a routine subject? Good photographs of children are a dime a dozen. But a really unusual photo of childhood, such as the famous photograph W. Eugene Smith took of his two small children walking in the woods in 1946, is a frequently reproduced classic.

5. When selling color, is the original transparency of adequate size? A scenic for a calendar must be 4x5 or larger to gain wide acceptance. On the other hand, a 35mm slide of a pretty girl might sell many times.

Coin and Stamp Photography

Other people's hobbies can be a source of income for you. Stamp and coin collecting, for example, provide a market which you may not know about.

One of the major problems every collector faces is insurance. Over the years the value of accumulated coins can reach a sizeable sum. If stolen, damaged in a fire or otherwise lost, insurance can pay for the loss. But insurance companies require *proof* that the collector had what he claims he had. This is where you come in.

You can use almost any camera to photograph coins, stamps and similar collectables but an SLR has significant advantages. See Equipment List E. The photographs are sold to the collector who will keep them in a safe place. Should loss occur, they will be used when he submits a claim.

Basically you can offer two services. One is individual or group photographs of a collector's holdings. You sell the negatives because no prints will be made unless something happens to the collection. Perhaps contact sheets will be ordered, but that is the extent of the printing. Your profit is made by charging for your time, materials and lab charges.

The second service is taking slides or prints of specific items, usually high-value ones, to aid the collector when he wants to sell them. Collectors who buy and sell rare pieces take a risk everytime they put valuable items in the mail. If a photograph is sent first, the potential buyer will have a good enough view of the items to make a commitment.

Then there is the owner of a rare coin, stamp, or other object who wants to talk about the piece at meetings with other collectors. While the item itself is usually on display, an enlargement or transparency is needed for the entire group to view at one time while the owner lectures about it.

How much money such work can bring you depends on your location. Your profit potential is limited only by the number of collectors, most of whom can be located by talking with local dealers and learning which coin and stamp clubs are in your area. Arrange with the presidents of these groups to discuss your service with the entire membership.

Photographing collectables requires some special equipment to take a photograph closer than normal. This is a supplementary close-up lens, a special macro lens, extension tubes, an extension bellows or even a combination of these items. Ideally you will have a single-lens-reflex camera which allows exact positioning for close-ups. However, even the top-of-the-line Instamatics can sometimes be used with a little care and practice.

Two examples of close-up equipment good for coin and and stamp photography. The bellows and the macro-lenses are enhanced by a camera body with through-the-lens metering to reduce exposure problems.

You need a stand to hold the camera and a holder for the objects to be photographed. At least you will use a table-top tripod and a piece of felt. At the upper end of the price range you'll find custom copy stands costing $50 or more. You also need a cable release, light meter and perhaps extra lighting equipment.

HANDLING VALUABLE ITEMS

Before you begin, there are a few facts you should know. How you handle coins and stamps will make a difference to a collector. Improper handling can damage the items to such a degree that their value is greatly reduced. A fingermark on a rare coin, for example, can leave a permanent mark which might reduce the value.

Let's start with coins because you are far more likely to handle individual coins than individual stamps. Stamps are photographed as mounted on album pages, recording a page at a time with only an occasional rare stamp photographed individually.

If you must handle a coin, it should be held only by the edges. Touching the surface, or even laying it in the palm of your hand, may cause permanent damage. As a safety precaution I always wear thin clean cotton or lint-free nylon gloves of the type sold by camera stores for motion-picture editing. When wearing gloves you should still hold the coin by the edge, but if you accidentally lightly touch the surface you will do no damage.

Coins must never be polished, cleaned or rubbed in any way. If a coin is almost black from aging, boost your lighting, bracket your exposures and pray, but do not try to clean it. Even if the collector lacks knowledge of the dangers of cleaning and suggests you rub it to make it look nicer, don't do it. The value will be greatly reduced and, if he ever learns better, he will blame you and not himself for damaging his collection.

You must be careful about what type of surface you use to support the coin. Rubber, for example, can leave a mark on the coin which may not be safely removable. I always use a piece of felt or velvet under coins I am photographing. Plain cloth is also safe. Be sure to clean the cloth regularly.

Coins should not be stacked on top of one another. This can cause scratching. If the coins are not in holders, lay each on a clean surface such as a piece of cloth. If they are in separate holders, do not remove a coin until you are ready to take its picture, then immediately return the item.

Some coins *must* be photographed without being removed from the holder. Proof sets—specially struck coins—are often packaged in clear plastic. Removing them from the original holder may reduce their value should the collector resell them. You may have to use a polarizing filter to reduce glare from the holder or perhaps one of the lighting tricks discussed later in the chapter. Better a little extra effort on your part than a damaged collection.

TECHNIQUE

The value of a coin is based on the number made, the number remaining, the condition of the coin. You must show all the details of a coin for your photograph to be of value to the collector.

Although the U. S. Mint began in Philadelphia, there are two branches today and there have been several others during our history. Each branch mint puts an identifying mark on the coins it produces. Knowing both the date and the mint mark is essential to determining the value of a given coin.

Unfortunately, most coins have the date in front and the mint mark in back, except for recent coinage. Photographing both sides seems straightforward to you and me, but to insurance companies it seems like hanky panky. They may suspect you shot the front of one and the reverse of another. So, a photograph of a rare coin could be meaningless when it comes to insurance purposes.

If a coin is worth only a few dollars, almost all insurance companies will pay a seemingly honest claim. They will accept photographic evidence. Remember that a very valuable collection can be accumulated with each coin worth only a few dollars, so in general your photographs will serve a useful purpose.

Many extremely rare coins, worth $100 to $100,000 or more, are distinguishable just from the front or back alone. The 1913 Liberty Head Nickel can be identified by date alone. All dated that year are valuable.

Then there is a Buffalo Nickel made in 1937 by the Denver Mint. A few of the coins were struck with the buffalo having only three legs. This is a valuable coin and that was the only date in the Buffalo Nickel series when they were three-legged.

By taking a close-up of the buffalo, your collector-employer gets all the insurance evidence he needs.

The point of all this is that the collector who hires you should be alerted to the fact that photographs of the collection may not always be adequate for insurance purposes. However, they are just about the best proof possible and will suffice much of the time. For the exceptions, an annual appraisal by a professional dealer will be needed.

You will, of course, photograph the entire collection for insurance purposes. The negatives from this work will be turned over to the collector, in protective sleeves, for long-term storage in a safe deposit box. The person hiring you should be told not to leave the film in his home because of the danger of fire or theft.

The collector will be regularly adding coins and/or stamps to the holders but will only have the collection appraised on an annual basis at most. Appraisals can be quite expensive so they are usually put off longer than they should be. This is fortunate for you.

After you finish photographing a coin or stamp collection to the owner's satisfaction, ask when you should return. Generally returning every three to six months will prove sufficient to handle new acquisitions. However, suggest that the collector contact you whenever he buys a major item so you can record it immediately.

Coins which occasionally cause photographic problems are the ancient coins of Greece, Rome and other early civilizations. These were often crudely struck on what looks almost like pebbles. It is difficult to make out the design and the writing, both of which must be seen to prove value.

With ancient coins, vary the lighting angle. You will normally light coins and stamps at a 45-

I finally had to buy a real copy stand but for a long time this collapsible, cheap ($12) tripod sufficed. I usually had to brace it and a cable release was a must. But it was a long while before my business volume warranted spending triple the money on a made-for-the-purpose stand.

If valuable items are stored in a bank safe deposit box, arrange to use an area in the bank where you can photograph them without removing them from the building. This might be in a room near the vault or in an employee's lounge. When you take the items from the bank, there is a chance of a robbery. Take all photographs in the presence of the collector.

THE OLD MIRROR TRICK—You may be able to get around the insurance company's concern that two photos of the front and back of a coin could be *two* coins. Take your photo so a mirror reflects the back side of the coin. This requires careful set up on your part and great attention to depth of field to keep adequate detail in the actual and mirror images. The collector may also want front and back views for better detail, but the mirror trick may eliminate any insuror's concern of being cheated.

degree angle. For ancient coins lower the light, shining it across and slightly down on the coin, much as you would light a piece of cloth in order to bring out its texture. Sometimes a slight over-exposure is also necessary. Bracket your exposures by as much as two stops over and one stop under the proper reading.

Stamps are easier to photograph than coins. While it is true that the amount of adhesive remaining on the back is a factor in determining value, also whether or not a hinge was used to mount an uncancelled stamp in an album, such matters are not all that important. If you can show the front of the stamp and bring out all the details, your photograph will solve most insurance problems.

Like coins, stamps require special handling. Rather than touching the edges as you would a coin, stamp collectors use tongs when handling the stamps. When handled carefully, without exerting so much pressure that the stamp is creased, tongs are totally safe. The collector should provide you tongs to use or he should handle the stamps for you. As I mentioned earlier, most of the stamps will be recorded an album page at a time, with only the extremely rare items recorded individually.

Occasionally you need to use color film for a stamp. There are certain printing errors which make a stamp more valuable. One of these is the omission or addition of color during printing. This is not always apparent in the gray tones of a black-and-white photograph so color-negative or transparency film must be used. Your lighting must be exact for this type of work so the colors come through correctly.

The value of stamps can also be determined by additions that are not really on the stamp. For example, some collectors buy a block of four stamps rather than getting them individually. Such blocks are worth four times the value of the single

Do not photograph stamps in a draft. This may seem like common sense but many people do not think of it until it is too late. Stamps are not pasted into albums. A sudden draft will send them flying and you may be held responsible for any losses.

Coin photographs need not be beautiful, but they must be exact. This image shows scratches on the surface of the coin which affect its value, and must never be retouched to make the coin look nicer.

stamp unless there is a serial number in the margin, completely separate from the stamps. Then the value increases considerably, occasionally doubling or tripling the worth of the stamps. When photographing blocks of four stamps, show everything rather than cropping out what seems like extraneous material. Remember that if something is retained by the collector, there is almost always a reason and it should be photographed.

Unlike coin collections, which always have a face value, stamp collections are often comprised of thousands of stamps that may be worth a few cents a hundred and a few dozen which actually have a high value. If the collector wants everything recorded, take close-ups of his valuable stamps and just photograph the album pages for the rest. In general the album pages are large enough to let you move back to a distance which gives you fairly good depth of field. This means that an album page will not have to be perfectly flat when recorded, and it can be difficult to get them flat because of the extreme thickness of most stamp albums.

Before taking an assignment, test to see if your camera equipment will do the job. Use a telephone directory for tests because the pages are about the same size as a stamp album page. Focus

Postage stamps generally have only one side about which you need to worry. This makes the work that much easier.

about midway across the page, then study the print to make certain everything is sharp. Smaller ƒ-stops give more depth, so fast film and good lighting helps.

If you decide the pages must be flat, have the person who hired you hold the album open so that the covers are at 90 degrees to each other. He will have to hold the pages so they don't fall on the side you are photographing. You can also use a variety of mechanical devices or even thick rubber bands, provided none of them actually touch any of the stamps.

Sunlight gives good illumination. The illustrations used for this chapter were all taken by available light in a room in my apartment which catches sunlight for six to eight hours a day. I set up my table-top tripod, background cloth and camera, then take the picture. If you do not have such a situation, you will need artificial lighting.

Two types of artificial lighting are effective. One is a clamp light, placed at a 45-degree angle to the stamps or coins. This lighting is intense, but the angle generally prevents glare problems, assuming the camera is directly over the coin or stamp, facing downward.

I also use a light bounced from an umbrella. I happen to own one of the excellent Reflectasol units, but you will get good results with inexpensive units sold by others. The umbrella and floodlights are on one stand, the light striking your coin or stamp after being reflected from the silvered umbrella. White or blue umbrellas can be used, blue with daylight color or black-and-white film only. This soft, even lighting is not as harsh as the direct flood.

WHY DO BRIGHT COINS PHOTOGRAPH DARK? Any reflective surface takes on the color of whatever it is reflecting. To keep bright, shiny coins looking that way in your photos, surround everything with a tent of white cheesecloth. Or, use white poster card all around your shooting "stage." Lights can be angled so they bounce off the white card. Make sure you and your camera are not reflected by the coin's surface or you'll get dark coins.

Although either system mentioned works fine when photographing stamps, direct lighting is a problem when photographing coins. The shiny surfaces of many coins act as mirrors, making photography difficult. A simple solution is to diffuse the light by shining it through a piece of white cloth stretched on a frame.

You can use dime-store picture frames covered with a piece of white cotton cloth tacked or stapled to the sides. Total cost, depending upon size, is from $1 to $2.50, with an additional few cents for the cloth remnant. You can also buy make-it-yourself wooden frame pieces from many dime stores.

Art stores sell stretcher frames for canvas. They are inexpensive and last a long time. When attaching the cloth, don't drive the tacks too far into the wood. If they are fairly easy to remove, you will be able to wash the cloth when it is dirty. A stapler can also be used to attach the cloth.

A polarizing filter on the camera is not effective in eliminating glare from metal surfaces unless you have also polarized the light source.

To read the light, an incident-light meter can be placed in the same position as the object to be photographed, the sensing cell aimed toward the camera. This is generally the most effective approach once you have learned to work with your lighting and set up.

If you are using a reflected-light meter, you may have problems. Most coins reflect so much light that the meter is fooled, much as it can be fooled when you photograph in the snow. Some stamps, on the other hand, seem to absorb an unusual amount of light, again making your meter reading inexact.

If the meter is not a behind-the-lens type, you have to make calculations to compensate for the bellows or extension tubes when you use them. Follow the instructions for the equipment and make some test shots. Close-up lenses which fit over your normal lens do not require exposure compensation.

If the meter is a behind-the-lens type, it will automatically compensate for exposure changes caused by bellows or extension tubes. However, no reflected-light meter will be truly accurate due to the glare and other problems mentioned. When measuring reflected light, substitute a neutral-gray card for the object to be photographed. Take a meter reading with the card in place, then replace the coin or stamp. Exposure determined in this manner will be close to the proper value.

Usually a meter reading taken from a neutral-gray card will result in a printable negative, even when a shiny coin surface or unusually dark stamp is photographed. With negative film there will be enough latitude to compensate for problems. If you have not made tests to prove out your lighting and exposure, take one exposure as metered, one a full stop over and another a full stop under.

Your exposure times will probably be fairly long because you will be stopping down the lens to its smallest opening for depth of field. I have exposed for as long as five seconds with objects that were both dimly lighted and being recorded on slow-speed black-and-white film. Camera shake will ruin your pictures.

We have already discussed the fact that your camera must be mounted on a copy stand or tripod such as the collapsible unit I use for my work. But even the sturdiest support is of little value if it is resting on a table that shakes from trucks passing outside the window or children racing through the house. The table or counter should be sturdy. If you can't use a kitchen counter top or heavy table but are forced to use a shaky card table or similar unsteady support, treat the table as you would a lightweight tripod used outdoors in the wind.

To support a shaky table, add weight to it. If you own some heavy bean bags, you might tie them together with a long rope and drape them over the table to add support. Or you can place heavy books on each of the four corners of the table to help absorb the vibration. Just be sure to add enough weight to prevent camera movement through table shake.

A cable release is usually a must. If your camera has a built-in timer, try setting the exposure, then triggering the camera by using the self-timer. Any vibration you might cause by touching the camera will have stopped by the time the timer releases the shutter. If your camera is a single-lens-

Keep floodlights fairly far from stamps and paper money. Floodlights get hot enough to set fire to paper near the bulb. This is known as a "hotshot."

Shiny silver coins require one stop overexposure with available light. Bracket your shots to determine what works best with your lighting technique.

reflex, be sure to lock up the mirror if possible as this eliminates another cause of camera shake.

In case you are thinking that you could avoid all these problems by just using a high-speed film such as Tri-X, you are right. Unfortunately you add the problem of grain and reduce the maximum enlargement possible with your film. Tri-X might be fine for one or two stamps or coins, but if you photograph an album page filled with stamps, you want to be able to make a 16x20 or greater enlargement of the page with extreme detail. The grain pattern of high-speed film becomes visible so enlargement will not be as effective.

Before photographing hobby collections, practice with your equipment at home. Use change from your pocket and stamps from your letters for experimentation. Practice lighting and close-up technique.

PARALLAX PROBLEMS

Rangefinder cameras don't permit through-the-lens viewing that makes close-up photography so easy. Some rangefinder cameras have severe parallax problems with close-ups. Some twin-lens reflex systems have the same disadvantages, but parallax correcting mounts are available to let you focus through the viewing lens, then move the camera so the taking lens occupies the identical spot.

If you use a close-up lens attachment on any camera when you don't look through the taking lens, you will not be able to see when the object is in focus so you must rely on tables and careful measurement of subject distance.

After experimenting and studying the results on film, you will find that it is possible to become fairly accurate when taking close-up photographs with most any camera but your procedures are inexact enough that you need to take a minimum

Never discuss the collections you have photographed, especially if they are kept in the collector's home. Crime is too rampant for you to be going around discussing valuable objects you have seen and recorded. Your discretion will be both appreciated and rewarded by increased business.

Always have duplicate negatives or prints made of any coins or stamps that are interesting. These you retain, without identifying the owner *even in your own file records* (File them under "Coins," "Stamps" and the specific item such as "Lincoln Cents"), for use in publicizing your own work.

of three exposures at three slightly different angles to be certain you are photographing the full object. This means more film, higher costs and more time, none of which is desirable.

My personal feeling is that you should skip this one money-making activity unless you have a single-lens reflex or equipment that corrects for the problems of parallax when working up close. I have mentioned other equipment in case you want to try it, but don't feel it is practical.

FINDING CUSTOMERS

The first step in obtaining business of this type is to talk with coin and stamp dealers in your area and in nearby communities. Explain what you are doing and show some samples. These samples can be the pictures of pocket change or common stamps you took for practice. The fact that the objects photographed are not rare is of no consequence. You are only trying to show that you can photograph coins and stamps.

The dealer will *not* give you a list of his customers but he will probably be glad to tell you about clubs in the area.

Most coin and stamp collectors are notoriously shy and hesitant about discussing their collections with strangers. Even a low-budget collector who has been enjoying his hobby for a long time may have a collection worth several hundred dollars. Other collectors have amassed fortunes in coins or stamps. They know that even if they keep their valuables in a bank vault, public knowledge of their collection could lead to a robbery attempt at their homes which would endanger their families. They will want to be certain about your intentions before dealing with you.

Once you have one or two clients, make some enlargements from the negatives to use as samples. Often dealers will be willing to put your photographs on display with a supply of business cards. They will refer interested collectors to you so

Side lighting enhanced the design on this coin, making it good both for insurance purposes and as an example of beautiful medallic art.

you can reach people who might not attend local meetings. Remember that a reputable dealer will never give you the name of a customer without the customer's permission, but he will be willing to recommend you to that customer.

After you have been taking coin and stamp photographs for a while, you will become known and your reputation will spread by word of mouth. You can expand your activities and increase your profit.

Coin shows and stamp shows are held on a regular basis in larger communities. These have special collections exhibits, often in competition for prizes, and a large room where dealers sit at tables offering items of interest to the collectors. These shows are ideal places for you to increase your camera profits.

Photographs of the overall show may be desired by the sponsor. They want a record of what happened to promote the next show. The light at these events is always excellent as it is designed for people to study very small objects. It will be easy for you to take candid photographs with high-speed film in the available light.

You can also photograph each exhibit, and offer 8x10 prints. Additional sales can be made to the men and women who win prizes for the best displays. In the latter case, photograph the winner

> Always ask a collector what details he wants brought out on the stamp or coin being photographed. Unless you are an expert in the hobby field, you will not know which marks make the object valuable.

When the coin's sides are photographed separately, the true value is not known. On standard coins, the front side has the date, but the all important mint mark is buried near the "H" in Half Dollar on the tail's side. This can be photographed by holding the coin near a large mirror and utilizing extreme depth of field. However, the chance of scratching or otherwise damaging the coin through handling is so great that this is not practical. A number of organizations used by collectors of rarities have special services for authenticating the coins. The use of such services is the best insurance record but your separate photos of front and back will be adequate.

holding the prize and standing by his or her award-winning display.

Don't expect to be allowed to photograph the displays anytime you wish. Major shows have individual coins on display valued at $50,000 to $100,000 or more. Elaborate security precautions are essential. You must talk with the people in charge of the show and arrange a time when you can work. This will generally be during a slack period or just before the show opens to the public. You will be alone in the room except for the guards and perhaps the exhibitors. When spectators are crowded into a room, there is a great risk that someone will attempt to steal an item from an open case.

It is possible to photograph directly through the glass of the cases by using a polarizing filter, but I don't recommend it. Most displays have coins encased in plastic causing double glare which the filter may not be able to eliminate.

Another source of income, assuming you have your own darkroom and can work quickly, is the hobby press. These are numerous newspapers and magazines devoted to coin and stamp collecting. Many of them will buy coin and stamp show photographs if they get them immediately after

the show. The pay is small, but it adds up to more profit from the day's work.

Most hobby publications are staffed by people who genuinely care about their contributors and will go out of their way to help people interested in supplying them with articles and photographs. If you don't make a sale the first time, they are likely to give you enough information about their needs that you will make a sale the second time if your work is good.

Coin and stamp photography is a lot of work and it will never make you rich. But once you get a reputation for handling it effectively, you will find a steady and seemingly endless line of customers waiting to hire your services.

Never take a coin or stamp collection out of the collector's sight. The owner may generously allow you to take it home to photograph at your leisure. There's a chance you will lose one or more items. Worse, you might open yourself to charges of theft when a dishonest owner claims you "stole" a coin or stamp he never really owned.

Photography for Annual Reports

Of all the ways to earn money with your camera, one of the most enjoyable has got to be annual-report photography. There is something exciting about being turned loose in a business to photograph anything and everything of interest. There is also the security which comes from knowing that if you do your job well, you will be asked to repeat the assignment year after year.

Annual report jobs are *not* ordinarily given to the advanced amateur. The annual report reflects the very heart of a business and must be handled with great care and sensitivity. If the firm preparing the report is a business, the photographs must indicate the successes which will cause outside investors to continue supporting it. If the firm is a service institution such as a hospital, the report must justify the institution's charges and its reasons for continuing as a tax-exempt enterprise.

Although many businesses and institutions spend a small fortune on annual reports, there are thousands of smaller enterprises which do not have the budget to hire a big-name photographer. They want to put out an annual report, but they have little money to spend, and tend to make do with a written report with few or no illustrations to make it interesting.

If you want to try annual-report photography, you may already work in a place that can use your services. Maybe you work in a manufacturing plant employing 20 or 30 people. Or perhaps you work for a hospital which serves a rural community. Or a small variety or department store with one or two branches. If so, you already know one market for your services. You can find others without too much trouble—one or more are in every community in the country.

You won't get rich doing a small firm's annual report, at least not while still an advanced amateur. But if the work you produce is high quality, you may find a steady source of income, and you will build a portfolio to go after those big-budget firms.

You will be showing through photography what a business does, what it looks like, and what its products are. The pictures are accompanied by

A perfect annual report photo. It shows an employee happily at work, treating a patient whose back is to the camera. It is obviously a hospital and the picture explains why costs are rising. Both a technician and an expensive piece of necessary equipment can be seen, two major hospital expenses.

a financial statement and a discussion of the past and future of the operation. It can be in color or black-and-white. Color brochures are expensive and not likely to be used by small firms.

Annual reports require interchangeable-lens cameras to be truly effective such as Equipment List B or C. They can be taken with fixed-lens cameras such as the twin-lens Yashica or Rolleiflex cameras, or even non-interchangeable rangefinder 35mm equipment. However, the limitations of a single fixed lens are so great that your work will only be satisfactory at best. It may suffice for someone who can't afford anyone else, but it will

probably not result in the kind of photographs that will help you get higher-paying jobs.

The first annual report I ever took was handled with an ancient single-lens-reflex 2¼x2¼ camera. The lens was interchangeable but I didn't have the money to buy the other two lenses available for it. I bought it used because it looked impressive and fit my almost nonexistent budget, trading in that camera mentioned earlier with the lens that kept falling off. At least I was making progress toward good equipment.

The report was for a small manufacturing plant just beginning to make money. It was harshly lighted, dirty and a genuine challenge. I wanted to do a good job and worked hard with different camera angles, selective focus, and every framing technique I could imagine. I needed the perspective of additional lenses.

My work was saved by an angel of mercy named, appropriately enough, Hope. She is a darkroom magician who was working in a lab where I took my negatives. Through cropping and extreme enlarging of small sections of my negatives, she gave them enough variety to please the client who was kind enough not to mention all the grain that was an inevitable byproduct. I learned my lesson and did not try that work again until my equipment was a little more versatile.

The photographs illustrating this chapter are from an annual report I did for a hospital. I am using these because hospitals represent an annual report market found throughout the country. Small businesses vary with where you live, but you will always find one or more hospitals a short drive from your home. Nearly all need annual-report photographs.

TECHNIQUE

Before you begin an assignment, take a complete tour of the business or institution to be photographed. This will familiarize you with the work it does and give you an idea of the visual potential of the assignment. I have found that if I try to photograph without advance knowledge of what I will be encountering, I discover too late that there is little of visual interest for "straight" photography. If I have previously toured the business, I can bring in special prism lenses and other equipment to provide unusual effects.

It is a good idea to carry a light meter on

This wide angle photo of a therapist at work sold to both the Public Relations Department and the Physical Therapy Department.

your tour and take readings of problem areas. A hand-held unit is the easiest to use. If all you own is a built-in meter, then you have to bring your camera. This can be a little awkward because people will assume that when you hold up your camera you are actually taking a photograph. When you begin, they may think you are already finished.

Mentally review what you have seen and how you will go about shooting it. If technical equipment is being used, such as an inhalation therapist at work, a wide-angle lens may help you frame the therapist, the patient and the tubing in an interesting and unusual way. Photographs of surgeons in an operating room will require telephoto lenses because you will not be able to get close.

Film should be selected carefully. Hospitals are usually lighted well enough that Tri-X is satisfactory. However, if you have more than one camera, you may wish to load one with Tri-X rated at ASA 400 and the other with the same film but rated at ASA 800 or ASA 1200 to be certain you

can use a shutter speed rapid enough to stop movement. I carry a roll of ultra-high-speed film, such as Kodak 2475 Recording Film (ASA 1,000-ASA 5,000) just in case.

When you begin to work, go to one department at a time, preferably with the person who hired you. Make certain the employees know what you are doing and how the photographs will be used. Then start taking pictures.

It is quite likely that the annual report will have a central theme. In the photographs used here, the hospital wanted to stress the number and variety of jobs done by employees. The major portion of a hospital's budget is for personnel and the hospital wanted to be certain the public was aware of the many services paid for. I was also instructed not to show patients' faces. Knowing the central theme and restrictions helped me photograph so everything I recorded was a potential sale.

Most people are a little self-conscious about either avoiding your camera or posing for you. You'll hear corny comments such as, "You don't want to take my picture. I'll break the camera." Just smile, laugh at the jokes and keep right on working. After a few minutes they get used to your presence. Then you can get down to serious photography.

Be careful about where you are working. Hospital labs have expensive equipment which you can easily knock to the floor while maneuvering to get an unusual angle of a technician at work. Factories often have molten metal and other potential hazards. No one is going to watch out for you so be careful about what you are doing.

Respect any restrictions placed upon your movement. Certainly it is important to get good photographs but there is always a reason for the restrictions.

If you are dealing with building construction, wear a hard hat obtainable from the foreman. If you are in a factory, be wary of machines, conveyors and fork-lift trucks. Wear shoes that give you good footing. This may mean normal shoes in one place, rubber-soled shoes in another and protective boots in a third.

Ask questions about what you are photographing. It is impossible to know what is important and what isn't without questioning someone. That piece of odd-looking machinery in a corner

Props can be used to make corporate reports more interesting, as well as for glamour and modeling work. Some of the best props are unusual items, although common materials, used imaginatively, can also work well. This "Copeless" doll was photographed by Randy Masser of New York City for the Haas Group, Inc. of New York. The doll was created by Copeless Concepts, Ltd., and is available throughout the country.

SAFETY PROTECTS YOU! Respect every rule or suggestion of the people you are working with. Wear the hard hat that's offered and the safety glasses too. You may not be allowed to use flash in some areas unless you put your strobe in a bag and tie or tape it tightly. The rules may seem strange or unnecessary but they've been made to protect every worker on the job, including you.

of the room may seem dull to you when in reality it is a new million-dollar computer which handles 5,000 calculations at the same time, makes coffee and sings Yankee Doodle. It is the only one of its kind in the world and it will be used on the report's front cover. But how would you know all this if your didn't ask someone?

Sex sells everything, even in annual reports. If a male worker is unusually handsome or a female unusually pretty, you can bet that good photographs of them at their jobs will be used. Take a few extra when you encounter such people, it usually pays off.

Look for one photograph that sums up the department where you are working. If space for pictures is at a premium in the annual report, your client will want a photograph that instantly shows the nature of the department or particular operation under discussion. It is also wise to try for a single photograph which says "Hospital" or "Factory" or "Business Office." This can be used for the front cover and for additional projects beyond the annual report. Naturally you should try to show something unique so you have not made a picture of an office but of the "Office of Frammis and Widget, Manufacturers of Plastic Hickies."

In many locations available light or flash will be the only light you can safely use. In manufacturing plants your movements are often restricted so the only additional lighting permitted would be the harsh light of a direct flash. Bounce light is impossible in most cases due to high ceilings and dirty walls.

The only time I ever worked with anything other than available light or flash was when I had the assignment to photograph a company which manufactured anti-shoplifting equipment. Although the manufacturing end was recorded with available light, I was able to bring floodlights into the office area. There was little movement with most of the employees staying at their desks. I took some excellent interior photographs after carefully boosting the lighting with hidden, bounced flood bulbs. Without the extra light there would have been harsh shadows to detract from the final effect.

Photograph any unusual objects, even if they seem out of place. At a manufacturing company I found an unusual carved table in the conference room. I had no idea what it was, and it seemed out

Close-ups can be unusual and dramatic. This close-up of a hand dipped into paraffin for a heat treatment is more interesting than overview with patient and therapist.

of place with the rest of the furniture in the building. However, I photographed the entire table and also small sections of the carvings in close-up.

It turned out that woodworking was the president's hobby and the intricate table was one of his creations. The photograph became the lead picture in the annual report even though it seemed out of place. The president was delighted and additional prints were ordered.

Be certain to fill the camera frame, especially small negatives such as 35mm. Low-budget companies try to get as much mileage as they can from photographs. A picture for the annual report might be enlarged for a mural in the president's office.

I once photographed a party being held to raise money for a charitable organization. One of the pictures, taken on 35mm Tri-X, was a group of women standing together talking. It turned out that one of these women was going to Europe and she ordered several enlargements of just her face for use as passport photos. Somehow the work

was in sharp focus, though the grain was the size of baseballs, and the woman was happy. I suppose it was no worse than many passport photos, but it does illustrate the extremes clients sometimes expect.

Plan your photographs around the limitations of your equipment. Telephoto lenses and low light mean large lens openings and minimal depth of field. The only person in your photograph who will appear sharp is the one you focused on. This is not the type of equipment for a children's ward, for example, where you might want to capture several children in different parts of the room in the same frame.

Another problem arises when you try to combine people and equipment in one photo with a wide-angle lens. Anything close to the lens will appear extremely large by comparison with everything else. If this distortion is not considered when planning, you will probably be left with an unsalable photograph.

BUSINESS PORTRAITS

Occasionally people who hire you to produce an annual report will request portraits of the directors of the business. These will be used in the report and for general public-relations.

Some professionals would handle the portrait task in their studios. They arrange for the directors to come in for a sitting and take very formal photographs. Other professionals go to the directors' offices with a 4x5 camera and three large electronic flash units, complete with modeling lights. The results are formal and usually excellent.

You may not be able to do that, yet you must create a quality portrait. You could bring in clamp lights, use a fine-grained film and hope for the best. This often works effectively. However, I prefer to work candidly as for the rest of the annual report.

Candid portraiture is easier than it might sound. My usual sales approach is to tell the client that a portrait should be more than just a picture of the man or woman being photographed. It should reflect the work being done.

One approach is to photograph the executive at his desk. Another might have him standing on a balcony, a giant factory slightly out of focus behind or below him. You might even have him in the shop with the workers, inspecting some of the products.

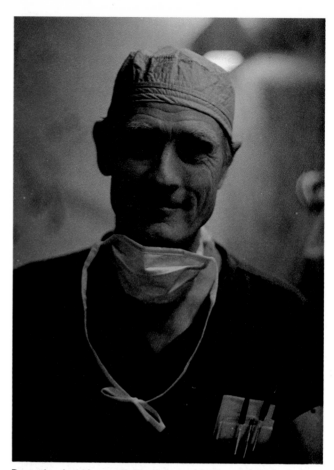

Portraits done by available light—sometimes with the help of an umbrella or fill light—can be effective and dramatic, especially if taken in the subject's normal working environment.

In a hospital you are doubly blessed. Not only can you photograph the administrator making the rounds of the building, you can often take a candid portrait in his office. The lighting in hospitals is always bright enough that it is like having your own supplemental lighting anywhere else. Even fairly formal poses can be achieved without effort.

GETTING CLIENTS

Your first decision must be which company, school or hospital you should approach. Almost any hospital is a target. The exception is a university-connected institution which invariably has both a staff photographer and the budget to hire outside professionals. Smaller hospitals, large rural hospitals and similar health-care institutions offer the best chance for success. Even if one of these employs a staff photographer, he may be so busy with day-to-day responsibilities that he does not

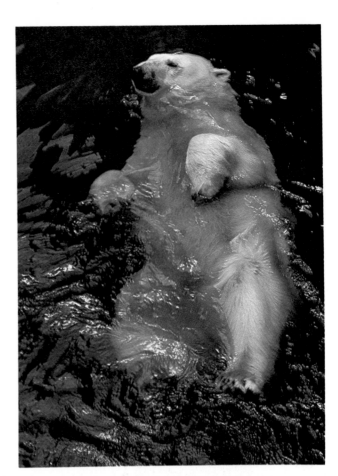

Don't overlook locations like zoos, which are constantly seeking both private and corporate funds. They produce annual reports for potential investors and the general public, and also like to have good shots for newspaper and magazine release. (Photos by Randy Lowery)

have the time for non-essentials such as the annual report.

When seeking hospital work, contact the community-relations or public-relations department. If the hospital has none, contact the hospital director's office. Under no circumstances should you go to the personnel office, though if you walk in cold and ask who buys photography that is where some unknowing volunteer at the front desk will invariably send you. Personnel hires staff people, not freelancers.

Explain that you would like to do photography on a freelance basis for the hospital. Tell them that you are interested in handling newsletters, special reports and other needs they might not have the time or ability to handle with their staff. It is likely you will be asked to handle some small chore first so the staff can assess your ability.

Remember that no assignment is a waste of time if it can lead to bigger things.

The question of samples is a sticky one. How can you have samples if you have never done this type of work?

I feel that you should take along samples only if you have something that in some way relates to the work you are seeking. People pictures, photos of men and women at work and similar related images are fine. However, if all you have are pictures of bikini-clad wenches or still lifes of rotting fruit artistically arranged in the bathtub, I suggest you leave them at home. Be honest about your past experience and ask them to try you on something to see your ability. In many cases you will be given a chance.

With a small business the manager or company president is the one to see. Ask to talk with

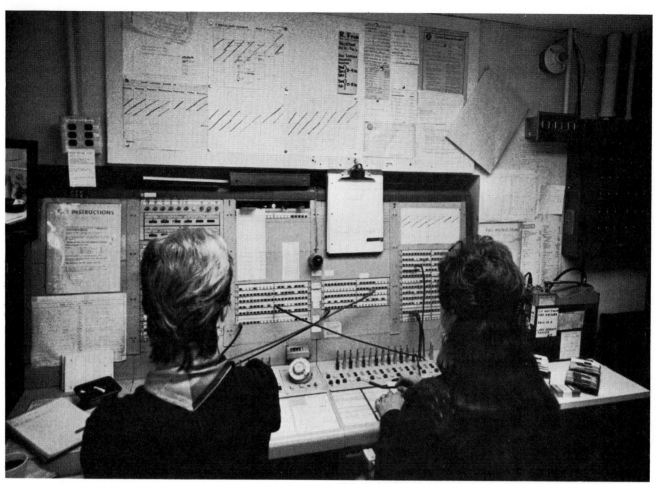

Two approaches to the all-important switchboard operators: One shows only the backs of their heads. The second using a mirror to show the person on the job and her face is far more interesting.

his secretary who will get you an appointment or refer you to another person in charge of such projects.

Special-interest schools and parochial or small private colleges can be prospects. Business schools have regular needs for photographs but generally lack the budget for a full-time professional. Most private and parochial colleges are in a constant money bind as well, making them equally good targets. Once again candor and a willingness to handle the smallest of assignments should get you that first one.

Some companies can be found by leafing through the Yellow Pages. Prospects such as small manufacturers can be found by taking a drive through the industrial area of your community or the nearest large city. Take note of the ones in smaller buildings and plan to follow up with a contact. Carry a notebook and pen to record names and addresses.

Although it saves time to telephone, I have

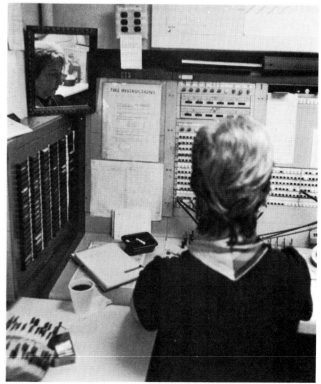

excellent results by dropping in cold and asking for an appointment. By asking for an appointment at a later time, you are not obviously trying to pressure anyone into seeing you.

PRICING YOUR WORK

Deciding what to charge can be a problem. The places which will be interested in your services when you are first starting have small budgets. You can't get rich or even moderately well off from them. The best you can do is get an hourly fee plus all expenses. This will probably range from five to ten dollars an hour. Be certain to add in your costs based on the price of film, processing, contact sheets and prints of various sizes. Generally there will be nothing wanted smaller than 4x5 or larger than 8x10.

Because your profit is influenced by the time you work, you will come out ahead working quickly, though not so fast that your work suffers. Your bill will be modest and your clients will want you to return.

This is the way I handle the charges for the annual reports I photograph, though my rates as a professional are many times what you will be able to charge.

First decide how much you want to earn per hour. This might be $5, $10, or more. Then examine your costs so you have an idea what your expenses will be. For example, you should know the price for a roll of film including processing and a contact sheet, as well as postage both ways, if any. Include a mileage allowance for any long distance driving at 10¢ to 20¢ per mile.

When you tour the building where you will be photographing, estimate how many rolls of film you will need to do the job efficiently. Be generous. Allow for bracketing exposures in areas with unusual lighting requirements, such as steel mills. This will give you a rough working figure of your total expenses before any prints are ordered. If you want to earn $10 an hour for your work and the client has a total budget of $150, your combination of time and expenses should not exceed around $110 to $120 in order to leave enough to pay for prints. If you think time and expenses will exceed $150, you are better off not taking the job than taking it at a reduced hourly rate. This is assuming your hourly rate is realistic for your skill.

You charge less than a full-time professional only because you have not established yourself. Your work might be every bit as good as the person charging five to ten times more than your hourly rate. The only difference is that the professional has a proven record of competence. The client knows the work will be of high quality and completed on time. Your clients are not so sure about you and are taking a chance because their budgets are limited. Once you have proven yourself on the small jobs, you can go after the big assignments and charge the same rate as the full time professionals.

Negatives should not be turned over to the client unless the client pays for them. Resale of prints means money in your pocket. Only twice have I sold negatives to clients, but they paid me three times my maximum charge for an annual report for the privilege.

In the case of slides, the client gets everything unless you have duplicates made for self-promotion. (You keep the duplicates.) This is the main reason the charge for color work should be considerably higher than black-and-white—often double. It does take special skills and you should get more.

Get an agreement in writing with your client concerning trade journal sales.

I once did an assignment for a group of builders working together on a massive housing project. One of the builders had me work in color, buying the slides and all future rights to money earned from the sale of those slides. They eventually became a cover story for a major engineering magazine but I didn't get paid anything for that use of the photos.

Another builder had me working in black-and-white for his own purposes. Again a magazine bought some work, this time for a black-and-white feature story I wrote. The magazine paid me for the article and photos. I had retained the right to resell the pictures. The client's reward was the publicity received from my article.

There is a way you can boost your profits. When I work on a time and expense basis, I always stress that printing will be done at cost only for those pictures ordered during the period I am doing the job. After they are filed away for a few weeks, any additional prints carry a markup. The price is your decision, not the client's. However, I

People going about their activities are not self-conscious. Try to stay as quiet and unseen as possible as you do your work.

do not price them out of the client's budget. Should the president like an annual report photograph so much that he wants a copy for his office, you will profit by this later sale.

Often you will find that a business or hospital has a set budget for the annual report. There will be funds for printing the report and a certain amount of money marked for the photographs. If you want to take the pictures, your bill cannot exceed the money assigned for this project.

Whether or not you agree to work within a set budget will be determined by what is expected of you. Sometimes a business is totally unrealistic. The owner wants so many pictures taken and so many prints that your profit will be nonexistent, perhaps only a dollar or two an hour. You must not let promises of future high-paying assignments lure you into accepting an unfair arrangement. If you are treated poorly the first time, what makes you think the company will ever be fair with you?

Other firms recognize that they have a low budget and respect your need to make a reasonable profit for the time you work. They will be willing to negotiate with you as to the number of prints and the time you work so that you can make money withing their budget.

After you have built up a portfolio of annual report pictures, including some samples of the reports after they are printed, you will have the background necessary to go "big time" and increase your rates.

There is no firm price schedule among professionals, but here's a typical situation. A west coast photographer, well known in the trade and sought after because of the quality of his work, charges $500 to $600 per day for his time. Add to this his travel expenses, food and lodging on location, plus film, processing and prints.

When you combine experience and a quality portfolio, you will soon see that there are few—if any—jobs beyond your ability.

Trade Journals

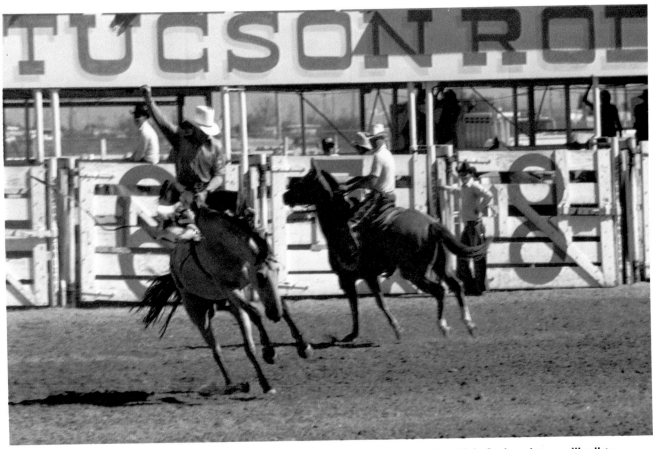

Action photos from rodeos and other activities have a broader market than you might think. Such a picture will sell to magazines about horses or professional rodeo riders, specialty clothing manufacturers and even local publications where the event is scheduled. All of these markets are interested in seeing what is happening and promoting their part in the activity.

You should be convinced by now that your camera can be a dollar producer rather than just a drain on your bank account. Your camera can also make you known across the country. Your pictures can be viewed by thousands of people in a particular field, earning you both money and a certain amount of fame.

Trade journals are special-interest business publications I mentioned briefly in previous chapters. Each is designed for a limited audience in a trade or industry.

In the medical field there is a magazine entitled *Doctor's Nurse Bulletin*. If you are a doctor, you might read *Hospital Physician*. If you run a hospital department the magazine *Hospital Supervisor's Bulletin* is for you. If you keep records, you can read *Medical Records News*. If you are a non-

medical person working for a doctor, you have the magazine *Professional Medical Assistant*. And so it goes. The list is seemingly endless and includes every type of business and industry.

Trade journals are among the healthiest magazines around. Advertisers know that readers of the publication will be likely to buy products related to their work. It is a far more secure market for advertisers than a general-interest magazine and so the companies renew their advertising month after month, year after year.

Unlike general magazines which send staff members all over the world, trade journals rely heavily on material submitted by freelancers. A factory that has a new way to make ball bearings will send a story to the trade journals. A bar owner who discovers a new method of attracting

customers might notify a magazine such as *The Bar Server Handbook.*

No matter where you work, no matter what your job, there is a magazine aimed for people in your field. Even more important, because trade journals try to show new methods of working or different approaches to routine jobs, anyone in the field can be an expert. You might work as a custodian but if you can photograph an unusual approach to cleaning the halls you can make a sale to a trade journal. Probably not to the trade journal aimed at the school principal, though you might take pictures for a story he or she writes for the school administrators' trade journals. There is a publication waiting for your photographs and captions or even a full-length illustrated article.

FINDING THE MAGAZINES

First step is to learn what trade journals are concerned with your job. You can often find this out by checking with your local library. Many libraries subscribe to a wide variety of trade journals. Others have lists of these journals in their reference sections or business sections. The reference librarian will be glad to help you.

Once you have identified the magazines, get copies and read these publications. This may sound like a rather simple-minded statement, but hundreds of people send photographs and articles to magazines without first reading the publications. In the majority of cases, the work sent has no relationship to what the magazine can use. The photographer or writer would have realized this if he had bothered to study the publication first. Shooting and mailing photographs costs money and it is a waste to send work where it will not be wanted.

Write to the publication directly, asking if you can purchase one or more recent copies for study. Often the magazines will be sent without charge. You may be asked to send money equal to the cover price of the issues mailed to you. This is a small fee to pay to learn about what could be a money-making market for you.

I should contradict one of the rules about freelance approaches to magazines. All the guides say you should learn the name of the editor and write to him personally. Most market guides list an editor's name, so this seems like a simple thing. However, I think you should address your letter "Editor." Once you have follow-up correspondence with an editor, use his name.

The reason I stress this is because of some sad experiences I have had over the years when I have addressed by name an editor I found listed in one of the market guide books. Editors are notoriously mobile, staying with one trade journal a

Be alert to businesses located in unusual areas. One reason to go to Sedona, Arizona to shop is the way the business community is nestled in the mountains. Many people will travel out of their way to shop if an area makes for a pleasant trip. The photograph tells more than the normal advertising of products available for purchase.

few months, then going on to a higher-paying job. Your letter may be forwarded to some other publication.

All right, now you've got the magazines and you've read them from cover to cover. By analyzing what was published, you will have a good idea what they buy.

Here's a specific example in a field of interest to you—photography. Around six years ago I decided to try my hand at selling pictures and articles to some of the photographic trade magazines. I got sample copies, read them and came to the conclusion that one I could sell with regularity was *The Rangefinder Magazine*, a Los Angeles publication aimed at the commercial studio owner. I have been selling them articles and photographs ever since.

Let's pretend you are analyzing an issue to see if it's a market for you. It has an article on

food photography, and one which tells how a magazine photographer has entered the motion-picture field. There is a short review of the working style of a successful and colorful professional, and an article on the use of the Minox subminiature camera for professionals. This latter piece, which I wrote, tells how to use the camera as a notebook to keep track of unusual lighting arrangements, models, locations, and so forth.

Continuing, there is an article on checking new camera equipment, and a variety of special-interest columns including one on marketing, one for portrait and school photographers, one for the staff of commercial studios and one dealing with technical problems. Now, what does all this tell you?

You know some things not to send them. Don't try to sell them an article on using the Kodak Pocket Instamatic as a professional's notebook

because that would be too similar to the Minox piece. Don't try to sell something on food photography because there is an article in this issue and it is one of a series. It will be three to five years before it will be handled again unless you have a radically new approach, in which case a query might be warranted.

Now, what to sell them? From the tone of the movie article, very few readers are adding cinematography to their work at the moment. Here is a field to be explored. If you know something about it or know an expert in the field, you could possibly sell several photo stories on this subject, using approaches aimed toward the still-photography studio owner.

Notice that the magazine is filled with advertisements from custom labs about their wedding photo prices. Obviously wedding photography is a major business of the people who read *The Rangefinder*. If you can show some new and different approaches to wedding work, such as using a multi-image lens, you may have a sale.

School photographers read the magazine. Do you have a new or unusual approach to school photography? Or have you seen some unusual school photographs taken by others? Sell the magazine a photo story on the other photographer at work, including at least one of his prints.

Because this is a magazine relating to business, something in that line is likely to sell. If you have a better system for filing negatives and prints, perhaps that will sell.

In my own case, after reading that issue, I decided to do a series on tape recording weddings as an adjunct to wedding photography. I also did a series on color films primarily available in 35mm and an article on the new electronic cameras in 35mm.

I used *The Rangefinder* for an example because I am a professional photographer and it's the field I know best. Your expertise is primarily in whatever area you earn your living or possibly your hobbies. At the very least you know your job and should be able to sell to a magazine in that field.

Don't shy away from trying to sell material to a trade journal just because you are only one of many workers in a particular area and rather low on the scale at that. You may feel that your

boss could sell to the trade journals but you can't because, after all, he's the boss.

Trade journals don't care if you are a "name" in the field or not. What they want is material from someone who can communicate what he knows to others through pictures or words. You can do that. Everytime you sell a photograph to someone, what you are selling is your interpretation of an event, whether it is a bowling tournament or a birthday party. You are communicating in exactly the same manner necessary to sell a trade journal.

Don't be frightened if the trade journal wants an article with the photographs. You might be able to team up with a friend who can write, splitting the profit. Once you've learned to shoot and sell photos and have that skill in good shape, *write it yourself!* When you add writing to your bag of tricks, you'll make more money than by just submitting photos with captions. Editors are often really in a bind for enough good usable material to fill an issue, but they seldom want to write an article from your bare facts. That's hard to do. You were on the scene, you saw the thing or what happened, so *you write about it.* After you have done this a while, you may get assignments for particular photo stories or requests for several articles a year.

The best way to learn to write is just like learning to sell photos: You have to start *doing* it. Community colleges offer courses on how to write. But, be sure to check with other students as you may find out writing is the one thing the course never gets around to. It's kinda like people who like to talk about photography but never do it.

Unlike general-interest magazines, trade journals are used to dealing with people who have something to communicate but are limited in their abilities to do so. They will usually edit what you send them so it is interesting and readable.

For example, one of the magazines I sell photographs and articles to is aimed at doctors. In a letter they send to contributors, they stress that if a doctor lacks the time or ability, they will write the story based on facts he supplies. These can be sent in longhand, typed or on tape. The important thing is a topic of interest to readers.

SAMPLE QUERY LETTER FOR PUBLICATIONS

Editor
Women's Wear Daily

Dear Sir,

Are you interested in a feature article about young American dress designers?

Here in St. Cicero there is an annual charity fashion show which has attracted newspaper and TV coverage. Fashions are modeled by high school and college-age girls who design their own costumes.

I'd like to cover the event for you on August 12 this year, and can furnish photos with captions and a short write-up.

Sincerely,

QUERY FIRST

When you have picked the magazine and decided what you want to offer, write a letter designed to arouse interest in the project you have in mind. If the editor likes the idea he will ask for some photographs. If not, it may not mean there is anything wrong with your idea. It's possible that similar pictures were run six or seven months earlier. The magazine stays in business by offering variety.

There is another fact of life when you deal with trade journals or any other type of magazine. This is the form rejection slip designed to save the editor time and cause the contributor anguish and aggravation. When you receive a form rejection you have no way of knowing how close you came to meeting the editor's needs. Maybe he thinks you are the world's greatest photographer but your project just missed what he's after. Or maybe he has never seen such trash and wonders why you wasted your time. In any case, you will have no way of knowing why your pictures were returned or your idea rejected. It is frustrating but something you have to accept until you are known.

Then editors will want your contributions and will carefully explain any rejections.

It may be that you have to photograph the subject of your query letter before you get the go-ahead. Photographs of an event have to be taken at the time when it is going on. If so, do it in the least costly way. For example, if you are using black-and-white film, as you will for 99% of trade-journal work, just have the negatives developed and a contact sheet made. Don't enlarge any of the negatives until you are certain there is interest in your work. Even the proof sheet is not really necessary, but it does give you positive evidence that the pictures came out the way you want them. You could tell the same thing by studying the negatives, but it isn't easy.

THEN SUBMIT

When you have an acceptance, make prints to cover the subject thoroughly, and also make a single eye-catching print to neatly sum up the entire situation.

Generally trade journals limit the number of pictures they run according to the amount of available text. They might run from one to three prints

Originally taken for a collector, these jewelry photographs eventually sold to hobby and art magazines. They also appeared with an article on investing in jewelry.

with captions only or a half-dozen or more with a full-length article. You should expect to supply from six to ten 8x10's and your proof sheet if it is requested. Color should be transparencies only and around a dozen should be sent. If there are more photographs available, note this in your accompanying letter. Remember that even for caption material you must describe in writing the scene, the event, the people, where it all occurred and when. Going by the old journalism concept of *Who? What? Why? When? and Where?* will ensure supplying all the needed facts.

Package the work as discussed in the chapter on selling from file. Remember that *your* address and adequate postage must be on the envelope included for the return of your photographs.

Once your work begins appearing in trade journals, you will find yourself benefitting several ways. People in your field begin to look to you when they have photographic needs. If you decide to go after annual-report work, for example, you can often get jobs just by showing magazines with your published photographs. The work you show does not have to be in the same field as the company whose report you are seeking to do. Just being published impresses people enough to hire you. In fact, you might even raise your rates.

PRICING

When selling to publications, you don't set the price. In a query letter you can ask about their rates and they will tell you. If it seems too low it is usually hopeless to ask for more money because the editorial staff usually has a fixed budget to pay for editorial matter.

Pay for b&w photos runs from $3 to perhaps $10 each in smaller magazines. For a color shot you may get only $25 even if it's used on the cover.

Some magazines pay by the page. Your photos with captions and your copy for the article will pay from $10 to $50 a page, depending on the magazine. After you have been a steady contributor they are likely to be a little more liberal because they don't want you to go away. What you want to do is go away—to a magazine that pays better. The stepping stone to larger magazines is by-lines in the little ones.

You will never get rich from trade-journal photography, but it's a good way to get a national audience while you pick up a few extra dollars. By studying the field, examining the magazines and taking the time to analyze a publication's potential needs, you might find yourself published on a regular basis.

Do a photo story on the oldest person in your community. Sell it to local weekly newspaper.

Does a baker teach cake-decorating classes in one of your area schools? Photograph the various stages in cake decorating for use a teaching aids. How about a Polaroid of each cake a student decorates to have long after the cake has been consumed?

Weddings

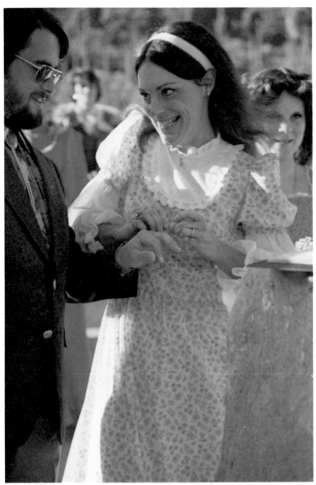

Randy Lowery caught this interesting look during the wedding ceremony. Don't be afraid to try something different, although you should always cover yourself with conventional shots.

As the organ strikes up the wedding march, your ears are filled with the beautiful music of money from your camera. Of all the ways you can profit from your photographic skills, none is so potentially rewarding for the advanced amateur as wedding photography. Not only is the supply of couples getting married seemingly inexhaustible, the amount of money spent for wedding photographs is greater than for almost any type of work an amateur can do on a freelance basis.

GETTING STARTED

The easiest way to break into wedding photography is when a friend or relative gets married. Show some of your photographs and say you would like to handle the wedding. They already know your interest in photography and have probably seen enough of your work to respect your abilities.

Because this will be your first wedding, offer to handle it on a cost-plus basis, perhaps charging $5 an hour for your time in addition to the bride's family paying all expenses. This gives you a portfolio and a little profit while giving them a bargain. The fact that you have no wedding samples to show will not matter provided your other work speaks of your general competence.

Handling a wedding is much like handling a news event. It is a one-time experience and anything you miss is lost forever. It's a high-pressure field and one many photographers don't enjoy. What you decide can only come after a little experience. The information in this chapter will help you shoot a wedding with enough skill and variety to please the couple and their families.

If no one you know is getting married, try asking friends about their acquaintances. Some clergymen will give you names of congregation members who have announced their engagements. Eventually your efforts will result in a chance to do that all-important first wedding.

There are promotion techniques. Put an ad in the personal classified ads in your local newspaper—Sunday edition. Contact people whose engagement announcements appear in the newspaper. Work through caterers, bakers and bridal shops, offering a bonus of perhaps $5 for every lead that results in your being hired. Display sample photos and scatter your business cards around. You can do a hundred things to promote yourself.

Your attitude will be important when starting to take wedding photographs. Every bride is beautiful. The moment she puts on that wedding gown, she is magically transformed into a raving beauty. This sounds a little silly, I'll admit, but your attitude toward the girl will be reflected in your work.

CAMERA EQUIPMENT

What equipment do you need? What equipment do you have? Any camera which uses 35mm or larger film is OK for weddings. You don't need interchangeable lenses, though they help, and you

Before the wedding the bride and her sister go out to the car. Such family scenes are as important to the bride as the photos of the ceremony. They help to increase your sales.

don't need the latest super Moneyflex camera. I recommend Equipment List D.

Professionals tend to use 120 roll-film cameras such as the Rolleiflex and Hasselblad, but for reasons which are generally outdated thanks to new films and improved 35mm equipment.

In the past, custom labs refused to process color-negative film smaller than 2¼x2¼. And the few labs which might process 35mm as a favor for regular customers had no facilities to provide quality prints. They argued, and rightfully, that 35mm lacked the quality of the larger sizes. They simply could not provide the working professional with a sharp, relatively grain-free enlargement from 35mm so they refused to handle such orders.

Today both films and labs have changed. Films such as Kodacolor II and Ektacolor S provide enlargements from 35mm film rivaling prints from the 2¼x2¼ film of just a few years ago. More important, the custom color labs now provide ser-

A good photograph of a wedding cake can sell to the caterer. A photograph of a reception orchestra can become a publicity photo for the group.

vice for 35mm users. They will even make professional quality enlargements up to 16x20 or more from 35mm film.

Generally the pro who knocks 35mm print quality is the kind of photographer who steps back far enough to get everything the lens will allow into each photograph. When the bride is coming down the aisle, he will not only have her framed in his viewfinder, he will have 80 feet of aisle space, half the pews in the church, the choir loft and anyone standing outside the church waiting to get in. When he sends this mess to the custom lab, the technicians crop all the junk from the large negative, returning a close-up of the bride holding her father's arm, walking down the aisle. It's a beautiful picture, a sensitive picture, and the photographer brags about his skill. If this same "professional" used 35mm negatives, the cropping and enlargement would be so drastic his prints would be masses of grain. It is because of *his* limitation, *not the limitations of the format*, that he doesn't get high quality from 35mm film.

Remember when using 35mm film to fill the frame with what you want in the print and nothing more. In the case of the bride coming down the aisle, wait to take the photograph until she and her father fill your viewfinder frame. If you do that, your work will outshine the photographer who lets the lab compensate for his inabilities.

Everyone knows that when a camera malfunctions, it always waits until the worst time to do it. A man from Mars has just landed in your back yard and you rush out to take his picture. You have the right film and the right light. You set your shutter speed, *f*-stop, advance the film and feel the gears suddenly grind themselves into powder.

If you photograph a wedding with just one camera, you are inviting mechanical disaster and the wrath of the bride's family who have been counting on you for the wedding pictures. A wedding is a once-in-a-lifetime event. At least that's what the couple thinks at the time. You can't ask them to wait while you call an ambulance to take your camera to the repair shop. The rule of wedding photography is you *always* have a back-up camera to use in case of emergency.

The simplest approach, if you have interchangeable-lens equipment, is to use two camera

Pre-focusing your flash results in consistent lighting. I misjudged slightly on these two so the perspective isn't quite the same but both negatives are close in exposure.

bodies, which fit your lenses. This is not an absolute must, though. My first wedding was taken with that 2¼x2¼ single-lens-reflex with the pop-bottle-glass lens mentioned earlier. My back-up was a borrowed 35mm camera in which I had loaded Tri-X.

As it turned out, the back-up camera saved me. I used the wrong combination of film and flash in the 2¼x2¼ and also put an unneeded blue filter over the lens for color correction. The bride's white wedding gown turned blue and her attendants' red dresses turned purple. It was probably the worst experience of my young life, but I got some good pictures with the back-up camera. They were not in color, and I charged the couple only the cost out of embarrassment. At least it was not a total disaster. Take along two cameras and shoot with both of them—just in case.

If you don't own a second camera, check with camera shops in your area. Many have several cameras available for rent such as an older twin-lens reflex or a 4x5. The twin-lens reflex will be better for your needs, though you might rent a 35mm instead.

If you rent a camera, get it far enough in advance so you can run a test roll through it. Take a series of pictures while varying shutter speed and f-stop. Plug in your flash and be certain it

works. If the flash does work, it may go off before the shutter opens or just after it closes. You must try it, then have the film processed immediately at the nearest lab so they can tell you if anything is wrong. You don't need prints or a contact sheet, just the negatives and the lab's evaluation. Naturally you should make notes about how each frame was exposed so you will know under what conditions a problem might exist.

Many photographers have earned an excellent and well-deserved reputation working with just a non-interchangeable twin-lens reflex. However, the more ways you can approach a wedding, the more views you can offer for sale. Lenses from 28mm to 135mm for 35mm equipment and from 50mm to 180mm for 2¼x2¼ equipment can all come in handy. Longer telephotos are unnecessary and wider-angle lenses may distort to the point of ruining your photographs.

Your lighting equipment must also be fairly versatile. Electronic flash is ideal. Units which come with separate battery packs generally offer the fastest recycling times. Mine, for example, recycles in 1½ seconds. It is not automatic and does nothing but provide quick, efficient lighting for around 1,000 flashes before the battery needs changing. The cost was less than for some of the tiny automatic units that sit on the camera, use

Outdoor weddings offer more flexibility because you can generally move around easier and don't have to worry about dim lighting conditions. There are exceptions, however; see the dawn wedding picture on page 144. For this wedding, this location was significant to the wedding party; therefore, the photographer pulled back so the setting was recognizable. (Photo by Diane Ensign-Caughey)

If the event is indoors and you are not permitted to take pictures during the actual ceremony, make arrangements in advance to have everyone stay afterwards for posed pictures. High speed emulsions such as Tri-X or Kodacolor 400 allow for strong images inside or out, without having to change film.

penlight-type batteries and take 7 to 10 seconds to recycle.

The need for fast recycling time is to get not only the picture that seems perfect when you are taking it, but also the one that might occur immediately after, before the 7 to 10 seconds have elapsed. This is almost never a consideration for the important moments, such as the processional down the aisle, so don't worry if you have a show recycling unit. Use it intelligently.

Whatever type of electronic flash you own, be certain it is working well and that you have calibrated it before the wedding. The Guide numbers supplied by flash manufacturers are based on use in average-size rooms with reflective painted walls and ceilings—not like a church. To be sure you are using an accurate Guide number, you must stand a known distance from a fixed object in church-type surroundings, focus and shoot test pictures.

For example, let's say that the flash manufacturer says his unit is rated at 1000 BCPS—Beam Candlepower Seconds. Never mind the claimed watt seconds. They don't mean much. With the color film you use, the film manufacturer says the Guide number is 80 for a 1000 BCPS flash. A chart showing the Guide numbers for electronic flash units is on the instruction sheet included with film. If you are standing ten feet from the object, take the first picture at ƒ-8. Make a note of the setting, then open up to ƒ-5.6. This assumes a Guide number of 56. Guide number equals distance multiplied by ƒ-stop.

Make test exposures at ƒ-4 and ƒ-2.8, then go up the scale, taking one at ƒ-11 and one at ƒ-16. If I use a camera with a between-the-lens shutter such as the twin-lens Rolleiflex or Yashica, I test at whatever shutter speed I will be using during the wedding, generally 1/60 or 1/125. With an SLR and focal-plane shutter, set at the proper shutter speed for flash.

Take the film in for processing only, asking the lab technician to note which frame is properly exposed. Find the corresponding number on your notes to learn which ƒ-stop was used. Then calculate the Guide number. Keep in mind that no two flash units of the same model are necessarily going to be exactly alike in their true ratings.

Even an automatic flash which measures the light and stops the flash when the proper exposure

is made must be calibrated. Some will consistently give too much light or too little.

You can use regular flash bulbs. My first wedding was done that way and there were no problems aside from the fiasco with the blue filter. Just be sure you have a way to handle your trash, even if this means using a second gadget bag for spent bulbs and the cartons they came in. Nobody likes the photographer who leaves junk around for others to clean up.

No matter what kind of flash you use, be sure you have an adequate power supply. If your unit uses a separate power pack, be sure the batteries are fresh. You can often judge the power of a 510-volt battery or similar high-power source by watching the ready light indicating your unit has recycled. If your flash, like mine, normally recycles in 1½ seconds, your battery should be OK for wedding coverage with a recycle time of up to four seconds. If it takes any longer than this to recycle, it is probably dying and you should buy a new one before the ceremony.

Self-contained units, whether rechargeable or with replaceable batteries, are extremely limited in the number of flashes. A rule of thumb is to plan for the maximum of 70 flashes per fully-charged set of batteries, with the last flashes taking 50% to 100% longer to recycle. Always start with a fresh or fully-recharged set of batteries, and carry a spare set. Perhaps you will not take 70 photos at the wedding, but if you approach that number and the action is happening faster than you are recycling, you will want fresh spares.

What I said about a spare camera body also applies to your flash unit. You must have a back-up in case of malfunction. This does not need to be an electronic flash. A standard flash gun and bulbs will work adequately, even though it is not as convenient.

To save gadget-bag space and reduce equipment weight, I often use a small AG-1 flash bulb unit as a spare. This is *not* a flashcube unit but a small flash gun with polished reflector. Be certain the reflector is smoothly polished. Units with a pebble-like surface—available as folding "fan" reflectors—do not reflect the light as efficiently as smooth, polished-silver units.

The flash gun uses the single AG-1 bulbs which come attached to plastic tubes. You slide one bulb from the tube and insert it in the flash,

 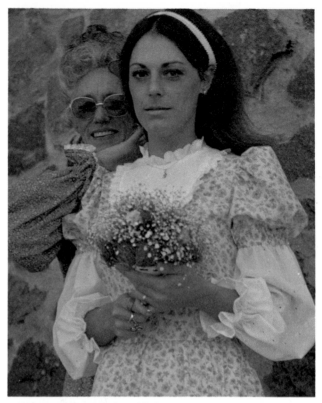

Outdoor portraits add to the flavor of the wedding album or slides—and can also result in additional sales of prints for display apart from the wedding. Family members always look good on such occasions, and will often buy extra copies for their own use. For this photo taken at a sunrise wedding, Diane Ensign-Caughey used full flash to avoid silhouetting the couple's faces. (Top right photo by Randy Lowery)

At certain times family members and friends may get in your way and block your view or prevent you from taking the best position for the shot you want. Work quickly and do the best you can.

much as you take larger bulbs from a carton. I always take the flash gun, spare batteries and three dozen bulbs. It all fits into a small side pocket on my gadget bag.

If you use these small bulbs, remember their limitations. They are good up to about ten feet. Beyond that they are practically worthless. However ten feet is far enough to be when the bride is coming down the aisle. You will get a nice tight picture of her and her father with plenty of light to illuminate her face.

Another potential trouble spot is the cord which connects flash unit to camera. These are fragile and always choose the wrong time to go bad. I carry three to be on the safe side as I have known of several times when a photographer used one, had it break, used his spare and had *it* break, all before the wedding was over. To make matters worse, the breaks are always internal rather than something you can see and anticipate. Remember to avoid "red eye" by having a cord long enough to hold the flash well away from the camera.

For film, there is very little choice. Color-negative film is essential, with more labs handling the Kodak line than that of any other manufacturer. This does not mean that other films are not good; they are just not so easy to get processed.

Color-negative film has more exposure latitude than slide film. Many wedding photographs are going to be taken far enough away that even with an automatic flash, exposure is liable to be a stop or more low. The labs can do wonders to correct for your minor errors when they make the prints, but this does *not* mean you can get away with sloppy exposure technique!

There are processing labs, film suppliers and camera equipment suppliers who can furnish almost anything you need. Keep in mind that every store and every processing lab is different. If you get terrible results from one, it's as likely to be

If a wedding is held in a new hotel or reception hall, the building manager may be interested in a photo of the happy couple taken during the festivities. Such a picture is used to convince other couples to use the facilities.

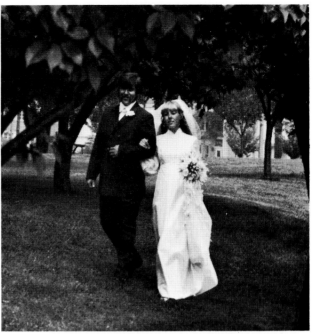

If there's time and a scenic spot, photograph the newly-weds walking together in their wedding finery.

their fault as yours—they'll never admit this—so try another until you get the quality you think you should have. Naturally, you must do this testing *before* you send off that important roll with the wedding exposures.

TECHNIQUE

There are two schools of thought about photographing a wedding. One is to use a checklist. You take no more and no less than the pictures on the list. It may include the bride and her attendants coming down the aisle, exchanging rings, the couple kissing, and so on. The result is an unimaginative album with a set number of photographs and nothing extra for further sales.

The second approach is: Film is cheap, the night is young and a round of beer for all! This may not be the exact terminology but it is close enough. You not only photograph the standard pictures found on any checklist, you also photograph everything that strikes your fancy. This ranges from the tearful mother-of-the-bride watching her daughter dance with the groom who isn't good enough for her to Uncle Harry over-loaded with champagne and dancing the Funky Turnip with one of the bridesmaids. You can probably skip the photograph of Aunt Alice giving Uncle Harry what-for about the champagne. This approach

Those all-important family photos. You may think it dull and routine, but every person who appears is a potential print buyer so be thankful for a large family.

Try to get the entire bridal party in a setting appropriate to the wedding. In this case the church setting blocked some of the people, but it was important to use that particular location because the minister was also the father of the groom.

brings out the real heart of a wedding. You capture the happy-sad-sentimental moments accurately portraying the real mood and memories of the day. It assures you far more sales than sticking to a rigid checklist of subjects.

The average professional is going to offer services which you can consider. He will photograph the bride being fitted in her gown, and he may also take a formal portrait in his studio prior to the wedding. You may not have the time to go to the fitting, nor can you charge what the full-time pro gets for that kind of work. You may not have a studio.

You will probably begin in the bride's home or at the church shortly before the wedding. If the bride requests a formal portrait, tell her it is more meaningful to have such a photograph taken where the ceremony is held, just before she stands in the receiving line. Then she will be radiating the inner beauty that emerges when a girl is married. Wedding experts say the candid trend has reduced the number of girls who ask for the formal studio-posed bridal portrait.

I have never heard of a bride *requesting* the fitting-room photograph. Many pros encourage the bride to order one because, if they handle weddings almost exclusively, it gives them something productive to do during the slack time of the week. Many brides think such a photograph is not necessary but go along with it because the pro says it is traditional.

Prior to the wedding day you need to ask about several things. You must know the church or temple photographic restrictions during the ceremony. Some allow anything you want to do including flash pictures. Others allow photos only by available light. Still others let you photograph as the bride goes down the aisle and as she and her husband return, but allow no pictures whatsoever during the ceremony.

If photos are permitted during the ceremony, find out if there are special moments of importance, such as the breaking of a wine glass, which you should be ready to shoot. Request a copy of the service so you will know what is happening. With some religious groups, such as the Episcopal Church, the bride already has a copy of the service in the *Episcopal Book of Common Prayer*.

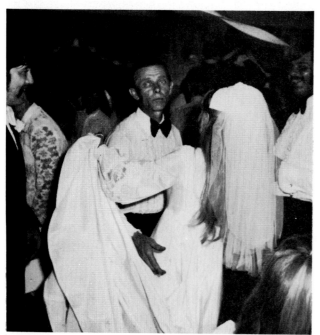

The bride's father seems to be wondering how his baby grew to be a woman so fast. Note the groom to the left of the picture. This is one of those photos a bride cherishes.

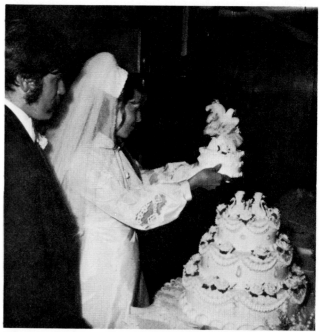

When the bride starts to cut the cake, you start taking pictures. Keep working until the couple has fed each other. Anything can happen at this time and probably will.

If there are specially important features which can't be photographed *during* the ceremony you may want to have them repeated when you are taking photos right after the ceremony.

Are there any customs you must know before entering the church or temple? Must *your* head be covered, for example?

If the church or temple allows you to roam and photograph freely during the ceremony, ask the bride if she has any preferences as to how you work. Just because a clergyman agrees to let you use flash during the ceremony doesn't necessarily mean the bride wants you to use flash. Her family is paying the bills and her wishes are important.

One photographer I know tells of the time he used regular #2 flash bulbs to photograph a wedding ceremony. In the midst of the service one of the bulbs exploded with noise that echoed through the church. At the reception the bride commented to the embarrassed photographer that she had been afraid the ceremony was turning into a shotgun wedding.

Never assume that because you have photographed a wedding in a particular location before, you automatically know what is allowed and not allowed. Although some religious places have set rules about photographing weddings, others do

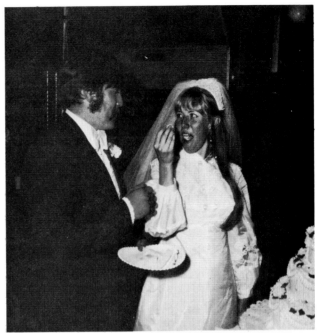

Don't let your wedding coverage stop with the reception. For an additional fee, meet the couple when they return from their honeymoon. Take a photo of the groom carrying the bride over the threshold of their new home or apartment. Then plan to photograph their children.

not. They leave the decisions to the officiating clergyman. So rules may vary with the person performing the ceremony. Find out ahead of time by talking with him.

Before we get to exactly what you photograph, let's talk briefly about the main reason you're reading this chapter—the money you can earn. A checklist at the back of this book will help determine your costs. To this add a mark-up plus perhaps an hourly rate for the time you work. Charge only in multiples of an hour. Figure an hour for the wedding, a second hour for photographs at the bride's home prior to the ceremony, another hour for the wedding dinner and probably at least two hours for the reception. You work only until the bride and groom leave—no matter how long the festivities go on after. If the family wants you to stay longer, charge more.

When you quote a price, make it for a certain number of prints of a certain size, generally either 8x10 or 11x14 for at least one album. Larger sizes are too costly and smaller sizes are not visually effective. She will select the ones she wants from the proofs, but she must understand that any additional prints will cost more money. If she is offering you a flat rate for your work, don't accept unless you can give her an album that will be profitable for you. It may be smaller than the one you would supply if setting your own charge, but this is not serious.

Many brides on a limited budget only have $100 to $150 to spend for pictures. If so, you must limit your time to just the wedding and perhaps a few portraits immediately afterwards. You might also use the color negatives to make black-and-white prints. If you can make a profit from what is offered, take the job because you can often sell additional prints in color when the couple gets more money.

After talking with a bride, type up an agreement stating what is expected of you and the agreed price. Use a carbon and both you and the bride, and her parents if she is under age, should sign it. This prevents misunderstandings. They happen rarely, but even once is too often.

Your work begins the day of the wedding, generally at the bride's home. You should be ready to start taking pictures the minute you walk in because you will find the place too much of a

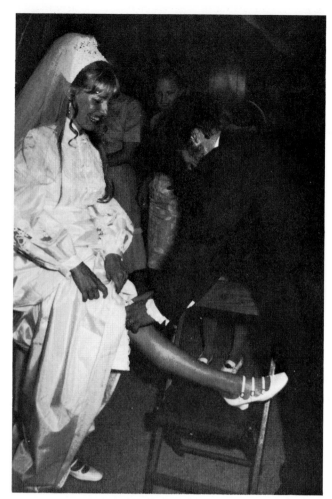

Another traditional photograph. This is part of the garter ceremony, and is always a hit.

mad-house to set up inside. The father of the bride will be sitting in the living room trying to figure out if a second mortagage will pay all the bills. The bride will be asking her mother if she is really doing the right thing. And the mother will be assuring her that she is *not* doing the right thing because the groom isn't good enough. Everyone is tearful, frantic and ill-tempered because, after all, this is the happiest day of her life.

If you have a wide-angle lens, you will probably use it exclusively in the home. Your job is to stay with the bride while she and her mother put the last-minute touches on her make-up and gown. Use available light if possible and, if not, try bounce lighting rather than direct flash. Photograph the bride and her mother as well as the bride alone. Interesting photographs can be taken as the bride looks in the mirror and as she speaks to her brothers and sisters.

The couple dancing together in a private moment. Another sure sale.

Be prepared to capture the father's face when he first sees his daughter in the gown. At that moment she is transformed from a financial liability to the most beautiful young woman in the world, and the expression on his face is filled with love.

For portraits of females who are not classic beauties, use soft lighting. If you own a diffusion filter, you may want to use it when you are taking a close-up of the girl's face. You can also step back a little so her face is a smaller part of the frame. You will want some full-figure photos anyway. If all else fails there is always the retoucher, though such skills cost dearly and should not be necessary if you are careful. Naturally, with an attractive girl, normal photographic approaches will result in excellent photos. No special tricks are needed.

If you are not using flash, stay in the background and keep as inconspicuous as possible while you work. Don't talk unless someone speaks to you. With luck, the bride and her mother will forget you are there. If you are inconspicuous, you will record intimate moments between mother and daughter and the pictures will be treasured.

Photograph the bride getting into the family car, then either drive to the church with her or ask for a couple of minutes head start. You want to be at the church to photograph the arrival. I prefer having one of the bride's family drive me because it gives time to concentrate on plans. If you have a wide-angle lens and travel with the bride, you might even take a couple of photos of her on the way. Don't distort her appearance by having the lens too close.

At the church take pictures of her waiting for the ceremony to begin, pictures with her bridesmaids and many others. If you have the opportunity, photograph the groom with his attendants. His role in all this is a minor one however. Nobody buys pictures of the groom *alone*, not even his parents. This is the bride's day so don't be concerned if there is no time to catch him.

When the ceremony is about to start, position yourself in the aisle. Locate a spot several feet in front of you where the bride and whoever is giving her away will fill the frame. Focus on this spot and set your flash and f-stop accordingly. As the wedding march begins and the attendants start down the aisle, take their photographs when they reach the pre-focused location. Photograph all attendants and the bride. Because you pre-focused, your negatives will be sharp and properly exposed.

In any large wedding, a slightly inebriated Uncle Harry is going to shove in front of you to take the same angle with his camera.

Your first instinct is to elbow Uncle Harry out of the way because you have a job to do. Ask him politely to please step to one side so you can work. If he refuses, go over to the bride's family and explain that with him in the way you are unable to capture all the beauty of the the wedding. Believe me, that will get results.

Occasionally all efforts fail to dislodge Uncle Harry. Drastic measures are necessary. My personal approach is one I developed when doing freelance news coverage of riots and similar events where people are less than cooperative with a photographer.

If he is just being a little pushy, I stand with

my feet apart, keeping my body balanced and my elbows out. If Uncle Harry pushes, he usually gets my elbow in his ear, side, or whatever portion of his anatomy is at that level.

If he is the type that likes to get in front of you, try staying very loose and relaxed up to the moment you want to take a photograph. Then step in front, taking the same stance as mentioned in the previous paragraph. Shoot and then move back to the side, letting him do his thing. Because you are not constantly in his way, he is unlikely to get belligerent.

Admittedly such tactics should not be necessary. However, you are there to record the wedding. Be quiet, inconspicuous and polite. If you encounter Uncle Harry, do whatever is necessary so he doesn't ruin your work.

When the bride and groom are at the altar, you may have to sit down and wait for the ceremony to be over. So pick a spot to take pictures of the couple returning up the aisle. Sometimes this means sneaking to the back, pre-focusing, and waiting for the ceremony to end.

At many marriages you will be allowed to take photographs during the ceremony. When the father gives away the bride, catch him kissing her or placing her hand in the groom's and stepping back to his seat. You can probably use flash, assuming the clergyman approves, but switch to available light immediately afterwards if at all possible.

The best approach to available-light photography is to take an incident-meter reading just before the processional by briefly stepping over to the altar or a similarly lighted spot. Usually this is not possible so you need a reading from your position in the church, which you can get with a spot meter or a long lens on an SLR with built-in metering. Or, go where the ceremony is being held a day or more in advance, perhaps during the rehearsal. Use your meter to take a reading, checking with the minister to learn what lights will be turned on and making sure they are on.

If you are shooting during the ceremony, do it quietly and without attracting attention to your-

WHAT TO SELL THE BRIDE

Basic album including binder and 12 to 20 color photographs in 8x10 size. This is what the bride expects for your basic charge.

Basic album with 11x14 prints instead of 8x10. This is the album you try to sell the bride because it means more profit.

Additional albums for family. A binder with the same prints found in the bride's album, usually smaller size. Try to sell one to the bride's parents and one to the groom's parents. Additional albums as gifts for grandparents and important relatives like Uncle Harry. Make a special offer of one album containing your proofs, so you are sure to sell them too. An album with prints in black-and-white can be offered as gifts for the best man, maid of honor and attendants.

Framed enlargements at 11x14 or 16x20 such as the portrait of bride and groom. These appeal to both sets of parents. A separate sale of the bride's portrait taken alone.

8x10 prints in attractive folders. These should be offered for mailing to family and friends. The prints will generally be of the bridal couple standing together or the couple with the people to whom the prints are being mailed.

Additional color prints for the bride's album. These are prints beyond the agreed upon number in addition to the basic album charge.

Sell the bride a box of photographic "postcards" for thank-you notes. Some custom labs offer these, but usually you will have to make the prints yourself.

Additional prints for the album or to be framed, offered six to eight weeks before the anniversary date. These are to be used as gifts for the bridal couple. If the original album was black-and-white, these might be in color and you can offer a color album. Or these might be previously unsold prints.

self. Kneel in the aisle for a low-angle. Take some views from the sides. Go up in the choir loft. Use telephotos, wide angles or whatever you have. A unipod, shoulder pod or tripod will come in handy no matter how much light you have. Try anything and everything so long as you don't take attention away from the ceremony.

If you have two cameras and an assistant, you might mount one camera on a tripod at the rear of the church or in the balcony. Attach a short telephoto lens, focus it on the couple at the altar and let the assistant click away. You roam with the other camera, thus insuring an even wider variety of pictures.

If you own a motor-driven camera, try mounting the camera over the minister, aimed down at the couple, if permitted. This is a problem involving both church regulations and the physical design of the building. The unit can be triggered with either a long hidden air release or an inexpensive radio trigger which many camera stores offer for under $50. However, all this is gravy. It's good to know and if you have the equipment, you will get unusual photographs. But these are not essentials.

When the ceremony is over, quickly take the posed photos agreed on in advance, before the couple is congratulated by friends and smeared with lipstick and tears. These may be formal portraits in the church, in front of the building or in the minister's study. You can pose close-ups of such things as the exchange of rings in front of the minister.

It is essential that you, with bride and groom, carefully plan the photographs to be taken *after* the ceremony as long *before* the ceremony as possible. You may need to visit the church or synagogue to see where pictures can be taken. Family and friends will be flocking to the couple the moment the ceremony is over. Have the newlyweds

go to the planned location for pictures immediately after the ceremony. Get this straight in everyone's mind and make sure they understand. Mention it again just before the wedding starts.

Next take photographs of the couple being congratulated by family and friends and photos of the couple with their families. If there will be a reception, you can wait for the family poses until then. In either case, be certain the bride and groom look presentable. Let them use tissues from your wedding kit to correct any problems such as lipstick on the cheek.

Be sure to photograph everyone *before* any drinking begins. I photographed one wedding where the bride's grandfather, whose picture she wanted more than any other, kicked up his heels and began dancing with the bridesmaids. He was carried from the reception hall, overcome by the liquor and excitement. I took his picture with the bridal couple before the reception began, so the wedding album was complete.

The wedding photo checklist at the back of this chapter is a guide to the important, traditional photographs, but be alert for the unusual. One photographer caught the bride pushing a piece of wedding cake into her husband's face. The couple thought the photograph was funny and ordered copies for all their friends.

There is a classic wedding photo where the groom accidentally toppled into the cake. This particular photograph made *Life* magazine's Miscellany Page. If you get such a picture, and you can get a model release, newspapers and magazines are likely to buy it. If you take it to the nearest office of The Associated Press or The United Press wire services, it may appear all over the country.

Look for unusual effects. Try framing the couple through the statues of the bride and groom on the cake. Perhaps the couple is reflected in a wine glass as they drink. Maybe some flowers can be included. Try a high angle or a low angle. In other words, move around as you work. Be daring and use your film. You will not be showing the couple every photograph you take but only those which turn out so you are proud of them. If you try something and it fails, no one will know. It is better to waste a little film than to deliver a trite album.

Before the reception is over, get a check for an amount agreed upon in advance. Normally this

It used to be a joke but more and more couples are holding divorce parties. If none of your friends are splitting, talk with local caterers who may handle these "affairs." Naturally you don't put the fact that you handle divorce parties on the same business card that says you handle weddings.

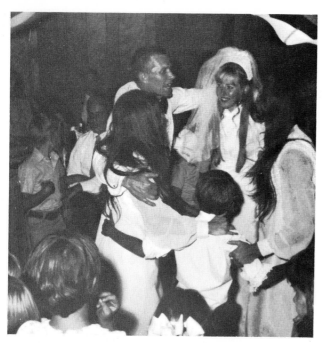

Shots of the bride dancing with members of her family are extremely important—these are the last moments she will be a sister and daughter; when she leaves the reception, she will also be a wife. Family relationships continue, but will never again be the same. These memories are very important. And don't forget another of the ceremonial happenings: The tossing of the bouquet is important to everyone involved—including the one who catches it.

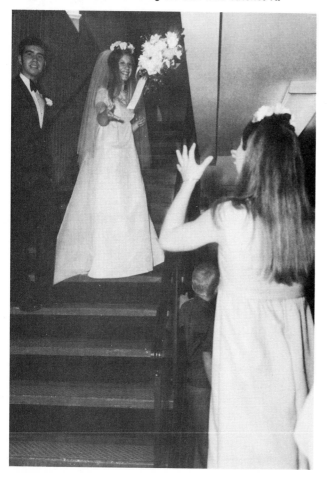

will be equal to your estimated expenses.

Meet with the wedding couple and perhaps her parents when the bride and groom return from their honeymoon or you get your proofs back from the lab. This is usually in two weeks when memories of the wedding have started to fade and the nightmare of the bills has not yet begun. It is a time when the pictures bring back the emotionalism of the day and when every photograph seems too beautiful to go unpurchased.

A few prints made at your own expense will boost your sales. Have the lab supply you some of their "gimmick" wedding prints such as wedding music overlaid on a photo of the couple, or the couple encircled by a heart, or the couple superimposed on a wine glass. If the couple agreed to purchase an album of 8x10 prints, have at least one photo made 11x14. This will either result in their buying the larger size album for more money or single prints for framing. Also show a drymounted 16x20 in an appropriate frame. You can use the same 16x20 as a sample for every wedding, to reduce expenses. However, the 11x14 print should be of the girl you are trying to sell it to.

Proofs should be shown in a wedding album of appropriate size. If the family likes the proofs, they may buy additional albums in the small size for relatives and bridal attendants. Proofs are small sample prints of quality equal to the larger ones. The days of proofs that would fade after a certain amount of time are gone. If you can sell every print the lab turns out, more money to you.

Wedding pictures should be sold for cash only. Full-time professionals can honor credit cards and set up time accounts, but you can't be bothered. If you know the bride and her family very well, you might be willing to let them make two or three payments during the next few weeks. However, a wedding generates a lot of bills. Once they have the photographs, it's easy to put off paying you until the other debts are paid. Use your own judgment, but extend credit very carefully.

FOLLOW-UP SALES

Mark a calendar with the couple's anniversary date. Six to eight weeks before that time, contact the family again. Offer prints as anniversary gifts. The family may decide they have enough, but if they had to limit their selection when you first did the work or if the couple only received black-and-white prints, you might find yourself

doubling or tripling your income through additional sales.

Weddings take a little extra effort and are often as demanding as covering a news story for a magazine. But they are happy times, colorful times, and they offer the best opportunity for part-time income.

CHOOSING YOUR PARTNER— A CUSTOM LAB

Quality and speed are important. Find out the *maximum* time in the lab so you know what to promise your clients. Most labs try to provide one or two-day service but can only guarantee they will take no more than five working days. If the lab is out of town, consider time in the mail as well.

When "checking out" a lab, find out:

Type of film handled (35mm, 2¼, etc.).

Size and cost of enlarged proofs—generally 3x5 or 4x5.

Special wedding packages, if any. Some labs will process 120 roll film and provide 8x10's for around $1 each if ordered at the same time as processing. Others provide proofs mounted in albums, and other services.

Print sizes available and costs. Most labs have two price ranges. One is for machine-made prints, the other for hand-made. The latter cost more but are generally better quality. Try samples of each before deciding which you will offer.

Special effects possible and cost. For example, these might be superimposed images, wedding music overlay sheets and pictures in hearts.

Maximum time for print order when no processing is included.

Other services available such as dry mounting, black-and-white printing and albums for sale.

TED'S RULES FOR WEDDING PHOTOGRAPHY

1. All brides are beautiful. It is your job to reflect this in your photographs, using your camera to show her at best advantage.

2. The standard wedding album will have from 12 to 20 photographs. You decide how many you will offer for a set price. However, by having more proofs than prints in the album, you can expect at least a 50% greater profit through the sale of additional prints.

3. The more people related to the bride who see the photographs, the more sales you will make.

4. Every high-quality photograph you can't sell immediately after the wedding, you can sell to the family 11 months later for anniversary presents.

5. There will be at least one drunk at every wedding who will wait until you are ready to take a photograph and then get directly in your way.

6. For every three flash cords you carry to a wedding, two will break down. Maybe all three.

7. No matter what your base charge for a wedding, get an advance that is equal to your expenses. When the bride sees the proofs, she is likely to spend the amount originally agreed upon *plus* the amount she gave you for an advance.

8. Your wedding profits will be affected by how much you eat and drink at the reception. If you act like a guest, the bride's family will pay for the minimum album and nothing more. If you act professional, refusing libation because you are at work, they will treat you as a professional and buy and buy and buy

9. Always carry at least one roll of film more than you think you will need.

10. A wedding is the bride's day. If you run low on film, reduce the number of pictures of the groom's side of the family. Her side spends the most money so give them the best selection.

When the couple is being congratulated, beware of lipstick turning their faces into something resembling a clown. Your touch-up kit of cold cream and tissues may be necessary.

The happy bride wants to give you money—for taking pictures like this.

LIST OF CUSTOMARY WEDDING PHOTOS

Last-minute preparations of the bride.
The bride arriving at the church.
The bride with attendants.
The processional.
The father giving the bride away (if possible).
Highlights of the ceremony (if possible).
The couple kissing after the ceremony.
The recessional.
The couple alone.
The couple with the clergyman.
The exchange of rings either posed or candid and a close-up of the hands showing the rings.
The receiving line or the couple being congratulated, however it is handled.
The cake.
A close-up composition of wedding symbols. This might include hands with ring(s), flowers, the license, perhaps a Bible, etc.
The reception.
The dinner.
The toast to the couple.
The couple toasting each other.
The couple's first dance as man and wife.
The couple with his parents.
The couple with her parents.
The couple with both sets of parents.
The bride cutting the cake and the couple feeding each other.
The couple with grandparents, aunts, uncles, cousins, etc. Take them singly, in groups or both. Remember to be certain to get everyone on her side of the family at least. Pictures not bought for the album will be bought for mailing to family members as mementos of the occasion.
The tossing of the garter.
The tossing of the bridal bouquet.
The tossing of the rice.
The decorated car.
The couple getting in the car.
The couple inside the car.
The family and friends waving as the car pulls away.
Optional: The parents of the bride "not losing a daughter but gaining a son."

WEDDING PRINT ORDER

Special Effect Prints in Album:

Mr. & Mrs. _____

Address _____

$_____ Phone _____

Additional Albums: _____ ☐ Color ☐ B&W $_____
Same as Wedding Album

Mini-Album of Proofs: ☐ All Proofs $_____
_____ Proofs $_____

ADDITIONAL PRINTS:	Dry-Mount	Special Effect	$
5x7			
8x10			
11x14			
16x20			
20x24			

CHARGES PAYMENTS Date Received

Special Effects in Album	$_____	Deposit	$_____	_____
Additional Albums	$_____	Balance	$_____	_____
Mini-Album of Proofs	$_____			
Additional Prints	$_____	TOTAL PAID	$	
Rush Charge	$_____			
TOTAL	$_____	Signed	Date _____	

Date Promised:

(Reproduce your business card here.)

WEDDING ALBUM ORDER

Bride _____ Groom _____

Bride's present address: Couple's address after (date) _____

_____ _____

_____ Phone _____ _____ Phone _____

Bride's Parents_____ Groom's Parents_____

Address _____ Address _____

_____ Phone _____ _____ Phone _____

COVERAGE

☐ Prints in Color

☐ Home before Wedding ☐ Prints in Black & White

Date: _____ Time _____

Address _____

☐ Wedding

Date _____ Time _____

Address _____

☐ Reception

Date _____ Time _____

Address _____

Person to Perform Wedding Ceremony:

Name_____

Phone _____

(Reproduce your business card here.)

ORDER
_____ 8x10 prints @ $ _____ each
mounted in Deluxe Album $ _____
Plus $_____ per hour for photo services,
_____ hours minimum $ _____
TOTAL $ _____

PAYMENTS		DATE RECEIVED
Advance Fee	$ _____	_____
Proofs	$ _____	_____
Prints	$ _____	_____
TOTAL RECEIVED:	$ _____	

Signed _____

Date _____

You can order additional prints and albums at any time.

THANK YOU!

Camera Maintenance and Buying Used Equipment

This chapter is slightly different from the others. So far you have been reading about projects to help you earn money. This chapter is going to show you ways to save it and spend it. This chapter deals with preventive maintenance and buying both new and used equipment.

Preventive maintenance is making simple repairs so major repairs are unnecessary or infrequent. You can have the most potentially profitable assignment ever given a photographer and the most talent ever seen, but if your lens falls apart you have lost that golden opportunity.

Preventive maintenance generally begins with the camera body. This is the heart of your tools and also the item that gets the most abuse. Your lenses may interchange so no one lens is used all the time. Flash is added only occasionally and filters are used for special effects. But your camera body is used day in and day out, all year round.

The shutter—whether in a lens or the camera body—is the primary source of problems. When the shutter goes bad, your negatives will come out too light, too dark or not exposed at all. Keeping it in good working order is essential to get quality work.

I am assuming that when you read this your equipment is in good shape. If it is not, it should be overhauled by a professional repairman before you start worrying about what is discussed in this chapter. I can keep you from seeing him very often, but I cannot help you avoid a needed repair bill for a camera that is currently malfunctioning.

Shutter problems are mainly caused by *under*-use, not over-use as many people think. Like the muscles of your body, a camera shutter goes bad when it does not get enough exercise. Because much of our work is done under fairly consistent lighting conditions, generally only three or four shutter speeds are used with regularity. Most cameras have nine or so different speeds, so this leaves perhaps a half dozen that may not get used for weeks or months.

First, check to see if all shutter speeds seem accurate in relation to each other. Remove the film from your camera, then hold the camera near your

Camera "tells" you when shutter speeds are not exact in relation to each other. Learn to listen for the differences.

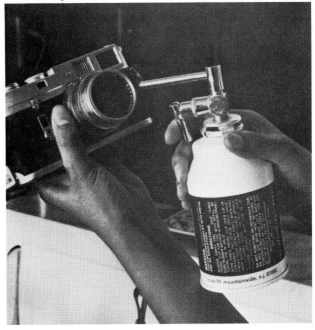

Most canned-air products are excellent. I use the Dust-Off because the variable air pressure valve lets me handle a wide variety of tasks.

ear and work each speed. Start with the slowest and progress to the fastest. If the camera is working properly, each speed should sound approximately half as long as the speed which preceded it. You can actually hear the difference and, with a little practice, you will find that your ear is a good judge of shutter-speed condition.

Some photographers say they can judge shutter speed by eye. They remove the lens and the camera back, hold the body up to the light and start running through the speeds. They claim they can see the difference between 1 second and 1/2 second, for example, and maybe they can. But the eye holds images for 1/10 second which means that any speed faster than 1/10 second will tend to fool the eye as to its actual duration. Your ears are not subject to such deception.

Assuming your shutter is in good working order, you will hear it operating properly. If one or more speeds seems to be lasting longer than it should, see a repairman. Don't take anything apart yourself. Such problems are usually caused by a little dirt and an inexpensive cleaning by a professional will be all that is needed. Keep in mind that the listening test determines the relationship of one speed to another. It has nothing to do with the accuracy of a shutter speed.

Most shutters are slightly inaccurate. 1/1000 second might be anywhere from 1/800 to 1/1225, for example, due to the tolerances allowed by camera manufacturers. This is to be expected. All that is important is that the shutter speeds be accurate in relation to each other, with each speed being half the time of the slower speed which preceded it.

Some may wonder how I can talk so calmly about the chance that your shutter speeds might be off. Keep in mind that a film's ASA rating is only a guide to set your camera. If your shutter speeds or light meter are slightly off, you may find that the ASA rating needs to be altered to suit your equipment.

I once tried Fujichrome color-slide film at its ASA 100 rating. With my equipment, that rating results in consistent overexposure. By using ASA 160, the exposure settings are perfect.

Once you know your shutter is working properly, keep it that way. Every two or three weeks *exercise* the shutter, working each speed

five or ten times. This takes only a minute or two and it helps the shutter to work accurately and consistently. It's a nuisance I admit, but less than having your camera in the repair shop.

Frequently check the inside of your camera body to be sure it's clean. Pay particular attention to the take-up spool. Often tiny bits of film will break off the leader. They work their way into crevices and scratch the negatives. Sometimes they move into a position that results in a shadow area being recorded when the film is exposed. I once took a roll of photographs at the zoo, every one ruined by a film chip lodging between the film and the shutter so it blocked light that should have hit one corner of the frame.

If you find a chip, use a pressurized can of air or gas which camera stores sell. I use Dust-Off brand which comes complete with an adjustable release valve. I can use low pressure to remove dust and a hard blast to dislodge a film chip. Such pressurized cans are the only truly safe way to remove such chips. Your fingers or tweezers are liable to damage the pressure plate or other parts of the camera.

Even if no chips are in the camera, cleaning it with pressurized air is a good idea. Any dust or dirt inside is dislodged and blown away.

If your camera has a built-in light meter, check the battery compartment to make certain the battery is in good shape. Sometimes a battery will start to corrode before you expect it. If you wait until the built-in battery tester indicates it needs replacement, you may have expensive damage inside the battery compartment. No matter what the manufacturers say about batteries lasting a year or two, I change mine every six months unless the battery tester indicates a more frequent change. I put a piece of masking tape on the bottom of my camera and mark the tape with the date the batteries were installed.

The flash contacts inside the camera should be checked every few months. There are all sorts of tricky ways to do this but the most reliable is to use a roll of film. First plug in an electronic flash and take photographs at the speed or speeds the camera instructions say are for electronic flash. Then use flash bulbs and try one at each shutter speed that can take flash. If the exposures are OK, the flash mechanism is working properly.

Jeweler's screw driver lets me tighten the screw without damaging the head.

When you can't carry a magnifier with you, the camera comes with its own device built-in. Just take off the normal lens and use it as a magnifying glass.

Every camera is held together by tiny screws. When they're tight, everything is fine. When they work loose, as they used to do around the lens of that ancient camera I once owned, you have trouble.

Vibration is the most common cause of loosened screws. Although there is no hard and fast rule, the less your camera cost the more frequently the screws will work loose. Expensive equipment often is made with such rigid quality control that seemingly minor tasks such as tightening the screws are done very carefully.

I use Leicas, for example. These cameras are expensive enough that the screws are tightened with care. I have taken my equipment more than 7,000 miles by plane and car in the last year, plus backpacking it on Arizona mountain trails. When I checked the screws, they were as tight as when first installed. By contrast, I used to own an inexpensive single-lens reflex. The camera worked well and took many salable photographs but I had to tighten the screws every six to eight weeks or they would loosen to the point of falling out.

To tighten screws without damaging the camera you *must* have screwdrivers with blades *exactly* fitting the screw slots. Tiny tools known as jewelers' screwdrivers are available at camera stores.

The more you pay, the better the steel and the longer they will last. Generally you can get an adequate set of the screwdrivers, complete with several different blades, for $5. Professional repairmen pay as high as $25 to get a set for heavy-duty use.

Before checking tightness, find the blade that EXACTLY fits the slot in the screw head. If it is too wide you will only scratch the metal around the hole. If it is too small, you will severely damage both the blade and the screw head, possibly making it impossible to remove the screw. When you have the right tool, carefully tighten the screw if it is loose. Each screw that is visible should be checked. If it is tight, don't tighten it some more!

Tighten screws when they need tightening but don't do any exploring in the mechanism. Repairmen spend years learning all the different parts and then they proceed with caution. If you open up your equipment, be prepared to pay for repair or replacement.

Your knowledge of preventive maintenance can help when shopping for equipment. Used cameras purchased from a reliable camera store that will guarantee good condition are excellent investments. The store must state that it will repair any

problems or replace the equipment without charge if it is faulty.

Check condition and operation the same as you do for preventive maintenance. Check the screw heads, though this time it will not be for looseness. Use a magnifying glass to examine the slots in the screw heads. Any evidence of damage indicates, at the very least, that the wrong size screwdriver was used for preventive maintenance. It may also indicate that an amateur dismantled the camera and interior damage resulted. My personal feeling is that when screw head damage is noticed, the camera should not be purchased.

Check the inside of the camera to make certain it is fairly clean. Look at the pressure plate. Are there any finger marks? Is the paint chipped? Let a light shine on the plate and hold it at various angles to spot any marks. If you find them or if you see scratches on the plate, don't buy the camera. The plate may be out of line or scratched to the point where it will damage the film.

Lenses must be treated with the same loving care as the bodies. Again the screws should be kept tight. In addition, the glass must be kept spotless.

There are numerous lens cleaning kits on the market, most of them containing a combination of fluids, special blowers and other expensive items. I don't buy them.

Lens cleaning fluid is needed only on extremely rare occasions. Most dirt and marks can be removed without it. More important, a slight miscalculation as to the amount of fluid needed to clean the lens may result in liquid seeping between the elements, permanently damaging the lens. Many photographers say that learning to use such cleaning fluids is only a matter of practice. However, while you're practicing, you may ruin your lens.

The best approach is to use the pressurized cans of air or gases mentioned earlier in this chapter. Blow off the surface of the lens, removing all loose particles. This must be done before any other cleaning can be accomplished. When you use lens tissue, dirt left on the lens will be ground in by your rubbing.

Lens cleaning kits include small rubber blowers which are excellent for keeping in your gadget bag. Such blowers sell for $2 to $3. My economy counter-measure is to buy an ordinary ear syringe sold in almost every drug store. The cost is around 50¢ to 75¢ for a small one and it is just as effective as the $2 blower.

After blowing the dust off the lens, take a piece of lens cleaning tissue and gently wipe the lens. If you wish, you can use a plain white cotton handkerchief that has been washed many times and is extremely soft. New, fairly stiff handkerchiefs will scratch a lens. You will be able to remove fingermarks and similar problems with this method.

Occasionally something adheres to the glass and will not come off with gentle persuasion. Fluid is necessary. Because of the risks involved, I usually take the lens to a repairman and let him remove the smear or whatever. It costs $2 to $3 but he doesn't make mistakes like I do.

When buying used lenses, stay with high quality name brands. These are built for many, many, years of service.

Check the screws in the lens mount as you would in the camera. Shake the lens gently to see if any elements seem loose. Amateur repair jobs often loosen the elements, which will adversely affect image quality and focus. Make certain the lens surface is not scratched, finger marked or otherwise damaged.

Focus the lens from infinity to its closest

Using the wrong type of flash bulbs with your camera will make your pictures look like the flash synchronization is not working. When you take the camera to a repairman, he will charge for the service even if he only checks it out and tells you nothing is wrong.

Hospitals have in-service training programs in many fields. Often the training takes several months with a ceremony at the end. You can make money photographing the graduation for the public relations department and by selling individual or group pictures of the graduates.

distance and repeat over and over again. It should move smoothly each time. If the lens openings are controlled by click stops, make certain that when you change the f-stop the control stops positively over the number. It is easy to move a loose aperture ring accidentally, altering exposure and ruining the picture.

If the lens is automatic, make certain it works with your camera. Does it shut down and re-open as it should? Take the lens on approval and shoot several pictures with the same f-stop. Is the f-stop consistent or does movement of the mechanism cause it to drift to a different setting?

Look through the lens as you turn the aperture ring. Does the aperture change as it should? Sometimes the ring moves but the lens opening stays the same. Remove the camera back and change the lens opening, releasing the shutter each time you set a different f-stop. You should be able to see the opening get smaller with each click of the aperture control from widest to smallest.

Checking the light meter is the next consideration. This can only be done with film in the camera and the store should allow you to use a roll while in the store. Naturally you will pay for the film.

There are two ways to go about checking a light meter. The least costly is to bring in your own meter if you know it is accurate. Then compare the readings you get when checking the same object in the same light. If the meters are within a half stop of each other, it may be all right.

The second approach is a combination of a separate check and a test roll of negatives. Put a medium speed film—ASA 100 to ASA 160—in you camera and take pictures in the store. Photograph people and objects in light of varying intensities. Also take one series of photographs of an object in fixed light, varying the aperture and shutter speed together so exposure should be constant. For example, 1/125 at f-8, 1/250 at f-5.6, 1/60 at f-11, and so forth. Then process the film immediately and make certain the negatives are all right. Use any local lab that can give you same-day service. You will not want prints or contact sheets, just negatives you can check. It's worth the slight expense to make certain the camera is working properly.

If you are going to use the built-in meter as your only meter, sensitivity must be a consideration when buying used equipment. Most new cameras have built-in meters sensitive enough to cover any photographs you can take hand-held as well as many situations where a tripod is required. This is not the case with older built-in meters. Be certain to check the meter under the same type of lighting conditions you expect to encounter while handling assignments.

Returning to preventive maintenance, the way you carry your equipment will determine its life. Fitted cases keep individual parts separated so they don't knock together. When you use such a case, decide where each lens and accessory will go, then make a habit of returning the item to its place after every use.

Gadget bags and carrying cases come in all sizes and costs. I have three bags. How many bags you own will be determined by your needs and your budget. Fitted cases designed for specific cameras such as the Nikon or Leica are sturdy, well designed and efficient—also costly. Many large camera stores have these cases used. If a used bag's straps show no sign of wearing thin, and the interior is in good shape, it can be an excellent buy. Who cares about a few scuff marks if the case is as waterproof and well sealed as when new? A camera case should be functional. Beauty is unimportant.

The main questions to ask yourself when considering a case are: Is it waterproof? Is it sturdy? Will it protect my equipment items from bumping against each other? Can I remove the equipment from the case quickly and easily when I am in a hurry? Will it hold everything I generally have to take with me? Can I get the same type case for less money at a different store? How is the strap attached—reinforced wrap-around or just stitched at either side of the bag?

If you only buy one bag, get the one that best fits all your needs, even if it is a little expensive. It's better to go around with an oversized bag and little equipment than to need everything you own and have a bag which can't quite handle it all.

Sometimes you can get a good deal on a case that is just a big empty bag without partitions or special padding. If the price is right and the bag meets all your needs, you may want to

buy it, then buy pouches to hold each of your lenses.

If you are intrigued by the attache-type fitted cases, why not buy a regular attache case, stuff it with foam rubber available from discount stores and fabric stores, and cut holes in the rubber to hold the items. Use a single-edged razor blade, leaving a little rubber between the lens and the walls of the case.

Someday you will drop a lens. I have done it twice and both instances were saved from disaster by lens hoods on the lenses. Lens hoods are inexpensive and offer good protection. They are a sort of preventive maintenance.

Whenever a camera is dropped, check all the controls to make certain everything works smoothly. If something seems to stick, no matter how slightly, or if a gear seems to be grating just a bit, take it to a repairman. Forcing the equipment or using it when it does not operate as it should can result in a minor injury becoming a major repair. If you drop a camera into water, get it to a repairman as quickly as possible.

Rangefinder and viewfinder windows should be cleaned regularly. Often these windows are tiny and difficult to reach. A cotton swab sold in every drug store is most effective for removing dirt from these tiny areas of glass. First use your can of compressed air to blow off loose dirt.

Polaroid cameras and Polaroid backs have unique problems. The developer paste tends to accumulate on the metal rollers in the camera. A moist cloth or cotton swab will remove this residue and you should clean up each time the camera is open.

Flash units require special care. An electronic flash is very much like a camera shutter in that it needs regular exercise to stay accurate. A flash unit is capable of providing a certain amount of light when it is new. This output is generally consistent throughout the life of the flash providing the flash is used regularly. If the flash is left idle for several weeks at a time, the capacitor loses its ability to reach full charge. Light output drops and your photographs will be underexposed if you have not periodically checked the unit.

To keep an electronic flash unit in good shape, manually flash it a few times every two or three weeks if it has not been used. You may use up your batteries a little sooner than you would like, but you will insure having a flash capable of giving you the amount of light you expect from it.

Regular batteries of penlight to D-size varieties should be replaced every six months or approximately every 70 flashes, whichever comes first. Larger batteries such as the 510-volt sizes are good for 1,000 or more flashes and can be safely kept for a year to a year-and-a-half. To store an electronic flash, let it recharge until the ready light goes on, then switch off and put it away.

Flash bulb holders have polished reflectors which blacken slightly with age and use. Keep them clean and free from the black deposit which will otherwise accumulate to reduce effectiveness.

Many photographers complain that flash bulbs don't make good contact when inserted in their flash holders. One solution is to wet the base but this causes corrosion over a period of time. A better idea is to have a small piece of fine sandpaper in your gadget bag. Wiping the base of the bulb against the sandpaper will improve the contact if this is a problem for you.

Remember my earlier warnings about flash cords. Connecting cords are notorious for either breaking or running off to Tahiti in search of adventure. The cords I've lost over the years must have gone *somewhere*. Always keep two or three flash cords for emergencies, just as you should always have a spare set of batteries on hand.

Rechargeable batteries can lose some of

If you see a dramatic scene, *take* the picture and *then* ask permission. Drama is impossible to repeat. If a photo is visually exciting, your client will usually try to use it. Perhaps a model release will be sought or an artist can obscure the features of people in the picture. The worst that can happen is destruction of a print, or a negative lanquishing in your files. Sales are never made from pictures that "got away."

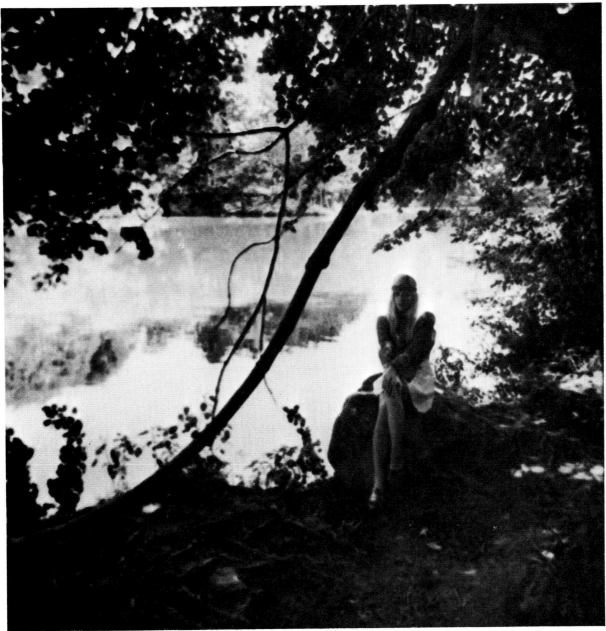

Your prints can signal an equipment problem. Over-all lack of sharpness warned me that my focusing mount needed repair.

their charge when idle. *TO BE SAFE, ALWAYS RECHARGE THE BATTERIES AND SPARES THE DAY BEFORE AN ASSIGNMENT.*

Warning! Some stores sell units which supposedly recharge any battery. What they really do is heat up the acid so the batteries can be used a few extra times. Not only is this dangerous, it also increases the risk of battery corrosion while in the flash. Never recharge a battery that is not *specifically* designed to be recharged.

For self-protection, always check flood-light extension cords to be certain they are in good condition. Frayed cords should be repaired or replaced. Keep all cords clean and dry.

Preventive maintenance, knowledgeable buying of used equipment and the careful consideration of new equipment can save you hundreds of dollars over the years. It may not help you earn money with your camera, but when you must spend money, it helps to spend it wisely.

Earning Money "In The Dark"

There is another side to photography which you might want to consider—the darkroom. Many people think a photographer is incomplete without a darkroom. Many think the darkroom is really "where it's at." They take pictures mainly to get negatives for the darkroom, and eagerly await the chance to get to their enlargers.

Perhaps you are one of those who have a love affair with the darkroom. Perhaps you want to earn money with your camera so you can afford a new enlarger or a more elaborate darkroom. Then your darkroom skills can also earn you extra money.

You may not be able to do professional quality darkroom work, but if your abilities are better than the typical drugstore photo finisher, you can start your own custom lab. You probably will not be seeking the work of men and women who earn their living from photography—at least not yet. You will be handling the work of advanced amateurs who want quality superior to the typical mass photofinishing. To begin, you should handle only black-and-white.

EQUIPMENT AND SUPPLIES

There are several items you will need before you can start earning money in your darkroom. Assuming you will be doing printing, you must have a condenser enlarger. A condenser enlarger gives extremely sharp prints. It is possible to use a diffusion attachment to soften a picture such as a portrait, if this is desired. But if you start with an enlarger other than the condenser type, you will not be able to make a truly sharp print.

The brand of enlarger you use is not important so long as it works. The lens *is* important. You must have the very finest lenses money can buy which generally means spending from $1 to $1.50 per millimeter. A 50mm lens will run from $50 to $75. A 75mm enlarging lens will cost from $75 to slightly more than $100.

In theory you will be doing custom printing for 35mm and perhaps 2¼x2¼ or half-frame negatives. You will also need a carrier for 126 film, but this film uses the same size enlarging lens as 35mm so that is no problem.

The reason for buying such expensive enlarging lenses is that you are offering a quality product. It is true that most enlarging lenses, regardless of cost, are extremely sharp when stopped down two or three f-stops to their optimum aperture. It is also true that the optimum aperture is likely to be the opening you most frequently use. But what happens when you make an extreme enlargement and have to use the lens wide open to reduce your exposure time? Or what about trying to correct an architectural shot for distortion? Then you have to stop down all the way to be certain the image is in focus when tilting the easel or lens holder. As with any other lens, check it out to see if it is sharp over the entire negative. Even good brands vary occasionally.

Custom service means quality service and you must prepare to offer it.

Until you find your business reaching a point where expansion of your facilities would prove profitable, you should only offer services that reflect quality equipment.

Let's examine what you need for different types of work. How to do this work is not covered here. There are books on darkroom procedure; a good one is *Do It in the Dark* by Tom Burk. All I intend to discuss is what you need to make money with your darkroom.

Developing equipment must produce properly processed negatives or slides repeatedly without dirt, scratches or any other marks. The film should wind onto the tank reel. You should have a tank

Christmas can be a moneymaker. Is there a Rent-A-Santa service in your area? Offer your services as the candid photographer. Polaroid is best. Photograph the kids talking to Santa. Your pay comes from parents or whoever hired Santa.

I needed a custom printer to handle this rush assignment. They burned in the detail of the stadium and waterfront a mile from the restaurant. If my local service could have offered retouching, I would have had the hot-spot reflection from my flood light removed. These are services a custom darkroom can provide.

capable of handling a single reel and a tank capable of handling several reels for large batches of the same type of film.

My own feeling is that you should have washers and dryers that can be used without removing the film from the reel. There are washers which are holding jars with holes through which the water goes in and out. They remove the chemicals in a short time.

The dryer is similar except warm air is forced through replaceable filter material which eliminates particles of dust. These are not cheap but they insure quality. They also provide dust-free negatives even when there is dirt in the room.

If you don't use a special dryer, you may need to install an electronic air cleaner to remove particles from the air such as dust and smoke. The cost can be several hundred dollars though a few companies offer excellent one-room units for under a hundred dollars.

You need to have a wide range of developers either in stock or available through a local dealer. You will want to process Kodak black-and-white films, of course, as well as less common films such as Ilford and H&W Control. You will probably standardize on a general-purpose developer such as D-76 as well as having special developers such as Microdol-X, Diafine and H&W Control.

Quality control is essential when doing custom work. I am very much against the use of developer replenishers because replenished developer does not always yield as fine a negative as the original developer. If you do replenish, do it sparingly and do not deviate from the manufacturer's instructions.

"One-shot" developers are excellent when you need to develop just one or two rolls of film in a hurry. These can be kept on hand or purchased as needed assuming your local dealer carries them regularly.

ASA 2,400 and who will process it? Many labs will not handle pushed Tri-X properly. Your service will be in great demand by available-light "freaks" like myself.

Just what you keep on hand will depend upon what is available in your area. In some communities the photo-equipment dealers only stock Kodak products. Chemicals for Ilford, H&W Control and other films must be special-ordered with a delay of six weeks or more. If this is the case where you live, you will have to maintain a fairly large supply of these chemicals if you are processing those films. They will have to be stored in whatever manner is best, such as in a refrigerator if that is the manufacturer's recommendation. And the supply will have to be closely watched so you can re-order before you run out, allowing time for the order to be filled.

Space is going to be a factor. You need a permanent storage area and you may need to use either the family refrigerator or a small 2 to 4 cubic foot model exclusively for the darkroom. Many discount stores sell such refrigerators for from $80 to $100.

It is essential to decide what services you can *realistically* offer based on your skills, your equipment and your storage facilities. Will you develop only 35mm film or will you handle 2¼x2¼, Instamatic, 4x5 and others? Will you handle the Kodak line exclusively or will you handle the less-common

films such as H&W Control and Ilford?

Next you must determine your capacity. Just how fast can you process, dry and contact-print negatives? Some of your potential customers may want rush service. Is this something you can offer or will your job, school or other commitments limit your darkroom time so that you will need 48 hours or longer to process film? How many rolls can you process at one time? How many rolls can you process in a normal week? Be conservative in your figures. Remember that you want to deliver the finished work when promised. You must know just how much you can handle at any one time.

You will find that if you standardize your procedures the work will go much faster. If you have a mixed batch of film, develop all of a similar type at once.

Printing requires much the same planning as processing. Will you offer textured prints? Contact prints? Colored paper? High-contrast prints? Generally you can get by with Polycontrast paper and a set of filters. However you may want to take advantage of some of the textured and colored enlarging papers. Resin-coated printing papers allow rapid drying and ease in washing. You must

decide what you are going to offer based on your skills and the amount of paper you can keep on hand?

What sizes of prints will you offer? Your equipment will have limitations. Can you print 11x14, 16x20 or larger? How small will you print? Will 4x5 be your minimum or will you go wallet size? Remember that for a small order there is little profit in the mark-up on a 3x4 or similar size print and the work is the same as for an 8x10. Chemicals and paper cost less but your production time is equal.

How much time does it take you to make a print? If you don't own a negative analyzer, you have to make test strips of each print. How many of these will have to be made before you can satisfy the client? You need to know both production time and cost.

In general you will find that the cheapest way to work is to buy large quantities of paper (100 to 500 sheets) and store them in a cool, dry location. If you have your own refrigerator, you can seal the boxes, place them in plastic bags and store them in the cooler. The plastic bags are additional protection from moisture.

Once again *storage* is the key word in your planning. You must keep supplies on hand to cover your client's requests. The more you can store, the more versatile you can be.

PRICING

Now comes the most important question. What do you charge?

Before you start figuring, see what various custom labs charge. Don't say you are planning to compete with them just find out what they charge. Their figures will be the maximum you can charge and still get customers. It is best if you can charge less because your services will be comparatively limited. Just be *certain* that your price includes a profit.

Now start figuring costs. What is the price of enough chemical to process one roll of 35mm film?

Going to an unusual vacation spot? Prepare a short slide talk to give to church groups, clubs and others. Charge $10, $25 or whatever the market will bear for a 45-minute to one-hour show.

What is the price for other films if you are going to process them? What about special processing such as with Microdol? Figure both mixing the chemical yourself and buying "one-shots." Developing a single roll of film is more expensive than developing several rolls in the same tank. The single-roll cost is the basis for your charges. When you handle several rolls you make extra profits.

For special processing you might add from 50 cents to a dollar in addition to your normal charge and the higher chemical cost, if any. You will probably find that you can handle custom processing, including one 8x10 or 8-1/2x11 contact sheet for under $5, an extra dollar added for special work. Rush orders should cost your customer 50% to 100% more depending upon how much of a nuisance it is. Overnight work should be at least 100% more and some labs charge triple their normal price.

Next figure out how much it costs you to make one print of each size to be offered even though it is unlikely you will ever have a time when your work session is limited to just one print. Include the cost of test sheets and all chemicals. Add 10 or 20 cents to cover water, electricity and other hidden expenses.

You will find that you can make a nice profit by selling prints for the same price as custom labs working by mail. You are more desirable because you do not charge the customer mailing charges and he or she has more control because you are local.

If you are going to offer dry-mounting, charge double the cost of the method you use. This usually means an additional $1.00 to $2.50, depending upon size and materials.

FINDING CUSTOMERS

Once you have figured out your charges, prepare a listing of all your services. Show what films you process, special services such as high contrast and push processing, the time it will take to do the work and special rush charges.

Your rate sheet for printing should be equally comprehensive. List the sizes of prints you make, special papers if any, and special printing services such as high-contrast work and solarization. Once

Photograph prize-winning plants at local garden clubs. Show plant alone with award, or have the owner hold it.

again the time required and rush rates should be listed.

Always be conservative when estimating your available time. When you do custom darkroom work you have to plan a certain minimum number of hours each week. Perhaps this will be an hour a night, or 8 hours one day a week. You should figure on the *least* time you know you will be able to spend so you don't take orders exceeding your capacity. Eventually you have to limit your clients or expand as word of your services gets around.

Neatly type your list, temporarily leaving off the prices. Then make sample prints in each size you will be offering. If you offer special effects or special paper surfaces, include these with your samples. Make a minimum of two complete sets. Be certain the images you use for your prints are dramatic and eye-catching. One set will be kept at your lab to show people who might choose to visit you personally.

Next telephone the manager of the largest camera store in your community and ask for an appointment to see him. Bring your sample prints and explain the custom darkroom work you offer. Ask if his store will refer people to you. You should expect to pay the store a fee for the referral, especially if the store will collect the orders and the money for you. This fee should be around 5% or 10%—negotiate the best deal you can.

Once the store agrees to tell people about your work, add prices to your list of services. The price will be the amount you originally figured plus the mark-up needed to pay the camera store commission.

Take the completed list to an inexpensive "quick-print" shop for 100 to 500 copies of the list. You want the cheapest printing possible. Print on one side of a single sheet and include your name, address, and telephone number at the bottom.

Keep 15 to 25 price lists for yourself, then divide the rest among the camera stores in your area. Contact every store and give each whatever percentage was agreed upon with the largest store. If you live in a small community with only one camera store, independent drug stores might also be interested in promoting your services.

Once you have a list of stores, divide up your price sheets among them. These will be given to

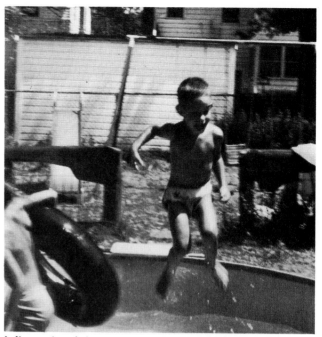

I disappointed the parents on this one. I had to mail my film and wait two weeks to find out. By then fall had set in and it was too cold for outdoor activities. Had I been able to use a local processor, I could have learned of my error in time to do a retake.

customers and used by the clerks when asked about your prices.

Many of your customers will want to come directly to you once they learn of your services. It would be nice to work directly with people and you will get some customers of your own through word of mouth. But remember the store managers who are making you successful and give them a break when possible.

When you start doing work for clients, you need a way to bill them and to keep track of your orders. Billing can be done with inexpensive blank invoice forms available through printers, office supply stores and dime stores.

Records are another matter. There will be a certain amount of bookkeeping but this will be made easier for you if you use the forms I've included. They show how to keep track of each order and help you maintain accurate records.

You also need a record book to keep track of sales. Again, use standard books sold by office supply firms and occasionally the stationery department of your local dime store.

All sales must be on a cash basis. You don't have the time or the knowledge needed to worry

DEVELOPING ORDER

Customer _____ Date _____

_____ Order # _____

Date Promised

☐ Mail to: _____ ☐ Hold for Pickup

FILM			TRI-X	PLUS-X	PAN-X	ILFORD	H & W	OTHER	TOTAL
35MM 36 EXP.	$_____ per roll	# Rolls							
		$							
35MM 20 EXP.	$_____ per roll	# Rolls							
		$							
126	$_____ per roll	# Rolls							
		$							
120, 620	$_____ per roll	# Rolls							
		$							
SHEET	See Schedule								
FILM PACK	See Schedule								
SPECIAL Developing	See Schedule								
RUSH CHARGE	See Schedule								
Mailing									
OTHER									
Contacts									

TOTAL DUE: $ _____

(Insert your name & address here.)

PRINT ORDER

Customer _____ Date _____

_____ Order # _____

Date Promised

☐ Mail to: _____ ☐ Hold for Pickup

SPECIAL INSTRUCTIONS:

Size	Single Weight	Double Weight	Matte	Semi-	Glossy	Special Paper	Dry Mount	$
4 x 5								
5 x 7								
8 x 10								
11 x 14								
14 x 17								
16 x 20								
Contact								

Subtotal	
Rush Charge	
Special Charges	
TOTAL DUE	$

(Reproduce your business card here.)

PRINT LIST

Customer _____ Date _____

_____ Order # _____

Roll # or Identification	Frame #	Size	Qty.	Paper	Special Instructions

Add your name & address here.

about credit accounts. If the store wants to let the customers use credit cards, arrange for the store to pay you immediately, even if they have to wait for their money. You must work on a strictly cash-for-work-done basis or you may find yourself losing money.

You need to buy envelopes to protect the prints you make. A sturdy manila envelope of the type sold by office supply stores is best. You need them in every size you will be offering to clients or the next larger size if necessary. When you find the lowest cost, figure the cost per envelope and add this to your printing cost figures. You also need envelopes or sleeves to hold finished negatives.

HOW ABOUT COLOR?

For some the question of color processing will arise. Custom labs and discount labs do such an excellent job of processing slides that there is no real market for this type of work. This is not an area where you can compete.

Color printing is an area you might consider, especially with such excellent relatively inexpensive systems as Unicolor available to the advanced amateur. Unfortunately, I have to say you probably cannot compete with the custom labs. If you are really into color printing to the point that you have a $400 or $500 color head or perhaps a $500 to $700 self-contained color printing unit such as the Sable Color Enlarger, you might consider custom color work. You need a negative analyzer to reduce the amount of wasted prints and you need special temperature-control systems. If you are in an area with periodic power reductions known as "brown-outs" you will also need voltage regulators on all your equipment. In other words, you will have to be a small-scale professional lab with perhaps $2000 or more in equipment to compete with the custom labs.

Custom labs use machinery to produce a truly high-quality photograph in color for as little as $1.25 per 8x10—or less! It is doubtful that any amateur could profitably produce a color print for less than $1.75 to $2.00, even with fairly good equipment. Furthermore, many amateurs have equipment that forces them to use filters between the lens and the baseboard which reduces quality compared with professional lab equipment using filters between the lamp housing and lens.

I will admit that a *quality* 8x10 costs from

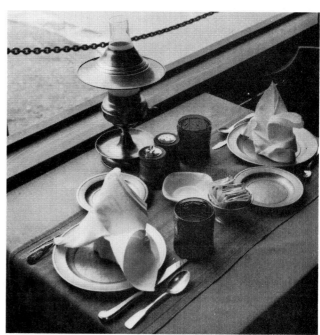

Lighting and printing were critical. I was saved by an advanced amateur earning money with his darkroom. I could personally guide him in what I wanted. He could have charged me any price and I would have paid it. The picture was that important to me when done right.

$6 to $15 from most custom labs and may go as high as $30, depending on the printing process. But such prices are for the *ultimate* in color reproduction. It is unlikely that you could produce the same quality for any less. These same labs generally offer an economy grade, machine-printed and of slightly lower quality. The average consumer can pay almost any price and still get custom work. Wedding photographers, for example, often pay less for color 8x10's than for a low-cost black-and-white print of the same size.

Color printing has changed too radically in recent years to consider competing with the custom labs. While you can offer genuine service to black-and-white customers, you can only offer relatively poor-quality, high-priced work in color. Leave this field to the professional labs and do it at home only for your personal pleasure.

Work for a company that has its own newsletter? The staff may be delighted to pay you to take pictures part-time. You might even work into a full-time position as company photographer.

PORNOGRAPHY

There is one more topic which must be discussed here. It is one I hesitate to mention yet one which must be considered when you start a custom lab service. This is the problem of pornography, nudity and related issues.

Today most people accept some degree of nudity in photography providing it is done in a restrained manner. Total nudity is seen in magazines sold in almost every city.

Artistically posed nudes are seen in art magazines, photography magazines and even some general-interest publications. The human body is a beautiful form and it is a genuine challenge to find new ways to light and pose. We have learned to accept this idea, for the most part, and we enjoy seeing artistic photographs.

This is all leading up to the fact that more people than you might think are trying to photograph nudes. The attempts are sincere efforts to create an artistic work. The final results are usually poor because this is a difficult field to handle effectively. However, there is never an attempt to show the model in a manner which most people would consider pornographic.

There are others, less numerous by far, who actually set out to take "dirty pictures." It is not the way I wish to spend my time behind the camera. But it is not for me to condemn what they do.

People who take nudes and especially those who take what is generally considered to be obscene, are unable or unwilling to use the services of a normal custom lab. So many *professional* photographers photograph nudes at one time or another in the course of normal work that almost all custom labs will handle such pictures. The labs will also accept the work of amateurs making a *sincere* effort to produce genuinely artistic nude studies, even if their inexperience results in photographs that don't quite make the grade. However, very few will print pornographic photographs.

When you set yourself up as a local custom lab, you must decide what type of work you will handle. If you are against nudity of all types, then make it clear in advance, preferably with a note at the bottom of the rate sheet that you will not print photographs of nudes. If you are only against pornography, mention this fact to the stores who send you work and to customers who ask you.

Return negatives, unprinted, *without comment* when you find pornography. When you process film, if you unknowingly process pornography, return it to the photographer at whatever stage you realize what it is. Sometimes this means returning negatives without contact sheets. Other times you will not be certain until you see the contacts. Charge for any work done and include a note saying that you cannot handle such work in the future.

One other point which should be mentioned here is the legal aspect. Keep in mind that you could be criminally liable for the actions of the individual for whom you are making the pictures. If you make one print from each negative, it is likely that the photographs are for the photographer's personal use. However, if you make several prints from each negative, you can be fairly certain that the photographer took the pictures for resale. If he is arrested for violating laws, you could be held criminally liable for printing the photographs.

Handling custom darkroom work can be a most enjoyable way to earn money in photography when your love is for the chemistry and not just the taking of pictures. If I have scared you slightly with my warnings about pornography, I am glad. Some custom darkroom workers go their entire lives without coming across such film. Others find such material in their first roll. By considering your feelings and deciding how you will handle the problem in advance, you will continue to enjoy the work that is also bringing you extra money.

Custom print for other photographers. Everyone needs a portfolio of photographs to gain clients. If your thing is the darkroom and you have friends who are strictly camera buffs, charge a special fee for a print portfolio in either 8x10 or 11x14. Charge a little extra and include the album. Most art supply stores have excellent sample cases for holding prints.

Special-Interest Films for the Free Lancer

characters, syrupy
ften as not having
arfare and patrioti
iousness). The Comm
aving the most beau
th official-looking

is my favorites were
, the Dalrymple (al1
e Rice Independence
r flags design was
better suited as a
ost Office legal-si
Utah (the patriot'
like an insurance a

Is H&W any good? These two pictures are tiny portions of 30x40 enlargements. You can see the texture on the paper that was photographed and the girl is exquisitely detailed.

This chapter is about films which have received rather limited publicity in the photography magazines. This is unfortunate because they can solve many of the problems encountered by freelance photographers trying to earn money with their cameras.

H&W CONTROL FILM

H&W Control originally offered two films—H&W Control VTE and VTE Ultra. However, today you will most likely work only with the latest film, H&W Control VTE Panchromatic Film with a rating of ASA 50. It is an ultra fine grain black-and-white film.

The H&W Control Films were originally designed for use as high contrast microfilms, and were almost grainless so they could be enlarged to great extremes. They also lacked a gray scale so they could only be considered special purpose films.

Then H&W Control discovered a developer—H&W Developer, of course—which provides a full gray scale. I use the term "full gray scale" somewhat loosely, as purists will tell you it is not quite as good as the gray scale of conventional black-and-white films. However, I have never noticed the difference in my prints and I doubt that you will see a difference in yours.

The results of the combination of H&W Control VTE Panchromatic Film and H&W Control Developer are excellent. The grain pattern is tight, images are sharp and potential enlargements from a 35mm negative are practically house size. Whatever your lens is capable of recording, this film can capture it.

H&W Control Film can be used normally when in bright sunlight. However, if conditions require a slow shutter speed, you can get the best

results by mounting your camera on a tripod. The extra steadiness insures a motion-free image which can be enlarged so it is indistinguishable from a normal 4x5 negative enlarged to the same size print. Many photographers rely on this film in the 120 format for billboards, architecture work and other circumstances requiring extreme detail and enlargement. It is easier to use this film and a small camera, perhaps with a perspective control lens at times, then to have to own an expensive 4x5 or larger view camera which might not be used very often.

One problem with H&W Control film is that your processing technique determines the quality of the grain structure and the gray scale. H&W Control Developer must be used according to the specifications on the package. If you are not handling your own developing, you will have to use a custom lab which agrees to use it, processing by hand because the order will be too small for using mechanical means.

I always check to see if the lab will stock H&W Control Developer. If it doesn't, I arrange to order it directly from the company and have it shipped to the lab. There is seldom a problem other than having to make the arrangements in advance by telephone. After you have done this once, you can do it again and again by asking them to keep it in stock.

For more information about the film or getting it processed, contact **H&W Company**, Box 332, St. Johnsbury, VT 05819.

ECN 5247

There was a time when ECN 5247 seemed like the "ultimate weapon" for photographers, and it still has a strong appeal. ECN 5247 is a 35mm motion picture film which a number of companies specially load for 35mm still cameras. It replaces ECN 5254 which may still be available from labs keeping large film stocks in their freezers.

ECN 5247 can be exposed at ASA 100, 200 or 400, and has successfully been pushed to ASA 8,000 in experiments. It can be exposed by 3200 degree Kelvin flood bulbs, electronic flash or daylight. Some labs compensate during printing for the color quality or the light you use, so no filter is required at the camera lens. WARNING: Use only one ASA rating and one type of lighting for each roll of film. Do not use several different light sources or several different ASA ratings! When processed, you can get negatives, slides and prints as a matter of course. It is also inexpensive, costing less than any other slide film I know.

There was a time when I would have unhesitatingly recommended ECN 5247. However, that was before Kodak introduced Ektachrome 400, and made changes in Kodacolor II and Kodacolor 400. The Kodacolor films are extremely fine grain, much finer grained than ECN 5247, and Kodacolor II is rated by some as offering better grain structure than Kodachrome. They are also usable under all lighting conditions with little color shift compared with normal. Kodacolor II is a daylight film rated at ASA 100, but works well with tungsten and photo flood lighting, having very little of the warm tone normally found under such circumstances. Even the green shift found when exposing daylight film to fluorescent lights is minimized, something which is not the case with ECN 5247.

Kodacolor film has traditionally been printed because it is a negative. However, what the manufacturers of ECN 5247 reloads fail to mention when they advertise that they make both prints and slides, is that custom labs processing Kodacolor will make slides from the film. Slides have always been possible from negative films though they have not been standard items. More important, the cost of ordering prints and slides from ECN 5247 is about the same price as is charged for making prints and slides from Kodacolor.

Ektachrome 400 is an amazingly high quality slide film from which prints can be made. It is finer grained and offers higher quality color than ECN 5247 pushed to ASA 400 and used outdoors. However, Ektachrome 400 is a daylight film which cannot be used under tungsten light without either filtering the lens or having a warm tone from the lack of blue in the tungsten lighting. Tungsten Ektachromes which can be exposed at ASA 400 are about the same quality as ECN 5247 exposed at the same rating. However, while Ektachrome film has the best color saturation, when exposed either exactly as rated or under-exposed by 1/2 stop, ECN 5247 maintains decent quality even when over-exposed 1/2 stop, something which can not be said for current Ektachrome. The color loss in Ektachrome due to over-exposure is much greater.

Some people feel ECN 5247 is preferable to more standard color negative films because the labs which process ECN 5247 will make black-and-white photographs from the negatives. What they fail to realize is that any custom black-and-white lab can make prints from any color negative film. Eastman Kodak and other paper manufacturers produce a photographic paper for prints designed to provide a quality image from a color negative. Thus, there is no difference in the potential.

ECN 5247 is unique in another way. Although the color negative seems almost identical to standard color negative films produced by Eastman, it is slightly different. What would be proper color filtration for printing color negative film made for still camera use is not quite right for ECN 5247. Custom labs which print ECN 5247 as a favor for their customers may not give the same quality as the lab which sells the film and specializes in processing and printing it.

What this means is that you may not be able to use ECN 5247 in areas where it seems as good or better than Kodacolor II and Kodacolor 400. Weddings, for example, require a fairly quick return of the proofs. You need to show the prints to the bridal couple within a week or two, and usually only labs specializing in this work can give you such service. Labs offering ECN 5247 are generally not geared to the needs of the professional.

As an example, a few years ago I photographed a concert of the singing group, The Carpenters. I used standard Eastman color film for my clients but took two rolls of ECN 5247 for my own use. I sent both to conventional processors—the Kodak film to Kodak and the ECN 5247 to a lab which had been handling ECN for more than a year. The standard Kodak film was returned to me in a week, but it was four weeks before I saw the ECN 5247 slides. The work was excellent, as I knew from past experiences it would be, but the waiting time was too long for professional assignments. More impor-

tant, had I been in a real rush, the standard Eastman film could have been done locally within three hours.

In theory, ECN 5247 provides optimum performance at ASA 100 and exposure to 3200 degrees K. However, I have been using this film extensively at ASA 100, ASA 200 and ASA 400, as well as under all lighting conditions, always without a filter. The results have ranged from being purple to providing breathtaking natural color. The quality of the returned film was consistently the result of the lab used and not the exposure of the film itself. Some labs have better quality control than others.

At the end of this section is a partial list of labs selling ECN 5247. Of the ones I have tried, I have been pleased with some, infuriated by others. All of them are relatively new to the business of specially loading and processing ECN 5247 for still camera users.

My feeling is that you should buy some ECN 5247 through the labs handling it, try it and learn what it can do for you. Compare the quality of all the labs you know performing this service, and then compare the work with the Kodacolor films you will be using. Finally, decide under what circumstances the ECN 5247 would be preferable to Kodacolor and/or Ektachrome 400. Then take advantage of this extremely versatile film whenever necessary. It will add an extra dimension to your clients.

Five labs handling ECN 5247 include: **MSI/Heritage Color Labs**, at either Box 2736, Portland, OR 97208, Box 30730, Jamaica, NY 11430 or Box 2075, Woodland Hills, CA 91364; **Dale Laboratories**, 2960 Simms Street, Box 900, Hollywood, FL 33020, and **Red Tag Photo**, 2214 Pico Blvd., Santa Monica, CA 90405.

Two labs which process Kodacolor so you get both prints and transparencies are **Unilab** facilities at Box 1616, Canoga Park, CA 91304, and Box 30900, Jamaica, NY 11430.

Other Approaches to Making Money

This chapter is devoted to ideas—money-making ideas, naturally. It is different approaches which can make a few extra dollars. They are all too short or too limited for complete chapters. Read them because the ideas can bring you extra money.

SPOT NEWS PHOTOGRAPHS

Spot news photography is a way of earning money which is as much a matter of luck as it is photographic skill. No one ever knows when he is going to encounter a newsworthy event. You are driving along when the car in front of you suddenly goes out of control and smashes into a bridge. You are walking past a construction site just as there is a cave-in. You learn that an important person will be arriving at your city's airport at nine o'clock on Saturday morning and will be in the city just long enough to change planes. It is being kept quiet and there will be no notification of the news media.

Do all these events sound a little far-fetched to you? The truth is that every one of these potential news stories actually happened to me.

There are two approaches you can use for spot news photography. The first is to carry a camera around and hope for the best. When you hear sirens, see if you can find where they are going. Don't speed if you are driving or get in the way of emergency vehicles. Always park a good distance away from fire engines, police cars and ambulances and walk to the spot where they are stopped, keeping back so you don't interfere. Talk with someone who is not busy to learn what is happening and begin taking a few pictures immediately. If you are lucky, the event will be important enough for local newspapers or television stations to be interested and they will not have dispatched their news people in time to catch the action you did.

The second approach is to buy a police and fire department radio monitor. These cost around $200 for the better ones which scan several frequencies at once, stopping whenever they pick up a call. You learn the location of a fire, accident or

My first news pictures. Lens too long, not focused critically and no over-view shot so one picture showed what happened. The paper developed my negatives and returned them to me. NO SALE!

I was first on the scene at this construction site accident. The pictures were the only ones of the rescue attempt as the news reporters didn't arrive until it was all over. One television station paid me $55 for these prints to use on the evening's news shows. Newspapers, contractor and his insurance company might also have been customers but I didn't think of it at the time.

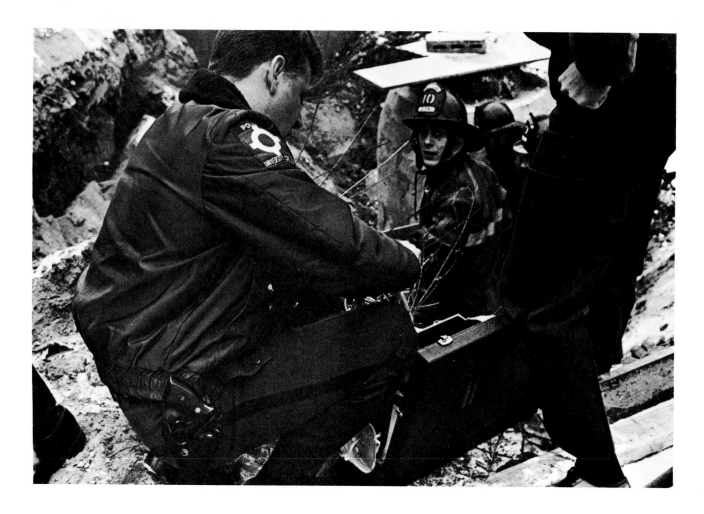

other event as quickly as the police and firemen. Then you drive to the location, again watching your speed and driving carefully, and hope to be the first photographer on the scene.

Obviously both these approaches have a lot of chance involved. Even worse is the fact that the second approach is going to cost you some money for equipment which may or may not help you to increase your income.

You should carry a camera with you whenever possible. Then, when you see something of interest, stop and photograph it. Once you have made some sales, there are ways of getting on a newspaper or television station's payroll as a stringer. Let's look at how to shoot spot news and how to sell it.

Fires are among the more common news events. If you're driving, leave your car at least a block from the fire in a spot that will not hinder the movement of emergency vehicles.

As you approach the fire, take an overview of the entire scene. Make note of the address. Then move in and begin taking isolated scenes of action. The firemen holding the gushing hose might be one photograph; men on the ladder might be another. A rescue attempt might be a third. If you are alert to what is happening, you might get a dramatic view of a wall collapsing or a fireman giving the "breath of life" to a victim. Most of your close-ups will be taken with telephoto lenses as it is impossible to get very close to the action without protective clothing or special breathing equipment.

Talk to any firemen who are not busy to learn what has happened, the exact location of the fire and whether anyone was hurt. If you can't get names of the injured, at least learn to which hospital they were taken.

When the excitement is over and the firemen are in the mopping-up stage, rush to the nearest telephone and start calling newspapers and television stations. Ask for the newspaper city desk and speak to any of the reporters who answer. The city editor is generally the man who makes the final decision, but he is quite busy most of the day. A reporter should be able to determine the newsworthiness of an incident and will immediately relay the information to the editor if he feels the paper might be interested.

When you call a television station, ask to speak with anyone in the news department. Remember that television stations often have tighter deadlines than newspapers and brief air time to show pictures. A picture which might fill the slot during a 6:00 p.m. news show, for example, could have no value five hours later during the 11:00 p.m. news.

All newspapers and television stations have standard freelance rates which they pay for most photographs. Unless you have a major story such as the amateur photographs taken of the Kennedy assassination, you are wasting your time trying to bargain. The news editor may politely ask what you want for the pictures, but don't try to set your own price. If the figure you quote is higher than the set rate, he will tell you the department is not interested. If your figure is lower, he may pay you the smaller fee. However, if you say you will accept standard rate, you will be treated fairly. You won't get rich on the deal, but you will be dollars ahead and may have the prestige of a credit line in addition.

Accidents are handled slightly differently than fires, though with *all* news stories you must write down the *who, what, when, where* and, if known, the *why* of any news event to be of value to the editors. I am never without a small notebook and pen for this reason.

Accidents require an overview. This is a single photograph which dramatically tells the story. After you have taken the general scene from several different angles you can worry about close-ups. Of course, if there is a dramatic close-up, take the picture and get the overviews later.

Accidents only sell when someone is injured. Occasionally two cars hit each other, are totally demolished and the drivers walk away unhurt. Such a freak situation might make a salable photograph, but it is the rare exception.

There can be additional value to your accident scene photos. If you can get the names and

Everyone likes to get a candid photo of himself. When you cover news events, the people involved might like a personal photo. For example, if you photograph a fire, take some prints to the fire station and offer to sell prints to the men pictured in your news shots.

Spot news comes in many forms, be it an industrial accident or a special dog show in the park. The accident shots can sell to insurance companies, newspapers or magazines. The park pictures can sell to family, friends, newspapers and magazines, as well as the city or park administration sponsoring the event, for use in promoting future programs. Warning: Be sure your equipment is always in top condition so a failed battery, film chip or smudged lens will not ruin these unplanned opportunities to make money with your camera.

addresses of the people involved, you can contact them later for insurance purposes. Often insurance companies will buy accident-scene photos to help with court cases or to help determine liability before they pay a claim.

Police emergency situations such as a robbery in progress, a berserk gunman blasting away from his bathroom window and other unusual events require you to think of your safety first. Use telephoto lenses and follow police instructions as to where you may stand. Obey any orders to move on. It is better to lose a chance-of-a-lifetime photograph than to lose your life.

Public disturbances often require special credentials. A riot, for example, or a labor strike that has degenerated into violence may be the type of events where the police have orders to remove all unauthorized people from the scene. Legitimate news people may stay but a freelancer trying to earn money with his camera may be forced to go. Under such circumstances you will have to visit the police station, explain that you are a freelance news photographer, and ask for credentials to photograph at the scene of the violence. Make it clear that you know you will be on your own and that there will be no effort to guarantee your safety. You accept full responsibility for anything that happens to you.

There are several areas for caution at public disorders. The first comes if the police are using tear gas. Don't let yourself get caught between the police and a mob or you will get the full effect of the gas. The same is true if you are downwind of the gas when it is released. If you are in doubt as to where to stand when the police put on their gas masks, get out of there as fast as you can.

It is possible to buy a gas mask to protect yourself but it may or may not fit and work properly. Army Surplus stores have such equipment but there is no guarantee it will work. It is better to leave and miss a photograph than to risk it.

Always try to stay with the police. Not only will you avoid such mob violence as smashing your camera, you will also have some protection. Full-time news photographers are paid to take risks. Their equipment is specially insured and they have access to replacements should the cameras they are using get damaged. You are working with no guarantee that what you are taking will sell. It is not worth taking risks.

My own feeling is that when there is some form of mob violence near where you live, you should avoid going there. I say this after having photographed several riots and with the knowledge that if I were to learn of another one nearby, I would grab my camera and go. There is something exciting about being able to record people at the height of their emotions that often draws me to areas where a sensible person would not go. Other people feel the same way, for if you recall the photos of the tragic shootings at Kent State, almost all of them were taken by amateurs who grabbed their cameras and rushed to the scene.

I think the best rule if there is any question about going to a scene of violence, is you should stay away. Some of us are drawn to such areas like steel to a magnet. It is dangerous, foolish and filled with risks. If you can't resist, you may end up making a career for yourself in news work for that is a sign of a good reporter. But stay an observer and not one of the victims.

BEING A STRINGER

After you have been involved with newspapers or television stations, selling them one or more spot news photographs, you may have the opportunity to join the staff as a *stringer*. This is a person who regularly supplies material that cannot be covered by the full-time staff. For example, in Akron, Ohio, an advanced amateur named Pete Matt worked as a stringer for a Cleveland television station. He had a 16mm movie camera and held a part-time job with flexible working hours.

Whenever there was a big fire or similar news story in his immediate area, he would photograph it, then put the exposed film on a Greyhound bus to Cleveland, around 30 miles away.

The station paid him a small monthly fee for being on call, plus $25 for each story he covered. They supplied the film, processing and paid for the shipping. It was far cheaper for the station to keep Pete on a retainer than to send a staff man to Akron for each story or to keep a full-time staff in that city. Because the station broadcast to Akron, it was important to devote some time to Akron news.

Newspapers use stringers in much the same way. They concentrate their staff in the city where they are located. Their circulation covers a much wider area, throughout the county or in

Restaurants about to open are good money makers. Contact the owner or the advertising director if it is a chain. I took these with one body and lens and some clamp lights. I should have had more equipment but I had no money and I needed the work.

Hotels and motels provide business. Increase your sales by choosing many different angles. The greater the variety of quality photos, the harder it is for the buyer to select one or two. Usually everthing is sold.

several counties. They need material of interest to rural readers.

If a paper likes your photographs, you may be hired as a stringer to supply pictures and captions concerning events in the rural areas. You might photograph a small-town mayor dedicating a new city hall. Or perhaps it will be the unbeaten high school baseball team in action. Or maybe a feature for the Sunday Magazine about 101-year-old Pop Henson who hand-carved an exact replica of World War II. Your pay will be a combination of retainer plus fee for each story used, or by the item with the pay determined by the space devoted to it, or by a flat fee for each item published.

Weekly newspapers also use stringers since few can afford a full-time photographer. Usually they use a writer who can handle a camera and rely on stringers to cover sports and other special areas. With weekly newspapers, and occasionally with dailies, you can get a job as a stringer just by showing quality photographs. Having taken salable news photos in the past is not a prerequisite.

If you are interested, see the news director of your local television station, the managing editor of the daily newspaper or the editor of the weekly.

One man who has been quite successful with this sort of work is Robert Owen of Napa, California. He is on disability retirement and took up photography to earn a little money when he was able to do some work. He regularly photographs the Pop Warner League football games and other sports events and sells pictures to his local weekly newspaper. Some of his photographs are in the sports photography section of this book and in other chapters.

TELEVISION STILLS

Several photographers around the country, including Robert Owen and Lester Lewis, take pictures of scenes of local interest for area television stations. These scenes are flashed on the screen with the station logo during station breaks. Lewis' photographs have been used on one of the channels in Arizona. Owen has had his work used by the cable television serving his area.

If you are interested, take some photographs of local scenes to the program directors of the

I made more than $50 profit on my first print sale after coming home with these vacation pictures. They are nothing spectacular, but the appeal is universal enough that they can keep on selling. Some people have bought them to use on Christmas cards—just to show a different type of scene.

Photographs of special events have appeal not only to the performers, but also to the public relations and advertising directors for the activity. Such pictures can be sold to magazines and newspapers—and could even be used for posters if you are lucky.

television stations near you. They may buy the slides for showing when they identify the station. The pay will be minimal but high enough to warrant your time and effort. Just be certain you sell only the right to reproduce the slides in the manner discussed. Don't let them have all rights to photos which could bring you income from calendars, post cards and other stock sales.

TELEVISION SPORTS

Now that an increasing number of television stations are installing Super 8 movie equipment, the market for freelance movie sales to the sports department is growing. As with news stories, the stations are unable to send someone to cover every sports event which might be of interest to local viewers. A skilled amateur with a good movie camera and zoom lens—a 4-to-1, 6-to-1 or greater zoom ratio—can often get a job photographing local sports for use on the television news. The station will supply you with film and a small fee for your time. You get the thrill of free admission, the chance to watch the game from the sidelines and the prestige of working for a television station.

PET PHOTOGRAPHY

This requires a book in itself and many have been written. The demand for pet photographs is both large and growing and it's not limited to owners of pedigreed dogs, cats, snakes, hamsters,

fish, birds or what-have-you. If the pet is a "Heinz 57 Varieties"—without pedigree—the owner typically wants an appealing picture for the family album or to frame for display at work. Sometimes a picture of the owner holding the animal or playing with it will prove very salable. In some families, pets are just as important as people and you should understand that ahead of time. I have even heard of pet photos being made for the express purpose of being buried with the owner.

If you are shooting an animal bred for show, its savvy owner will know the exact poses to show the finer points of stance, ears, eyes, head, tail and so forth. He or she probably has a breed book, bulletin or magazine filled with pictures just like those you are expected to shoot. Many are so similar you might wonder whether they are all of the same animal. Look at these pix and strive to achieve similar results by positioning your camera and lights to bring out the things the owner has asked you to emphasize. If you can, borrow the books or magazines to study ahead of the actual shutter session.

Let the owner handle the animal. No need to get bitten—or even stepped on if you are working with a horse or some 4-Her's prize calf or bull. Your show-animal photos will sell *if* you capture the points/markings the owner wants. Just pay attention and keep asking questions. The owner will never tire of telling you about the fine points of his/her animal, believe that!

BICYCLE PHOTOGRAPHY

Bike sales are rising rapidly with bike thefts climbing at an almost equal rate. Unfortunately, when a bicycle is stolen, unless it has been specially registered in advance, most owners cannot describe the bike well enough to give police a good chance of spotting it.

If you live near a college or university, retirement community or other area where bicycle riding is a way of life, offer your services as a bike photographer. You photograph the new

Offer real estate companies your services. Shoot houses for sale. Also buyers posed so both the people and the house are shown. Happy buyers make good advertising photos.

I had gone from my $15 pawn-shop special to a $25 discount-house wonder when I made 75¢ profit for each house I photographed for a local realtor. It was just a record or what was being offered but it made a high-school photographer feel rich.

bike, in color, from the front, back and sides. Then you file the photographs as explained in the chapter on storage of prints and negatives. You might give the owner a set of small prints, one from each negative, in addition to filing the work. Then, when the bike is stolen, either you or the owner can supply the police with pictures to help them spot the vehicle. It doesn't always get results, but it's the best method for quick identification developed to date.

To advertise your services, post notices in bicycle shops, community and apartment bulletin boards. Buy space in school newspapers and see about putting up a notice in the college or university student union. An ad in the personal section of your daily newspaper's classified section can also have results.

Any equipment can be used for this work.

Don't distort the bicycle by getting too close with a wide-angle lens. I find it's best to step back a few feet with either a normal lens or a telephoto in the 85mm to 100mm range, kneel down and take the photograph on the same level as the bike. This results in the clearest picture possible. You might also make close-ups of any unusual markings and special equipment.

These have been just a few suggestions for making money with your camera. By now, if you have tried projects in this book, your bank account should be considerably fatter and you will have lost your amateur status. Some will go on to work full-time in this field. Others may just work occasionally to get a little extra cash. Whatever your circumstances, you should walk a little taller. You have crossed that magic invisible line. You are a professional!

Appendix

Here is the equipment list mentioned earlier in the book. Use it as a guide for basic equipment you should have. No specific brands are suggested; these should be of your own selection, based on ease of use and cost factors.

Laboratories and other suppliers are located around the country. If you are in a small town, you may have to order certain services by mail or catalog; otherwise, you should be able to find what you need in your local Yellow Pages. If you do not know where to find a product or service, ask your local photo dealer.

On the next page you will find a Pricing Check List which can be copied and used for keeping records of your expenses and billing charges for jobs.

EQUIPMENT LISTS

A. Camera and lens, flash unit. Any camera from the top-of-the-line standard Instamatic to 35mm, 2¼x2¼ or larger. Pocket Instamatics cannot be used.
B. Camera with normal, wide-angle and telephoto lenses, flash, reflectors.
C. Camera with normal, wide-angle and telephoto lenses or 2¼x2¼ non-interchangeable lens camera. Multiple flash or floodlights.
D. Two cameras with wide-angle and telephoto lenses or two non-interchangeable twins-lens-reflex cameras. Two or more rapid-recycling flash units or one electronic flash unit and one flashbulb unit. Slave trigger for multiple flash work, assuming you have an assistant to hold an extra unit, is optional. Two or more 6- to 15-feet long sync cords.
E. Camera with normal lens or short telephoto lens or macro lens. Extension tubes or bellows housing or close-up lenses except with a macro lens. Copy stand or collapsible tripod to allow close focusing of the mounted camera. Lights. Polarizing filters for camera and light holder. Velvet material or similar soft cloth. Clean cotton gloves.

POSTCARDS, NOTE PAPER, ETC.

Make additional sales of religious group photographs by convincing the board to order postcards, note paper and similar items using your photographs. Companies listed below offer such services. Contact them for samples and price lists. You might also check picture postcards of local tourist attractions; the publishers of these items usually have their name and address somewhere on the address side of the car, and are often locally based.

Refer the religious group to them or order for them, but *always* get an advance equal to your costs. Most companies want cash on the line. Include a slight mark-up for your trouble.

Dexter Press, Inc., Route 303, West Nyack, NY 10994. Postcards and brochures.

MWM Color Press, 107 Washington Street, Aurora, MO 65605. Postcards, brochures and related items.

Koppel Color, 153 Central Avenue, Hawthorne, NJ 07507.

Dynacolor Graphics, 1182 N.W. 159th Drive, Miami, FL 33169.

SUPPLIES

Spiratone, Inc., 135-06 Northern Blvd., Flushing, NY 11354. Electronic flash units, postcard-size enlarging paper and hundreds of accessories including lenses and filters for special effects.

Cambridge Camera Exchange, 7th Avenue and 13th Street, New York, NY 10011. Film, flash, etc.

Executive Photo & Supply Corp., 120 West 31st Street, New York, NY 10001. Film, etc.

Porter's Camera Store, Inc., Box 628, Cedar Falls, IA 50613. You name it, they have it.

Hirsch Photo, 699 3rd Avenue, New York, NY 10017.
Ritz Camera, 11712 Baltimore Avenue, Beltsville, MD 20705.
47th Street Photo, 36th East 19th Street, New York, NY 10003.
Olden Camera, 1265 Broadway at 32nd Street, New York, NY 10001.
Park Camera Co., 558 South Western Avenue, Los Angeles, CA 90020.

LIQUID EMULSION SOURCE
Rockland Colloid, 302 Piermont Avenue, Piermont, NY 10968.

MAGNIFYING UNITS
National Camera, Inc., 2000 West Union Ave., Englewood, CO 80110. This company supplies optical aids and tools primarily for camera repairmen, although they sell to everyone and will send catalogs on request.
Porter's Camera Store, Inc., Box 628, Cedar Falls, IA 50613. This general camera store has a newspaper advertising many products, including magnifiers.

TRADE JOURNALS

"Writer's Market," annual publication of *Writer's Digest* I have mentioned frequently throughout this book, has a substantial listing of trade journals.

One reasonably complete source is the *Standard Rate and Data Book,* used by advertising agencies. If you know someone in an agency, try to borrow their SRDS book for an evening. It will not be available in a library. Some of the photographic market books also list numerous trade journals.

PRICING CHECK LIST

ITEM	ESTIMATED $	ACTUAL $
Film		
Flash Bulbs		
Batteries		
Mileage		
Travel and Living Expense		
Tips and Wages Paid		
Film Developing		
Postage to and from Lab		
Contact Sheets and Proofs		
Negative Costs		
Markup on Negative Costs		
(1) TOTAL NEGATIVE COSTS		
Printing Charges		
Special Effects		
Postage		
Mounting		
Holders and Frames		
Albums		
Mileage		
Print Costs		
Markup on Print Costs		
(2) TOTAL PRINT COSTS		
Hourly Fee		
Sitting Fee		
"Per Job" Fee		
Incidental Services		
Service Costs		
Markup on Service Costs		
(3) TOTAL SERVICE COSTS		
TOTAL JOB: (1) + (2) + (3)		